Taking the Quantum Leap

Taking the Quantum Leap

The New Physics for Nonscientists

Fred Alan Wolf

PERENNIAL LIBRARY

Harper & Row, Publishers, New York
Grand Rapids, Philadelphia, St. Louis, San Francisco
London, Singapore, Sydney, Tokyo, Toronto

Acknowledgment is due to the following for the artwork in this book. The number refers to the page on which the artwork appears:
5 courtesy Dr. Heinrich Düker; 26, 42, 138, 175 courtesy John Snedeker; 49 from Fundamentals of Optics and Modern Physics *by Hugh D. Young. Copyright © 1968 by McGraw-Hill, Inc. Used with permission of McGraw-Hill Book Company; 62, 69, 94, 103, 117 courtesy AIP Niels Bohr Library; 70–71 from* Vision: Human and Electronic *by Albert Rose, Plenum Press, 1974. Used with permission of Albert Rose; 81 courtesy AIP Niels Bohr Library, W. F. Meggers Collection; 89 from* PSSC Physics, second edition, D.C. Heath & Co. *Used with permission of the Education Development Center, Newton, Mass.; 90 courtesy Burndy Library, AIP Niels Bohr Library; 93 courtesy Dr. Gottfried Mollenstedt; 106 courtesy Friedrich Hund, AIP Niels Bohr Library; 110 from* Atlas of Optical Phenomena *by Cagnet, Francon & Thrierr. Used with permission of Springer-Verlag, New York; 127 courtesy F. D. Rasetti, Segre Collection, AIP Niels Bohr Library; 129 by Fred Alan Wolf; 132, 150 ("Belvedere") by M. C. Escher. Reprinted courtesy Escher Foundation, Haags Gemeentemuseum, The Hague; 133 courtesy Sidney Janis Gallery, New York; 136 from* Quanta *by J. A. De Silva and G. Lochak. Used with permission of McGraw-Hill Book Company; 183 courtesy Rijksmuseum Kröller-Müller, Otterlo, The Netherlands; 197 courtesy Harvey of Pasadena, AIP Niels Bohr Library; 199 by Fred Alan Wolf.*

Pink Floyd lyrics quoted in the epigraph of chapter 2 and the title of part I (from the song "Welcome, Welcome to the Machine") are copyright © 1975 by Pink Floyd Music Publishers Limited for the World and are used by permission. Moody Blues lyrics, quoted in the epigraphs of chapters 1 and 10 (from "In the Beginning" and "The Best Way to Travel") are copyright © Gemrod Music, Inc. All rights reserved. Used by permission.

Timelines on pages 18–19, 30–31, 34–35, 40–41, and 76–77 are adapted from F. Rutherford, G. Holton, and F. G. Watson, directors, The Project Physics Course *(New York: Holt, Rinehart & Winston, 1970), copyright © 1970 by Project Physics. Used by permission.*

First PERENNIAL LIBRARY edition published in 1989.

Library of Congress Cataloging in Publication Data

Wolf, Fred.
 Taking the quantum leap.

 Bibliography: p. 274
 Includes index.
 1. Quantum theory. 2. Physics—History. I. Title.
QC174.12.W64 1989 530.1'2 80-8353
ISBN 0-06-055137-2
ISBN 0-06-096310-7 (pbk.)

89 90 91 92 93 HC 10 9 8 7 6 5 4 3 2 1
 90 91 92 93 HC 10 9 8 7 6 5 4 3 (pbk.)

Acknowledgments

There are always many people who influence and guide us as we pass through life. To my wife, Judith, I am most grateful. She, more than any other, offered guidance, encouragement, and critical, hard-nosed support, all of which were necessary. To my loving friends Bob Toben and Lanier Graham I owe a great deal; they believed in the project when I had my doubts.

I would also like to thank Michael Wolf, Don Barmack, Philip Ball, and Ken Mann, who lent their generous support when it was needed.

To Susan Rumsey, who did a thorough job of copyediting, Kathy Reigstad, production editor, Tom Dorsaneo, production manager, Bruce Kortebein, book designer, Ed Taber, illustrator, and Clayton Carlson, editor—special thanks.

I would also like to acknowledge Marie Cantlion, Joanne Farness, Alan J. Friedman, and Michael Katz for their helpful and contructive comments in their reading of the first version of the manuscript.

I am grateful to John Snedeker for supplying photographic artwork.

Contents

In the fond memory of my father,
Maurice Wolf,
and my mother, Emma Wolf.
Thank you for the gift of life.

Preface:
Six Years After

In January of 1986, a group of around two hundred quantum physicists gathered at the World Trade Center in New York City to spend one week discussing just what this strange quantum business means. This meeting,* occurring six years after the publication of the first edition of *Taking the Quantum Leap*, seemed to me to be an appropriate starting point for the new, updated edition. Attending the meeting reminded me of an earlier time—a time I described in chapter seven—when Albert Einstein, Niels Bohr, Max Planck, Max Born, Madame Curie, Erwin Schrödinger, Paul Dirac, Louis de Broglie, Hendrik Lorentz, Werner Heisenberg, Wolfgang Pauli, and several other stars of the quantum discovery (numbering around thirty) gathered at the Hotel Metropole in Brussels in 1927 to discuss the same matter. Things haven't really changed idea-wise in the ensuing years.

Certainly all of the stars of the 1927 conference have passed on. The last was Louis de Broglie who died in 1986 at the age of ninety-two, plus or minus a year or two. The new stars are surprisingly not many in number even though the quantum has become *de rigueur* in the twentieth century.

The new conference was in honor of one of the "grand old men" of the present quantum era, Eugene Wigner, who, at the conference, offered his wit and insight but no cigar to anyone. The mystery remains. Schrödinger's cat still resides living or not in the box that may or may not be filled with cyanide gas. The quantum wave of probability (the qwiff) is still spreading out in space waiting for some unsuspecting observer to "pop" it—altering the probability and suddenly creating an observed reality. Wigner's friend is still wondering if he or the professor observing him and the quantum system he holds in his hands "popped the qwiff" and created the reality he so enjoyed when he observed the system himself. And Albert Einstein, Boris Podolsky, and Nathan Rosen's reality paradox still twists the heads of all in attendance who wonder if quantum mechanics is complete and if not, what bizarre theory will be needed to complete it.

And even though John Bell did not attend, his spirit was strongly felt as his theorem echoed through the World Trade Center faster than a speeding photon. New luminaries appeared and offered inventive insights which led to more mysteries.

New Techniques and Ideas in Quantum Measurement Theory, conference held by the New York Academy of Sciences on January 21-24, 1986, in New York City.

Daniel Greenberger, the convention chairperson, reminded me of Lorentz, who introduced that famous Solvay 1927 colloquium in Brussels where Einstein announced that he hadn't really gotten into this quantum business. Greenberger told us that the 1986 conference was the first comprehensive meeting on the quantum to be held in a very long time in the United States. I would venture a guess that this conference was the only one of its kind since 1927.

Greenberger explained that the quantum theory of reality has run counter to the usual theory of science. Normally, after a few decades or so, innovative experimental evidence is accrued that brings to light new phenomena that cannot be incorporated into the existing theory. But this is strongly not the case in the quantum theory. Inventive experimentation has proven that the quantum theory is still valid in spite of its debatable meaning. Quantum theory is correct, and it is as weird as ever.

When I was a student studying quantum mechanics at UCLA, there were certain examples, "thought experiments" as Einstein once coined them, that illustrated the strangeness of quantum mechanics. The famous cat of Schrödinger was one of them. In those days we students would sit in the back of the room listening as our professor explained the paradox, secretly smirking to ourselves, "How silly this all sounds."* Little did we suspect that hardly thirty years after, the cat would live—and not live—in experiments being carried out at the IBM Research Laboratories in superconducting devices. Instead of a "cat in a box" there is a bit of magnetic flux caught in a tube. However, this isn't just some tiny bit of magnetism. It is a macroscopic, or large-scale, amount—something that can be realized within the classical world of our everyday senses. And just like the cat who must exist in a ghostly world where it is alive and dead at the same time, this bit of flux must exist on two sides of a barrier simultaneously until some observer takes a peek and then—like the cat—it just pops onto one side of the barrier or the other.

Indeed, one of the major themes of the conference was the realization of quantum weirdness—something that we smirking graduate students hardly ever dreamed would become a reality. Instead of finding quantum mechanics restricted to ever tinier corners of the universe, we physicists are finding its applicability ever increasing to larger and larger neighborhoods of time and space.

Thus it is that six years after the first printing of *Taking the Quantum Leap*, the quantum has become even more compelling. While 1945 christened the "atomic age," I believe that a new age is upon us. We are living in an era that properly should be called the

* I'm sure readers who pick up this book for the first time are wondering about this famous cat. Just skip ahead to chapter eleven and read all about it.

"quantum age." One need only look around at modern technology to see many of its examples. No television set purchased in the U.S. today will work without the tiny quantum of action playing its game. We are living in an age that performance artist Laurie Anderson calls "digital." We speak of turning on or being turned off. It's either all or nothing—a quantum of action that results in zero or one, with nothing in between.

A word about what's new in this edition. I have added a whole new chapter—the fifteenth. There I will tell you some more about two of the novel discoveries that have taken place since the first printing of this book. Since I am most interested in new ideas, the emphasis is on our understanding of these new thoughts. As ever, I shall try to make these concepts comprehensible to even the most scientifically unsophisticated reader. I can't help but tell you that the major theme of these ideas concerns our understanding of space and time. That old space-time of Einstein ain't what it used to be. It seems that there may be parallel worlds out there that we will be able to tune to; even in this world the future may be able to reach back toward us and alter our perceptions of reality itself.

If you have already read the first fourteen chapters in the previous edition, don't worry. This edition hasn't altered a word. The fifteenth chapter, however, is new and perhaps even stranger than what goes before it. Just what will come of these new ideas, no one knows. The weirdness of the quantum age has still to reach the common world we all live in. But tomorrow is here today, and if these ideas about time and space are correct, we may be reaching an age of miracles as time turns the corner into century twenty-one.

Fred Alan Wolf
San Miguel de Allende, Mexico
December 1987

Introduction

The "quantum leap" to which the title of this book refers is to be taken both literally and figuratively. In its literal sense, the quantum leap is the tiny but explosive jump that a particle of matter undergoes in moving from one place to another. The "new physics"—quantum physics—indicates that all particles composing the physical universe must move in this fashion or cease to exist. Since you and I are composed of atomic and subatomic matter, we too must "take the quantum leap."

In the figurative sense, taking the quantum leap means taking a risk, going off into an unchartered territory with no guide to follow. Such a venture is an uncertain affair at best. It also means risking something that no one else would dare risk. But both you and I are willing to take such risks. I have risked writing this book and you, a nonphysicist, have risked picking it up to read. My colleagues warned me that such an undertaking was impossible. "No one could understand quantum physics without a firm mathematical background," they told me.

For the scientists who discovered the underlying reality of quantum mechanics, the quantum leap was also an uncertain and risky affair. The uncertainty was literal. A quantum leap for an atomic particle is not a guaranteed business. There is no way to know with absolute certainty the movements of such tiny particles of matter. This in fact led to a new law of physics called the Principle of Indeterminism. But such new laws were risky, and the risk was to the scientists' sanity and self-respect. The new physics uncovered a bizarre and magical underworld. It showed physicists a new meaning for the word *order*. This new order, the basis for the new physics, was not found in the particles of matter. Rather, it was found in the minds of the physicists.

Which meant that physicists had to give up their preconceived ideas about the physical world. Today, nearly eighty years after the discovery of the quantum nature of matter, they are still forced to reconsider all they had previously thought was sacrosanct. The quantum world still holds surprises.

This book presents both the history and the concepts of the new physics, called *quantum mechanics*. The most abstract concepts, those least grounded in common experience, are presented imaginatively. In this way, what was literal is presented figuratively. The thread of history and imaginative concepts runs

throughout the narrative. Thus I hope to reach even the most mathematically unskilled among my readers.

Let me give an example. Quantum physicists discovered that every act of observation made of an atom by a physicist disturbed the atom. How?

Imagine you have been invited to tea. Surprise: the tea is given by extremely tiny elves! You will have to squeeze into their little elfin house. Welcome in anyway. Watch your head, though—the rooms aren't very high. Watch your step, too—elves only need tiny furniture to sit in. Be careful . . . oh well, too late. You just stomped a tiny teacup out of existence.

Peering into the world of atoms and subatomic particles is like looking into such an elfin house, with one additional distraction: every time you look in, you must open a door or shutter, and in doing so, you shake up the delicate little house so badly that it appears in total disorder.

Moreover, not only are the elves tiny, they are very temperamental. Walk into their house with a chip on your shoulder or feeling just plain lousy and the little people behave very badly toward you. Smile and act nice and they are warm and sparkly. Even if you aren't aware of your feelings in the matter, they are. Thus when you leave their little home, you may have had a good or bad time and not realize how much you were responsible for your experience.

If you now add that all you can observe are the results of such actions (i.e., opening and closing elf house doors, shaking up elf houses, breaking cups, etc.), you soon begin to wonder if what you are looking at is really a normal elf house or something entirely different. To some considerable extent, observations within the world of atoms appear equally bizarre. The meagerest attempt to observe an atom is so disruptive to the atom that it is not possible even to picture what an atom looks like. This has led scientists to question what is meant by any convenient picture of an atom. A few scientists hold to the belief that atoms only exist when they are observed to exist as fuzzy little balls.

In their reluctant attempts to describe the world of tiny objects like atoms and electrons (tiny particles contained within an atom and carrying an electrical charge), physicists devised quantum mechanics. The discovery of the new physics is the story of their adventure into the magical world of matter and energy. Their attempts were reluctant because each discovery made led to new and paradoxical conclusions. There were three paradoxes.

The first paradox was that things moved without following a law of mechanical motion. Physicists had grown accustomed to certain basic ideas concerning the way things move. There was an invested "faith" in the Newtonian or classical mechanical picture of matter in motion. This picture described motion as a continuous "blend" of changing positions. The object moved in a "flow" from one point to another.

Quantum mechanics failed to reinforce that picture. In fact, it indicated that motion could not take place in that way. Instead, things moved in a disjointed or discontinuous manner. They "jumped" from one place to another, seemingly without effort and without bothering to go between the two places.

The second paradox involved scientists' view of science as a reasonable, orderly process of observing nature and describing the observed *objectively*. This view was founded on the conviction that whatever one observed as being out there was really out there. The idea of objectivity being absent from science is abhorrent to any rational person, particularly a physicist.

Yet quantum mechanics indicated that what one used to observe nature on an atomic scale "created" and determined what one saw. It is like always seeing light through a set of colored filters. The color of the light depends on the filter used. Yet there was no way to get rid of the filters. Physicists don't know what the filters are. Even the most basic idea of matter, the concept of a "particle," turns out to be misunderstood if one assumes that the particle has properties totally independent of the observer. What one observes appears to depend upon what one chooses to observe.

In itself, that is not paradoxical. But the total picture of the observed, drawn from the sum of observations, appears to be nonsensical. Consider another example.

In a well-known experiment called the *double slit experiment*, a stream of particles is directed toward a screen. A second screen, containing two long and parallel slits, is placed in between the stream's source and the original screen. In this way each particle must pass through one slit or the other in order to reach the final screen. Each time a particle strikes the final screen it leaves a tiny imprint or dark spot. Yet the amazing thing is that if you close down one of the slits more particles make their way to certain places on the final screen than if you leave both slits open.

There is no way to understand this paradox if you regard the stream as simply made up of little particles. How does a single

Wave or particle?

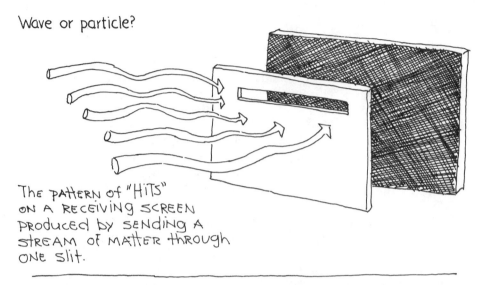

The pattern of "Hits" on a receiving screen produced by sending a stream of matter through one slit.

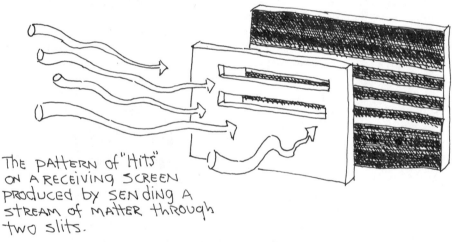

The pattern of "Hits" on a receiving screen produced by sending a stream of matter through two slits.

particle know if you have two slits or only one slit open? Since each particle has a choice of two slits to pass through, each has twice the opportunity of reaching any point on the final screen. This means that, with two slits open, the particles should reach the empty spaces on the screen with a greater frequency. Yet that is not what we observe. When two slits are opened, the particles leave empty spaces on the final screen adjoined by darkened regions where they do finally land.

Closing down one of the two slits denies the particles any choice. Yet they manage to fill in the blank spaces between the darkened regions as soon as one slit is shut.

Why do the particles avoid certain places on the screen when both slits are opened? Are the particles "aware" of the two slits? No ordinary commonsense picture of a particle explains the weird behavior it demonstrates when confronted with two choices. Perhaps the two possible paths for each particle, either through one slit or the other, interfere with each other and cancel themselves out. Or perhaps the particles in the stream bump into each other when they pass through the slits.

No, it doesn't work that way. The particles can be controlled so that no more than one at a time passes through the slits. Yet each and every particle avoids the blank spaces on the screen when both slits are opened. Perhaps there is another way to explain the experiment.

Yes, there is. The particles are not particles when they pass through the slits—they are waves. And waves do interfere with each other. In fact, when each particle is given a wavelength and wave interference is taken into account, the blank spaces on the screen are completely explainable. That means there must have been an error in the first picture of the particles. They are not "particles" at all. They are waves.

No, that isn't correct either. When the waves arrive at the screen, they do not land everywhere on the screen at once like any ordinary wave should. Instead, the waves arrive as a series of pointlike spots. Thus the "waves" are particles after all.

Particles or waves? Which is the true picture? It depends on which part of the experiment is being performed. With one slit open, the stream is composed of particles. With two slits, it is composed of waves. The nature of the physical stream of "particles" depends on how we set up the experiment.

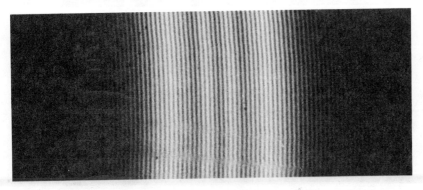

The interference pattern from an arrangement analogous to a double slit produced by electrons.

Which brings us to the third paradox presented by the new physics: despite the natural disorder apparent in this and other experiments, quantum mechanics indicates that there is an order to the universe. It simply isn't the order we expected. Even describing the true order of the universe is difficult because it involves something more than the physical world. It involves us, our minds, and our thoughts. Just how physics and our minds are to be brought together is a controversial subject. The gradual recognition that what we think may physically influence what we observe has led to a revolution in thought and philosophy, not to mention physics.

Quantum mechanics appears to describe a universal order that includes us in a very special way. In fact, our minds may enter into nature in a way we had not imagined possible. The thought that atoms may not exist without observers of atoms is, to me, a very exciting thought. Could this fact concerning atoms also apply in other realms of science? Perhaps much of what is taken to be real is mainly determined by thought. Perhaps the appearance of the physical world is magical because the orderly processes of science fail to take the observer into account. The order of the universe may be the order of our own minds.

Welcome to the Machine

The Passive Observer

I think.
I think I am.
Therefore, I am,
I think?

THE MOODY BLUES

"Who has seen the wind?" asks poet Christina Rossetti. "Neither you nor I," yet we certainly believe it is there. Similarly, no one has ever seen a fundamental particle, and yet physicists have a great deal of faith in its existence. But to hold to that faith, they have had to give up some very precious ideas concerning the physical world, the world of matter and energy. What emerged from their reluctant ventures into this tiny world of atoms, molecules, and other fundamental particles was quantum mechanics. What they discovered using quantum mechanics has turned out to be a new insight concerning the universe: the observer affects the observed.

The roots of quantum mechanics, the new physics of motion, are buried in the ancient soil of our earliest awareness of how things moved. Even further back in time, before any awareness of motion, there existed a tiny tendril from these roots, and that was the idea of the observer. And within that idea is the notion of the "passive" or nondisruptive observer. Humans are creatures of the eye. They believe what they see.

Before scientific observation could take place, one had to learn to observe, to tell things apart, and this took a very long time to do. The earliest human observations were quite passive and nondiscriminatory. We first began to observe our own separate existence. Looking up and out, we next began to observe things that were not ourselves. Timidly we reached out and touched, sometimes with painful consequences. The world "out there" was not always friendly. Overcoming our fears, we began to touch things again and take them apart, especially if these things didn't bite. These were active or experimental observations.

More than likely, our first observations were of moving objects, such as grass blowing in the wind or clouds drifting overhead. At night we saw the stars . . . and wondered. From daybreak we watched the sun make its journey through the sky, following a path much like that of the stars through the night sky. Perhaps we picked up a rock and threw it.

Movement caught our eyes and told secrets of the natural order of things. Fire went up. Matter stayed close to the earth. Air floated above water, and water fell to earth where it too floated upon the earth's surface.

When things were out of their natural places, they moved, seeking the places they had come from. Fire came from the stars, for example. When humans entered the scene, we disrupted the natural flow or continuous movement of everything to its proper place. By passively observing, we would learn nature's secrets. By touching, we would disrupt and learn nothing.

But we could think about motion. We could imagine how it was occurring. We could even make models of motion, imagining the movement of an arrow flying as a series of stationary arrows, each arrow following upon another, like a sequence of still frames in a motion picture reel.

These thoughts and first observations were the roots of the modern science of motion, the magical world of quantum mechanics.

Dawn of Consciousness

It is not difficult to travel back in time to the earliest human attempts at observation. Simply observe a newborn baby. As you watch an infant's attempts to grasp a finger held before its eyes — and indeed grasp understanding — you are witnessing the early human observer. The child is becoming aware of the subtle division between itself and the outside world.

A process of thinking is going on. It is wordless. Einstein often said that he got his best ideas in pictures rather than words. In fact, Einstein did not speak at all until he was four years old.

Perhaps there is a process of synthesis or analysis going on in an infant's mind. The child may be attaching the sounds its mother makes to the things it observes. In any case, a distinction must be occurring in the child's mind. That distinction — the separation of the "out there" from the "in here" — is called the *subject-object distinction.*

When the first hypothetical observer was first learning this distinction, he was becoming conscious. Consciousness means awareness, and that first awareness had to be the concept of "I am." In sensing this "I," our first observer was learning that he was not his thumb nor his foot. The "in here" experience was "I." The "out there" experience was "it."

Today we make this distinction with no trouble at all. Consider a simple example. Become aware of your thumb. You can feel your thumb or, better, you can sense the presence of your thumb. Next, become aware of your left heel. Again with just a

thought, you can feel your heel. In fact, you can sense any part of your body this way. You need not reach over physically and feel your body parts with your hands. You are able to sense them all with your mind.

Once you have done this you realize that you are not the thing you feel. We could regard this experience as the movement of your consciousness or awareness from your mind to your body part. A certain division takes place. A distinction separates your "in here" from your thumb or your heel. That "in here" experience is necessary before any real observation can take place. Observation deals entirely with the "out there" experience.

It is thought that perhaps three thousand or more years ago, people were not able to distinguish the "out there" in a clear way from the "in here" or "I am" experience. They may have been only dimly aware of their capacity to make such a distinction. They had no "I" consciousness. Julian Jaynes offers a speculation on the development of the "I" consciousness in his book, *The Origin of Consciousness and the Breakdown of the Bicameral Mind.*[1]

Jaynes claims that, about three thousand years ago, our fore-parents suffered their first "nervous breakdown." They then became aware of themselves as "I" people and ceased to be unaware automatons following the voices of "gods" in their heads. According to Jaynes, the two halves of the bicameral brain were functioning more or less separately. But when the break-down occurred, the voices stopped and human beings became aware of themselves as independent entities.

From this rather rude awakening humans learned a new awareness of their surroundings. The period of the early Greeks started only about five hundred years after the general breakdown proposed by Jaynes. Internal "godlike voices" are no longer ruling human consciousness, but there are probably still some remnants of the early rumblings in Greek heads. The Greeks began to observe everything in sight with a passion. However, being afraid of the "out there" and not too sure of them-selves, they remained passive but quite accurate observers. And their first question was: "Is all one, or is all change?"

All Is One, All Is Change

The first observations of the early Greeks had to do with God, the spirit, and matter.[2] They considered two conflicting ways of understanding the human condition: either all was one or all was

change. These were no idle thoughts to the Greeks. They were based upon observation. Indeed, these thoughts were largely based upon self-observation.

Let us consider the hypothesis that all is one. How can we today understand that idea? We start with the undeniable experience we all feel—the experience of our own existence, the instant knowing that is for each of us consciousness of our being. This is the "I" experience, perhaps the only experience that each of us "knows" for sure. As you hold this book in your hands, take a moment to reflect that you are doing so. That instant of reflection is the "all is one" experience that the Greeks were thinking about. To them, this experience was ultimate and fundamental.

But what about everything else? Everything else was an illusion, a trip to Disneyland or the movies. After all, we cannot ever be certain that everything and everyone out there is really there. They are beyond our immediate experience. This was the "all being" or "at one with God" experience described by the Greeks. By always keeping track of this experience—i.e., remembering oneself each instant—this "one being" experience, the "I," was God, and all else was illusion.

Some early Greeks held a conflicting view. For them, all was change and there was no God, no omnipotent, unchanging Being. The moment or instance of "I" awareness was the illusion. The only reality was continuous change or movement. This was all there was. There were no things at rest. To hold on to the illusion of "I" was incorrect and impossible. You change. Moment follows moment. Time marches on whether or not we wish it to do so. Returning to the original example of you holding this book in your hands, notice that even to grasp the idea that you are now reading requires change. You cannot hold the moment still. Even your awareness that you "know" this has, just this instant as you read on, passed into the past. There is no "I." There is no you. There is only change and movement.

Thus arose the conflict between change and Being. And it led to many lively discussions on the shores of ancient Greece. The beginnings of the scholastic tradition of thinking and writing about such matters was the next step after the dawn of consciousness. The mystery of God, spirit, matter, and motion were being pursued with vigor. Out of this debate arose the very spirit of science. The roots of quantum mechanics were strengthened. If things change, then how do they do so?

The Idea of Discontinuity

I have always found Charlie Chaplin movies amusing. The little guy is always getting in trouble by sticking his nose where it doesn't belong. But, miraculously, he escapes from every predicament. Usually he manages this by moving in a very disjointed or discontinuous manner. I am amused, of course, because I know that motion doesn't really take place the way it appears in a Chaplin movie. In real life, motion appears smooth and continuous—not at all Chaplinesque. The "jumps" that we see in the film are artificial. They occur because the real life motion has been replaced by a moving series of still pictures.

The notion of the continuity of motion being composed of a series of stationary instants has been with us for a long time. Since we are also able to experience being at rest or sitting still while posing for a photograph, it is natural to try to imagine how we can move from one place to another.

The first scientific thoughts about the discontinuity of movement undoubtedly occurred to the early Greeks. The Greek thinkers Zeno and Aristotle[3] pointed out the difficulty with attempting to analyze the motion of an object as a series of "still frames."

Zeno presented his idea of the discontinuity of motion as three paradoxes. He pointed out that there is a difference between what we mean by motion as we imagine it occurring and what we actually see occurring in real life. He showed this difference by analyzing the motion of an object as if it consisted of consecutive still frames in a motion picture film.

Later, Aristotle attempted to salvage the idea that motion could not occur this way, that in real life an object moved as a continuous "whole." He felt that Zeno's "motion picture" concept of movement had to be wrong. And he demonstrated his perspective by pointing to two different ways of interpreting Zeno's idea of motion. Aristotle's attempt to show Zeno's error turned out to be quite successful. It paralyzed further thinking about motion as occurring discontinuously and it led to the faith that, "in principle," motion could be understood as a continuous stream of inseparable still instants.

This idea of continuity of movement has proven extremely difficult to shake. It is at the heart of modern mathematics, particularly evident in the concept of continuous functions and modern calculus. The entrenchment of Aristotle's concept of motion, together with the Greeks' reluctance to analyze nature,

kept these early thinkers from discovering the discontinuous motion of atomic-sized objects. Despite Zeno's theory, this discovery would not take place for another two thousand years.

Zeno and Moving Things

Zeno lived in Elea, which had already been established as a home for scholastic thinking. And think he did. Although often overlooked in a typical course in science, Zeno was the forerunner of the modern theoretical physicist. The job of theoretical physicists is to explain observations. If we are unsuccessful in doing so, we are to point out that something is askew in our understanding of those very same observations. In short, we earn our money either way. Either we show how to understand an observation that was previously not understood or we tactfully point out that we have been mistaken in thinking we understand what we have seen.

Zeno fulfilled the second role of the theoretical physicist very well. He pointed out to his fellow scholastics that "their heads were filled with beans." He used logical argument (a newfound tool of thinking after the bicameral breakdown) to prove that motion is impossible.

Now of course Zeno knew that motion was not impossible. These Greeks were not stupid. But Zeno was concerned with the understanding of motion, and he was offering, through a series of arguments, an analysis of motion. This was not an easy thing for his fellow thinkers to accept, since Zeno was attempting to prove that the way motion took place was not the way they thought it did.

Zeno provided three paradoxes concerning motion. Each dealt with the way an object moves through space and time. The

question Zeno brought out was, "How can we understand movement if an object is to occupy a given place at a given time?"

Indeed, an object *must* occupy a given place at a given time, for it cannot occupy more than its given place at any one time or it would have to be in two or more places at the same time. "Thus we must assume," as I imagine Zeno presenting himself, "a given object must occupy a given place at a given time and certainly no more."

Now we come to Zeno's second point. He continues: "If it is true that the object behaves as I have stated, then it must leave its given place at the given time in order to reach the next place at a later time. And therein lies the rub." Let us look at this "rub" in its three paradoxical parts presented by Zeno.

Zeno's First Paradox

"Motion cannot exist," says Zeno, "because in order for a runner to reach the endpoint of his race, he must first reach the point halfway between the endpoint and the starting point." We would certainly concur. The runner must go at least halfway to the goal line before he can cross it. "But," Zeno continues, "don't you see the paradox in this? Before he can reach the halfway point, he must reach the point midway between the halfway point and the starting line." Again we see no problem here. "Well, there is a problem," Zeno retorts, "because the statement I just made can be applied to any distance in this race. Before the runner can reach the quarterway point, he must reach the one-eighthway point, and before that, the one-sixteenthway point, and before that . . ."

Zeno's race: The runner never can get started.

The last halfway.

Finish line

Okay, so we see that for the runner to go any distance in the race, he must go halfway first, and there appears to be no end to the number of halfway points along the route to the finish line. "That's it!" cries Zeno. "There are an infinite number of these halfway points, and each of them marks off a finite distance the runner must reach before he can go on to the next point. Therefore there is no first distance he can run to, because. . . ." Because he must go halfway first and so on—we finally see the point. The runner is stuck at the starting gate with no way to go. But of course runners do run, and Zeno knew this. Therefore, the question still remained, "How do we explain this?" Before we do, let us allow Zeno to present his second paradox.

Zeno's Second Paradox

"Achilles can never overtake the tortoise in a race," Zeno declares. "Even though the slower tortoise is ahead of Achilles by a modest distance, the faster Achilles cannot reach him. Because to do so, Achilles must first reach the point just departed by the turtle before he can catch up to the turtle. And as my first paradox demonstrated, there would be an infinite number of such points for Achilles to face. Certainly as long as there is any distance between them, the turtle will have left any point before Achilles arrives there."

Do you see that Zeno's second paradox is very much like his first? Instead of a runner racing along a fixed course, we have Achilles racing to catch up with the tortoise, which is always a little distance, and therefore a variable distance, in front of him. Hence, Achilles has his work cut out, for no matter how small that distance may be, it too contains an infinite number of midway points along the way.

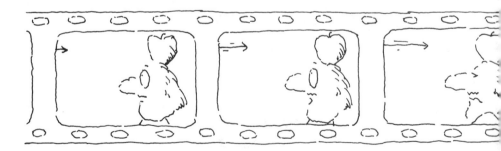

Zeno's third paradox will be different. It will directly confront our conception of motion as a series of still instants. As Zeno presents this paradox, imagine you are looking at a strip of home-movie footage containing several frames of an arrow in flight.

Zeno's Third Paradox

"The arrow cannot fly. It cannot fly because an object that is behaving itself in a uniform manner is either continually moving or continually at rest. The arrow is certainly behaving itself in such a uniform manner. Now watch the arrow as it travels along its flight path. Clearly, at any instant, the arrow is occupying a given place. Therefore, if it is occupying a place, it must be at rest there. The arrow must be at rest at the instant we picture, and since the instant we have chosen is any instant, the arrow cannot be moving at any instant. Thus the arrow is always at rest and cannot fly."

You may be tempted to point out to Zeno that an object occupying a given position could be moving and not necessarily be at rest. However, you must remember that Zeno insists that the object behave itself in a uniform manner and that means it must behave consistently. If an object occupies space, it stays in that space. Filmmakers use Zeno's consideration of consistency to create animated movies. They shoot each frame as a still photograph, minimizing jiggles and nonuniformities in their carefully laid-out mattes. They would agree that an object in a film scene must be at rest in each frame it occupies.

Zeno's arrow: Moving from frame to frame by Quantum Jumps.

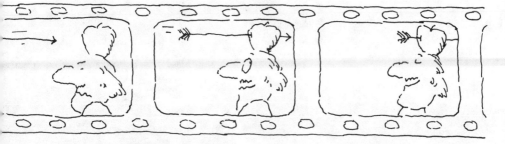

Historical Events

- 500 BC
- 400 BC
- 300 BC
- 200 BC

PERSIAN WARS
PELOPONNESIAN WARS
SPARTA DEFEATS ATHENS
RISE OF MACEDONIA
384 Aristotle 322
THE PUNIC WARS
CH'IN DYNASTY IN CHINA

Government

Xerxes
Pericles
Philip II
Ptolemy I of Egypt
Alexander
Hannibal

and Science

Confucius
Anaxagoras
Zeno of Elea
Parmenides of Elea
Protagoras
Democritus
Socrates
Mencius
Epicurus
Zeno of Citium
Hsun Tzu

Philosophy

Plato

Diogenes

Euclid

Archimedes

Erastosthenes

Literature

Aeschylus

Pindar

Sophocles

Herodotus

Euripides

Thucydides

Aristophanes

Xenophon

Demosthenes

Chang Tzu

Plautus

Fine Arts

Phidias

Myron

Polygnotus

Polyclitus

Zeuxis

Timotheus

Scopas

Lysippus

Praxiteles

Apelles

Aristoxenus

Thus Zeno was asking us to think about how we move from one still frame to another. How can an arrow appear in different positions in each frame? We know the answer with the animators who shoot films. They alter the setup when no one is looking and so create a magic illusion of motion. Zeno wondered how nature or God performed her or his magic show.

Aristotle felt that Zeno's ideas were very important. He also felt that he had an answer to Zeno's paradoxes of motion. The answer was continuity or, better, the wholeness of continuity and the mistrust of analysis.

Aristotle's Attempt to Resolve Zeno's Paradoxes

Although Aristotle attempted to dispose of Zeno's arguments, he still considered them important. He presented Zeno's paradoxes and his own resolutions in *Physica*. Aristotle wrote *Physica* nearly one hundred years after Zeno lived. I'm sure that if Zeno had been around at that time, their debate would have been quite lively. In fact, the conflict between these two thinkers reminds me of a later debate between Bohr and Einstein. We will get a chance to "overhear" their discussion in a later chapter. It concerns a very similar issue: is nature continuous?

Aristotle showed that Zeno's paradoxes of motion could be resolved if we understood that there were two very different ways to interpret Zeno. The key was the idea of the infinity of space and time, the space and time occupied by an object as it moves from one place to another.

"For there are two distinct meanings to an infinite number," Aristotle explained, "depending on whether we are dividing up or adding together. When we are adding up small pieces of space or time, we soon run out of either if we go on to infinity. But if we have a *finite* region of space or interval of time, then we can go on dividing it up forever by making each piece as small as we wish.

"Thus," he continued, "a runner reaches the endpoint of his run without difficulty. The distance covered is finite and can be divided into as many small pieces as we wish on to infinity. The same is true for the time of the runner's race. Time, too, is finite and can be divided up to infinity. So motion exists because it does not take an infinite amount of time for the runner to cover the distance. Both the time taken and the distance covered are finite, even though they can be infinitely subdivided.

"When we apply the same argument to Achilles and the tortoise, we can see that the faster-moving Achilles will overtake the tortoise in the race. The distance between them is finite and therefore it will take Achilles a finite time to overtake the turtle. That ends the first and second paradoxes.

"As far as Zeno's third paradox is concerned, the arrow will assuredly fly. It is quite simple to see how—just add more frames to its motion picture as is done in high-speed motion photography. The time interval between any two frames can be subdivided again into an infinite number of subintervals so tiny that each represents a 'point of time' perfectly frozen. If a single snapshot is taken for each of these frozen instants, we will have a continuous dissolve of one frame to the next showing that the arrow moves continuously."

Although I've updated Aristotle's language a little, I'm sure that if he were around today, he wouldn't mind. His arguments are quite convincing. Yet they are based upon the subtle assumption that it is possible to subdivide to infinity. We certainly would agree with him that we cannot add up to infinity.

But hold on. To see the arrow move as a series of continuous dissolving movie frames, we must view many more than the modern filmmaker's usual twenty-four frames per second. We need an infinite number of frames passing before our eyes each second. So dividing up motion to infinity is really no different than adding up to infinity.

This subtlety eluded Aristotle and everyone who came after him for the next two thousand years and more. By assuming that the arrow's motion was continuous, it was natural to imagine continuity as "made up" of an infinite number of still frames, even though we would never attempt to make such a motion picture. We just believed that "in principle" it was possible.

By 1926 that hope was demolished. Werner Heisenberg, the young physicist who demolished it, was later to be awarded the Nobel prize in physics for his realization that Zeno was correct after all. Heisenberg's Principle of Indeterminism (or Principle of Uncertainty, as it is often called) reaffirmed Zeno's objection that "an object cannot occupy a given place and be moving at the same time." Heisenberg recognized that observation, as we actually experience it, does not allow us to analyze motion on to infinity. Sooner or later we see that our activity introduces discontinuities in whatever we are observing. These discontinuities are fundamental to the new physics of the twentieth century.

In dismissing Zeno's arguments, Aristotle was reaffirming the already firmly fixed idea that, "in principle," passive observa-

tion could be continued no matter how we subdivided time and space. Thus the continuity concept and passive observation went hand in hand. There was no point in seeking still movie frames of discontinuous motion—they were not to be found. Motion was a whole. It was a continuous dissolve. It was its own thing undivided.

Retrospect: The End of Passivity

Aristotle's thoughts would continue to play a role in Western thinking for nearly two thousand years. Although it was not "good physics" to analyze motion by actually stopping an object in flight and then assume that motion was a series of connected "stops," it was certainly all right to do so as a mental exercise. Anytime humans intervened, they interfered with natural motion. But there was no harm in thinking about motion as connected stops.

Aristotle believed in natural motion. Humans' interference produced discontinuous or unnatural movements. And, to Aristotle, such movements were not God's way. For example, Aristotle envisioned the idea of "force." The heavy cart being drawn along the road by the horse is an unnatural movement. That is why the horse is struggling so. That is why the motion is so jerky and uneven. The horse must exert a "force" to get the cart moving. The horse must continue to exert a "force" to keep the cart moving. As soon as the horse stops pulling, it stops exerting a "force" on the cart. Consequently, the cart comes to its natural place, which is at rest on the road.

Aristotle did not seem to enter into the debate between those who believed in an "all is one" divine Being and those who supported the "all is change" philosophy. However, he did feel that the mind, spirit, and soul were more important than the physical world. It is possible that the fifth element in Aristotle's physics, the ether, was the same "physis" mentioned by his forefathers in Elea. This "physis" was the essence of all matter. Perhaps Aristotle saw the origin of movement in the vibrations of this essence. He certainly wondered about it. "How come the arrow flies continuously," he asked, "now that the bow that caused its flight is no longer in contact with it?" Somehow the perfection of natural movement was being imitated by human interference.

Within the world of the mind, these thoughts occurred thousands of years ago. Scientists were passive then. It would take a while before they would attempt to reach out and touch, to try ideas and see if they worked. Then scientists would no longer simply accept the naturalness of motion. They would have to see for themselves by setting up experiments that would isolate and separate motion into parts. They would learn something from this. What they would learn eventually would not resolve any of the paradoxes of motion, however. It would turn out that both "truths" of Zeno and Aristotle were correct. Motion was continuous and smooth, provided it was unseen. Motion was discontinuous, whenever it was observed, provided we looked hard enough to see it.

These discoveries would not occur until the twentieth century. Before then, we would attempt to analyze motion while assuming that, "in principle," our manipulations were nondisruptive. This period of scientific history may be regarded as the age of the active observer. It would produce some remarkable successes. It would also produce some still-to-be resolved mysteries concerning motion.

The Active Observer

Welcome, welcome to the machine. It's all right boy, we know where you've been.

PINK FLOYD

With the coming of active observation, the invisible wind became visible. It was seen as a hailstorm of molecules, tiny little particles only billionths of an inch in diameter. All motion was analyzed or, in principle, could be analyzed or envisioned as consisting of these tiny "hailstones." A new spirit of inquiry had appeared. It foretold the coming of the Mechanical Age or Age of Reason. It would lead to mechanics or the science of motion. Quantum mechanics would emerge from the human desire to reach out and touch things.

In the latter part of the sixteenth century, almost two thousand years after Aristotle lived, the fear of active analysis would at last be overcome. Passive observation had ended. The active observer was eager to explore and take things apart.

This period of unrestricted inquiry would take precedence for the next four hundred years. It would begin with a small number of dedicated scientist-analysts working as individuals throughout western Europe. These would include Copernicus, Kepler, Bruno, Galileo and Descartes. Later Isaac Newton would refer to these men as having provided the firm foundation for his thinking. As he would state, "If I have seen farther than others, it is because I have stood on the shoulders of giants."[1] Newton would see far. And after Newton would come a "Golden Age of Certainty."

A new faith in the "mechanical universe" would be born. Michael Faraday would discover how to turn electricity into magnetism. James Clerk Maxwell would invent a mechanical model of light and show that light was a form of electricity and magnetism.

These were a new breed, these scientist-analysts. Their aim was to take things apart, analyze everything, be critical, and use logic ruthlessly. The image of the cold, withdrawn scientist starts here. Unfortunately, the image of this kind of scientist is still with us today.

In the typical, corny movie, the wild-eyed, splatter-haired, and white-coated scientist is seen experimenting on his newest monster. He is a fictional relic from the Age of Reason. Scientists were building machines to take machines apart. The human-made machines were designed to peer into the nature-made machines. Nature was no longer something to just sit back from and ponder over. Science was an activity requiring careful experi-

mental or "hands-on" abilities. There was no limit to what one could see by searching into the smallest of things. The new scientist-analysts had faith that mathematical analysis would correctly describe the behavior of even the tiniest things they discovered.

Welcome to the machine.

This approach would have been near heresy to the early Greeks. Mathematical analysis, like actual "hands-on" analysis, would not have been trusted. The idea that motion was a continuous dissolve from one stationary point to another was accepted by these later analysts. Newton and Leibnitz would even develop a mathematics of continuity, which we today call "the calculus." This mathematics of continuity would describe motion as observed in Newton's laws of motion. The never-ending numbers of explorers into the Lilliputian land of physics would always be able to dissect every line into an infinite array of points, each point joined to the next.

The "whole" observed by the Greeks was always more than the sum of its parts. No longer. The "whole" envisioned during the Mechanical Age exactly equaled its sum of parts. No more and no less. This was essential to the mechanical picture. There were no missing pieces. Everything measurable was accountable. Laws of conservation arose. Mass or matter was conserved. Momentum, the product of mass and velocity, was also conserved, providing you measured not only the speeds of the objects involved, but also the directions in which they were going. Energy was conserved. Things were what they were—no more and no less.

As scientists carefully studied its parts, the world of physics became simpler, more understandable. By piecing together these parts, they found they could understand any complex motion. Only by a careful study of the tree could the forest be seen. The acorn was, after all, just an acorn. The emerging oak tree grew according to laws of motion, even if we didn't happen to know just how to apply those laws to it.

Newton's laws of motion were the supreme laws of the universe. But within their formulation was a carefully hidden assumption: The observer does not disturb; the observer observes what is there. The physical world was a gigantic clockwork. It could be taken apart and put back together. It would work the same. And Newton's laws predicted a strange kind of symmetry. The clock would work just as well running backward as running forward. From any given moment in time, the future was completely determined and could be predicted by following the continuous mathematical description offered by Newton's laws.

Furthermore, by knowing the "now," the past could be reconstructed. But the reconstruction would not be based on hindsight and fallible human memory. Rather, it would follow the "time symmetry" in Newton's equations. The past was continuously

connected to the present. The future was continuously connected to the present. Thus all was determined. By the nineteenth century, the mechanical Age of Reason had become the Age of Certainty.

And with the end of the nineteenth century, a new and yet ancient view would begin to emerge. It would start with two mysteries. The first would be the discovery that something was missing in the mechanical picture of light, that light waves traveled without any substance to wave in. The second would be the realization that the colors of light from any hot glowing material, such as the filament of a light bulb, could not be explained by the mechanical movement or vibrations of that material.

With the new spirit of analysis and the discovery that light and heat behaved in mysterious ways, quantum mechanics would begin to break the soil of the grounded Age of Certainty. Without the efforts of all of the scientists during this pre-twentieth-century period, quantum mechanics would not have occurred.

All of this began with that small group Newton called "giants."

Newton's Giants: The Age of Reason

The first of the Age of Reason new breed Newton called "giants" was Nicolaus Copernicus. In the sixteenth century, when he wrote that the earth could not sit at the universe's center, it was heresy even to say such a thing. Saint Thomas Aquinas in the thirteenth century had brought his Christian theology together with the Aristotelian view that the earth was positioned in the center of the universe and the stars moved in perfect continuous circles around the earth. Therefore, to suggest that the earth was not at the center was to risk death at the hands of the church's inquisitors.

In 1514, Copernicus published his first work, a monograph suggesting that the earth was not at rest. Possibly fearing to be too explicit, Copernicus wrote his work in an overly philosophical style. The work went virtually unnoticed.

Undaunted, he continued for the next twenty years gathering what scant data existed to support his theory. In 1543, just a few hours before he died, Copernicus saw for the first time the results of his two decades of labor in a published form. His

second book, *De Revolutionibus Orbium Caelestium* (*The Revolutions of the Heavenly Spheres*),[2] was shown to him by a young Lutheran professor who, we can assume, must have had his own reasons to be disenchanted with Christian theology. Copernicus' book had been published in Nuremberg and was soon banned by the Catholic church. It was not to be seen again for the next three hundred years.

Giordano Bruno was Newton's second giant.[3] Born in 1548, the Italian Bruno had somehow heard of Copernicus' theory. The very idea that the sun was the center of the universe and the earth moved around it must have seemed like magic to the young Bruno. "How can it be so?" I can imagine Bruno asking. "When I look to the sky, I see the sun rise and circle the earth upon which I stand. Now to think that it is the earth, and I with it, that moves overthrows all that I have believed was true."

Bruno's imagination soared. He saw multitudes of solar systems, sun-centered universes, scattered among the stars. In each solar system, he saw parallel earths just like ours. He envisioned life on other planets. And he told of what he had seen. In 1600 he was burned at the stake as a heretic.

Johannes Kepler, Newton's third giant, was born in Germany in 1571. Having a fondness for astrology and astronomy, he worked as assistant to astronomer Tycho Brahe.[4] While attempting to confirm Copernicus' view that the earth revolved around the sun, he devised three laws of celestial motion. These three laws would later serve as the basis of Newton's laws of motion and lead to his discovery of the law of universal gravitation. Moreover, they would provide a new vision of the universe: as a gigantic clockwork of orderly moving things.

Kepler would be the first of many to use mathematics to formulate his observations. This approach to observation had been left unturned by the Greeks. The assumption was that mathematics could provide a basis for understanding observation. Of course, Aristotle would never have been satisfied with just a mathematical explanation. Music, for example, was more than mathematical vibrations. And even Kepler felt that something else was needed to back up his mathematics.

The fourth giant was René Descartes. In 1619 during a snowstorm in Bavaria, he had shut himself up in a heated room for two weeks. During this time he said he had three visions. These visions left him in total doubt concerning anything he had thought he knew or understood. He rejected all religious dogma. He put aside all authority figures. There was only one thing he knew for sure, and that was: "I think, therefore I am."[5] He had

Timeline scale: 1350 · 1400 · 1450 · 1500 · 1550 · 1600

Historical Events

- BLACK DEATH IN EUROPE
- GREAT SCHISM IN ROMAN CHURCH
- WARS OF THE ROSES
- DISCOVERY OF AMERICA
- 1473 Copernicus 1543
- SPANISH CONQUEST OF MEXICO
- GLOBE CIRCUMNAVIGATED
- SPANISH CONQUEST PERU
- ROANOKE COLONY IN VIRGINIA
- SPANISH ARMADA DEFEATED

Government

- Richard II
- Joan of Arc
- Lorenzo de Medici
- Isabella of Castile
- Ferdinand of Aragon
- Richard III
- Henry VIII of England
- Montezuma of Mexico
- Elizabeth I
- Ivan the Terrible
- Henry IV of France

Science

- Prince Henry the Navigator
- Gutenberg
- Christopher Columbus
- Jean Frenel
- Tycho Brahe
- Giordano Bruno
- Galileo
- Andreas Vesalius
- Ambroise Pare
- William Gilbert

Philosophy

Thomas à Kempis
John Huss
Martin Luther
Savonarola
John Calvin
Erasmus
Machiavelli
Thomas More
St. Ignatius of Loyola

Literature

Petrarch
G. Chaucer
Jean Froissart
François Villon
Rabelais
Montaigne
Shakespeare
Cervantes
Edmund Spenser

Art

Donatello
"Master of Flemalle"
Rogier van der Weyden
Sandro Botticelli
Leonardo da Vinci
Michelangelo
Raphael
Tintoretto
Pieter Brueghel
El Greco

Music

John Dunstable
Guillaume Dufay
Josquin des Prez
Palestrina
William Byrd
Andrea Gabrielli

returned to the ancient position of the Greeks. It was the old being versus change argument. But Descartes had taken that argument a step further.

Recognizing that he thought, he concluded logically that he existed. In other words, his awareness that he existed was his only proof of his own existence. We might point out that this evidence is conclusive. It is an overwhelmingly powerful and simple argument. Of course, I can imagine existence after I am dead or before I was born, but I cannot prove it. Thus Descartes recognized that being and change were complementary. All was neither total being nor total change.

"I am" meant being. "I think" meant change. Therefore, being was the background for change. And change was necessary for awareness of one's existence. Descartes offered a firm shoulder for Newton. That shoulder was the foundation of logical thought. Even today, French schools follow the Cartesian methods of analysis and thought. There must be reasons for things. If the planets revolve about the sun, there is a reason.

Descartes made a bold attempt to construct a complete theory of the universe using nothing but the elements of being and change.[6] These were called matter and motion. He even attempted to resolve the Copernican view of the universe with the Aristotelian view. He saw motion as relative, not absolute. For example, when two ships at sea are left unanchored and one collides with the other, which is at fault? Which ship moved into the other? Though each might claim that the other had been at fault, Descartes would demonstrate that the problem was one of perspective and the relative motion of each ship to the other. The crew of either ship would see the other ship moving toward them, while their own ship would seem to be at rest. Similarly, the sun could appear to move around the earth, or the earth could appear to move around the sun.

Because of these four scientist-analysts—Copernicus, Bruno, Kepler, and Descartes—a new reason for motion would be devised. The absolute movement of all things to their natural places was no longer accepted as a sufficient answer to the question of why things moved. Mathematical description was not to be avoided. Analysis would become a trusted tool of science. But the efforts of a fifth giant would be required to provide Newton with all that he would need to explain being and motion. He would be the first experimental physicist, the first to actually reach out and touch the universe. His name was Galileo Galilei.

Galileo: The First Active Observer

Galileo is the prime example of the modern physicist.[7] He devised methods of observation, description, and analysis that today we take as the basis for all physics. His essential contribution to the eventual discovery of quantum mechanics was the replacement of the passive observer with the active observer.

Passive observation was any observation that the observer wished to perform that left the observed undisturbed by the observer. In other words, passive observation required that the presence of the observer have no effect on the outcome of whatever was observed. For example, the sun rises whether or not we look at it. Our observations have no effect upon the movement responsible for that observation, which we now recognize is the rotation of the earth about its axis. There is little if anything we can do to stop the earth from spinning. We take this for granted.

Until Galileo's time, little had been done to attempt to discover reasons for motion other than those offered by Aristotle. Experimentation or actual analysis of motion was difficult and was not even attempted. But Galileo was part of the new breed. When he was barely seventeen years old, he made a passive observation of a chandelier swinging like a pendulum in the church at Pisa where he grew up. He noticed that it swung in the gentle breeze coming through the half-opened church door. Bored with the sermon, he watched the chandelier carefully, then placed his fingertips on his wrist, and felt his pulse. He noticed an amazing thing: the pendulum-chandelier made the same number of swings every sixty pulse beats.

"How could this be so?" he asked himself. "The wind coming through the door changes the swing at random. Sometimes the chandelier swings widely and sometimes it hardly swings at all. Yet it always swings at the same rate." Persisting in his passive observation of the chandelier, he had discovered the principle of the first mechanical clock. The movement of a pendulum could be relied on to measure time.

Later he would remember this experiment. Time would provide the necessary background for the measurement of all motion, not just the years it takes to observe the movements of planets, but also the seconds it takes to observe motions nearer to the earth. Unlike Newton's other giants, Galileo was bringing observation down to earth. Not satisfied with just looking, he had to bring instruments into the play of science.

In a popular story, Galileo stands before his inquisitors,

Historical Events

1500 — 1550 — 1600 — 1650 — 1700

1564 Galileo 1642

- BEGINNING OF THE REFORMATION
- SPANISH CONQUEST OF MEXICO
- CIRCUMNAVIGATION OF THE GLOBE
- SPANISH CONQUEST OF PERU
- FRENCH WARS OF RELIGION
- DEFEAT OF THE SPANISH ARMADA
- OPENING OF THE GLOBE THEATER
- ESTABLISHMENT OF JAMESTOWN
- 30 YEARS WAR IN GERMANY
- PASSAGE OF THE MAYFLOWER
- PURITAN REVOLUTION
- KING PHILIP'S WAR

Government

- Henry VIII of England –
- Ivan the Terrible
- Elizabeth I of England
- Pope Urban VIII
- Cardinal Richelieu
- Cromwell
- Louis XIV of France

Science

- Copernicus
- Jean Fernel
- Andreas Vesalius
- Ambroise Pare
- Tycho Brahe
- Giordano Bruno
- Francis Bacon
- Kepler
- William Harvey
- René Descartes
- Blaise Pascal
- Robert Boyle
- Christiaan Huygens
- Newton
- Gottfried Leibnitz

Philosophy

Machiavelli — Erasmus — Martin Luther — St. Ignatius of Loyola — John Calvin — Thomas Hobbes — Spinoza — John Locke

Literature

Rabelais — Montaigne — Cervantes — Edmund Spenser — William Shakespeare — Ben Jonson — John Milton — Molière — Racine

Art

Michelangelo — Titian — Pieter Brueghel — El Greco — Bernini — Velázquez — Rembrandt van Rijn — Rubens

Music

Palestrina — Orlando di Lasso — Giovanni Gabrieli — Monteverdi — Henry Purcell

begging them to peek through his telescope and observe
mountains and craters on the moon. No, they say. The instru-
ment cannot be trusted to give a true view. It is not worth their
while to look into it. "What we would see is produced by the
telescope and does not exist objectively and independent from
it," they claim. Galileo points out the features of the lunar
surface. But even when one of the inquisitors finally peers into
the instrument, he does not see anything that resembles what
Galileo had described. "The craters are in your mind," the
antagonist cries. "No," Galileo insists, "they are really there.
Why can't you see them?"

In another story, Galileo appears before the Medici,
a wealthy ruling family in medieval Italy. He has set up an
inclined plane, a plank with one end elevated above the other,
and proceeds to roll various objects down the plank. He has
devised this experiment to demonstrate that objects accelerate
as they roll down the incline, that they do not move with
constant speed as Aristotle predicted. Even more surprising, all
the rolling objects, whether light or heavy, accelerate at the same
rate and all reach the bottom at the same time. This is definitely
not according to Aristotle, who said that the heavier objects
would roll faster and reach the bottom of the inclined plane ahead
of the lighter objects.

The Medici are unimpressed. Indeed, they suspect that
Galileo has provided nothing more than a good magic show.
"How can we trust your prestidigitations, Galileo? Clearly, you
must be pulling a fast one. For nothing you have shown us makes
any sense according to Aquinas and Aristotle. Do not mistake us
for fools. We, too, are distinguished philosophers and observers.
But we wouldn't presume to equate the tricks of such primitive
playthings with God's true motions. Such activities on the part
of any observer must be discouraged. You, Galileo, are respon-
sible for these observations, not natural law." Their words echo in
Galileo's ears.

In both of these stories, Galileo brought before his skeptics
a new way of science. It was the *doing* of science, the active
participation of the observer with the observed. Yet, in the first
story involving Galileo's telescope, the skeptical inquisitors
cannot see the moon's craters. They do not trust the instrument,
and their minds cannot accept that Galileo's creation can make
visible what their eyes alone cannot see. It is beyond "reason"
that such should be true. In the second story, Galileo's attempts
to demonstrate natural law are ridiculed because his methods are
too gross. His detractors are offended that nature's continuous

movements should be disrupted by Galileo's rude interventions.

But Galileo understood that such experiments were only approximate indications of the true nature of motion. He agreed that his methods were crude. He didn't agree, however, that he was disrupting nature. Instead, he was attempting to reveal the natural laws of motion by *removing* those disruptions that keep us from seeing the truth. Through careful analysis, he was able to pierce all the extraneous influences that otherwise cloud our observations. In Galileo's mind, analysis meant simplification and discovery of God's laws. By reaching out and touching the universe, Galileo had set the precedent of modern experimental physics.

Now all it would take to fulfill modern physics was a precedent for modern theoretical physics. And that would come from Isaac Newton.

The Continuity of Mechanics

Isaac Newton was able to bring together the concepts of passive observation and active observation. In fact, with his point of view any distinction between the two approaches vanished. Active observation was, for Newton, nothing more than an extension of passive observation. Instruments simply detected; they did not alter the existing world they explored. Active observation and such thoughts as these allowed this scientist of the late seventeenth and early eighteenth centuries to see the great continuous ocean of truth. As he said,

> I do not know what I may appear to the world; but to myself I seem to have been only a boy, playing on the seashore, and directing myself in now and then, finding a smoother pebble or a prettier shell than ordinary, whilst the great ocean of truth lay all undiscovered before me.[8]

Whether Newton peered through a telescope or contemplated Galileo's many experiments made little difference. The important fact was that good mathematical and experimental tools were helping scientists to see more clearly and grasp more firmly the universe about them.[9] The telescope, the microscope, and vacuum pump were opening up new worlds. Analytic geometry and the calculus were new mathematical forms to play with. The cross-fertilization of mathematics with experimental methods was

resulting in major insights. Scientists were looking up into the universe and peering down into the tiniest objects observable. All instruments of science were simply extensions of the human senses. Following on Descartes' philosophical discourse, mind was distinct from matter. The observer, therefore, was distinct from the observed. Everything that was not ethereal was fair game to Newton's analytical mind.

Basing his work upon that of those who preceded him, Newton wrote his now famous *Principia* (Philosophiae Naturalis Principia Mathematica, London, 1687). In it, he brought together, with meticulous logic, centuries of thought about motion and the universe. The idea of continuity was extremely important for Newton. From this single concept, he was able to realize his three laws of motion. In fact, without continuity none of these laws would make sense. Even the infinity concept, which Zeno and Aristotle brought forward to explain time and space continuity, would present no stumbling block to Newton. To grasp his ideas, we might imagine him in conversation with some of his students. The question is raised, "What is time, Sir Isaac?"

A Conversation with Isaac Newton

I can imagine Newton responding, "What is time? Nothing to it. It is absolute, true, and mathematical. It flows continuously without any relation to anything else. Pieces of time, which we call durations, are relative, apparent, sensible, and measurable. We measure these pieces by their motion. We assign different names to these pieces according to the amount of their motion. A year is the motion of the earth around the sun, a month is the motion of the moon around the earth, and so forth."

"What about space, Sir Isaac?" another young student asks. And Newton answers, "Space is immovable and infinite. It always remains just as it is. But length is a different matter. It is sensible and it is relative. We measure length by comparison. A man is as high as an elephant's eye, etc."

"But then how do things move?" yet another student asks. Newton answers, "Things move because that's all they can do. Motion is natural. It's only when motion is disrupted that we should wonder what's going on. All things in the universe move, taking part in the great flow of time. If everything in the universe was left unattended and alone, all things would move

just as they had eons ago. Whatever motion they had then, they would have now. Everything would flow in a continuous way. But things do interact with each other. And each interaction causes their motion to 'bend' or accelerate. The planet's path bends into a circle around the sun because the sun pulls on the planet with a force. I call that force *gravity*. The ball falls from the high building to the earth for the same reason. The ball's motion is changed by gravity. The ball accelerates, gathers momentum as it falls. All of this is explained by my laws of motion and theory of gravity."

"But, Sir Isaac," our young student asks, "do you mean that forces make motion discontinuous?" Newton replies, "No, not at all. The motion is still continuous. Though the force causes the motion to change, the change takes place continuously. Each instant, the accelerating ball falls a tiny bit faster. Each instant, the planet's path bends just a little from a straight line. After many instants, the planet finds itself following a circle instead of a straight line. That's how we know that a force has acted upon it."

"Can all motion be explained this way?" queries the student. "Yes, indeed," Newton answers. "The laws of mathematics I have written show that. And they show even more. My third law states that action equals reaction. This means that if a body bends your path or causes you to accelerate, then you are doing the same thing to it."

"Hold on," says the student. "Certainly the earth is bending the moon's path. But is the moon also bending the earth's path?" Newton replies, "Indeed, it is so. But the moon, having less matter, suffers the greater bend. The earth, having more than six times the moon's mass, suffers a smaller deviation."

We can imagine Newton's students asking questions and Newton answering their questions on and on into the night. Newton had answers, all of them supported by mathematical analysis. His laws and insights made the world seem both simpler and more complex.

On one hand, the world seemed simpler because Newton provided the basis for analyzing any motion. If a motion was bent, the cause could be found, and one could predict with total certainty what would happen to the object that was moving. Newton's mathematical tools were based upon the firm assumption that all motion was continuous and could be separated into parts. These parts could be examined, one piece at a time. And each piece would follow a firm law.

On the other hand, the world seemed more complex because

Historical Events

1600 — 1650 — 1700 — 1750

SETTLEMENT OF JAMESTOWN

SETTLEMENT OF PLYMOUTH

PURITAN REVOLUTION

1642 Newton 1727

GLORIOUS REVOLUTION

PEACE OF UTRECHT

Government

Cardinal Richelieu

Oliver Cromwell

Jean Colbert

Louis XIV of France

Peter the Great of Russia

Science

René Descartes

William Harvey

Johannes Kepler

Blaise Pascal

Robert Boyle

Christiaan Huygens

Gottfried Leibnitz

Edmund Halley

Jean Bernoulli

Galileo

Literature Philosophy

Thomas Hobbes
George Berkeley
Spinoza
Montesquieu
John Locke
David Hume
Voltaire
Ben Jonson
Alexander Pope
John Milton
Jonathan Swift
Henry Fielding
Molière
John Dryden
Daniel Defoe

Art

Peter Paul Rubens
Jean Watteau
Velázquez
William Hogarth
Bernini
François Boucher
Rembrandt van Rijn
Christopher Wren

Music

Jean Lully
Henry Purcell
Antonio Vivaldi
Johann Sebastian Bach
George Frederick Handel

it had so many parts. These parts made up the whole of the universe. Nothing need ever be left out. Any observance that motion deviated from Newton's laws meant that there was another body around influencing things. The whole was—had to be—the sum of its parts. The universe was a machine.

Everything that influenced anything was part of this great machine. And all of the machines built during this time worked in accordance with the new understanding provided by Newton's analysis. A mechanical philosophy was appearing. It became popular to regard both the physical world and the nonphysical world as mechanical. For every effect, there had to be a known cause. For every cause, there had to be accountable effects. The future, therefore, became a consequence of the past. It seemed there was little anyone could do to alter the world. Even our thoughts were to be explained somehow by Newton's machine. The "hand of God" had set the machine in motion eons ago, and no one could stop it. All consequences, all ideas, all human thoughts occurred because of this initial cause a long time ago. In other words, nothing was left to chance. Everything had already been determined by God. This view was known as *determinism*.

Newton's great machine.

The Nightmare of Determinism

Picture a quaint French drawing room, circa 1800. White wigged, white stockinged, drawing room society is enjoying an evening of folderol. The butler, or whatever he is called in such circles, announces the arrival of a famous philosopher and scientist, the Marquis de Laplace. Conversations hush and become murmurs. The Marquis enters. People move aside quietly as if to welcome a king into their ranks. Perhaps more to the occasion, we should view the Marquis as a famous actor-artist. Chairs are drawn into semi-circular rows. The presentation was about to begin.

Pierre Simon Laplace, known as the Marquis, became the darling of Paris' early nineteenth-century drawing room crowd. He was known for his dramatic and eloquent presentations of that mysterious and quite abstract science known as *celestial mechanics*. He held his audiences completely suspended as he told of the worlds beyond, all of them caught in that action-at-a-distance force, which Newton called gravity. No cosmic strings, yet powerful was the influence of this never-observed, yet totally present, cause of acceleration.

The universe and all its worlds followed well-defined laws according to the same guiding principles. Everything was, and is, predictable. Only find the force, know the masses, positions, and velocities of the objects under study at one single time, and all is predictable. It matters not what the objects are. Planets, stars, and rolling cobblestones—all fall victim to the force.

The universe is a gigantic Newtonian clockwork. Cause and effect rule. Nothing is by chance; everything is ultimately accountable. Read Laplace's words (translated, of course):

> We ought then to regard the present state of the universe as the effect of its previous state and as the cause of the one which is to follow. Given for one instant a mind which could comprehend all the forces by which nature is animated and the respective situation of the beings who compose it—a mind sufficiently vast to submit these data to analysis—it would embrace in the same formula the movements of the greatest bodies of the universe and those of the lightest atom; for it, nothing would be uncertain and the future, as the past, would be present to its eyes.[10]

Perfect determinism, from a heartbreak to an empire's rise and fall, was no more than the inevitable workings of the Great Machine. The laws of physics are to be obeyed, because it is

impossible to disobey them. The dream of an ultimate under-
standing of nature was the discovery of the hidden force that was
the cause of the yet-to-be. Once this force was found, there
would be no room for free will, salvation, and damnation, or
for love and hate. Even the most trifling thought had been
determined in a far-gone age.

Ethics, morality, pride, and prejudice were jokes. You may
imagine that you are a free-thinking person, but even that
imagination is nothing but the universal clockwork turning in
some yet-to-be-discovered way. Discovery of how the whole
universe works was still to be achieved, but nevertheless, in
principle, this materialist philosophy was the basis for the
universe.

The idea that free will had vanished was called the "night-
mare of determinism." Even thinkers and philosophers of this
period who were not disturbed by the "nightmare" felt the impact
of Newtonian thinking. Because physics was able to explain a
remarkably large number of physical phenomena, from the
movements of planets to the kinetic motions of the tiny particles
within an enclosed volume of gas, with only a few principles, it
became the model of human knowledge.[11]

Nineteenth-century thinkers sought to emulate the precision,
universality, and orderly procedure of physics. They sought
general laws to explain history and human behavior. Karl Marx,
for example, suggested that matter is the only subject of change
and that all change is the product of constant conflict between
the opposing forces inherent in all things. When one force over-
comes the other, change is produced. Thus, for Marx, a revolu-
tionary movement can never be a cooperative venture between
the ruling and working classes, for the force of one class must
eventually overcome the opposing force of the other class. This
theory, known as *dialectical materialism*, sounds very much like
Newton's second law, which states that force is the cause of
change in motion and matter is what force acts upon.

Even Clarence Darrow, the famous lawyer who defended the
theory of evolution in the Scopes "monkey trial" of 1925, was
influenced by Newton. In another of his well-known cases, the
notorious Leopold and Loeb murder trial, Darrow defended his
clients by pointing out that they were victims of heredity and
environmental forces. Although Leopold and Loeb were clearly
guilty, Darrow defended the two murderers on the grounds that
they had no choice in their actions, that there was a lengthy
series of causes leading inevitably to the eventual death of their
victim. Even the environment in which the two murderers grew

up was presented as a product of that long chain. Therefore, how could society presume to punish these two for a situation over which they had no control? They were as much victims of their crime as the individual they killed. All were powerless to stop the Newtonian clockwork.

It is understandable that Laplace, Marx, and Darrow should be so influenced by Newtonian machinery.[12] Certainly it is easier to imagine that the whole is simply a sum of its parts and that understanding the part will inevitably lead to understanding the whole than to consider a world in any other way. What other way could there be? Why, even mind itself must ultimately prove to be nothing more than an extremely complex mechanical device. Since mind must come from matter, what else could it be? Indeed, mind must show itself as a direct outcome of its material base. So thought Sigmund Freud.

Freud associated certain dream images with primitive ideas, myths, and rites.[13] He claimed that these dream images are "archaic remnants"—psychic elements that have survived in the brain from ages long ago. The subconscious mind is a trash heap. No wonder we suffer guilt, for we suffer not only for ourselves, but also for our ancestors who may have raped, murdered, and pillaged thousands of years ago.

Hugh Elliot (1881-1930), editor of England's Annual Register during the time of transition from classical physics to quantum physics, was a champion of mechanistic science and materialism.[14] He posited three principles: (1) the laws of the universe are uniform, and while the universe may appear disorderly, careful scrutiny by science reveals that these universal laws are to be obeyed; (2) teleology is a myth, for there is no such thing as a purpose to the universe and all events are due to the interaction of matter in motion; and (3) all forms of existence must have some kind of palpable material characteristics and qualities. Elliot wrote:

> It seems to the ordinary observer that nothing can be more remotely and widely separated than some so-called "act of consciousness" and a material object. An act of consciousness or mental process is a thing of which we are immediately and indubitably aware: so much I admit. But that it differs in any sort of way from a material process, that is to say, from the ordinary transformations of matter and energy, is a belief which I very strenuously deny.[15]

I enjoy quoting Elliot, because few individuals have expressed such confidence in the totality of a material universe as

well as he did. He went on to say that "there exists no kind of spiritual substance or entity of a different nature from that of which matter is composed. . . . there are not two kinds of fundamental existences, material and spiritual, but one kind only. . . ."[16]

And thus is the stage set. We are, all of us, machines.

By the end of the nineteenth century, classical physics had become not only the model for the physical universe, but the model for human behavior as well. The wave of mechanical materialism, which began as a small ripple in the stream of seventeenth-century thought, had grown to tidal wave proportions, sweeping all Greek thinking aside. Physicists investigated dead things and physicians sought clockworks in living people.

Somewhere along the way, Descartes' "I think, therefore I am" was lost. Or, rather, it was turned around and became "I am, therefore I think." The search for objective reality, cause and effect, the hidden mechanical order was on. The horizon of science was clear.

Speaking about the future of science, one celebrated theorist said that it would only consist of "adding a few decimal places to results already obtained."* However, there were others who did not express such confidence in the mechanical universe. One of these individuals, a man known as Lord Kelvin, became an authority in European circles during the mid-nineteenth century. Toward the end of that century, he said that he saw only two dark clouds obscuring the horizon of the Newtonian "landscape." These two clouds were two mysteries in the otherwise perfect mechanical explanation of light and heat.

An Explanation of Light and Heat . . . with Something Missing

By the end of the nineteenth century, a world picture had been completed. Scientists felt they understood the physical universe, and the Newtonian mechanical model was being used to explain everything else as well, including those qualities that Aristotle felt were beyond mere explanation as parts of a whole or the

* This famous remark was made by A. A. Michelson in 1894. Michelson believed he was quoting Lord Kelvin and later confessed that he regretted ever having said such a thing. [L. Cooper, *An Introduction to the Meaning and Structure of Physics* (New York: Harper & Row, 1968), p. 431.]

machine. Scientists were eager, therefore, to find a mechanical explanation for the invisible parts that made up the material universe. Two specific areas of physics needed explanation. They were heat and light.

A century earlier, the Italian physicist Amadeo Avogadro had modeled a gas as consisting of many tiny particles. And in the seventeenth century, Robert Boyle had discovered the general gas law that related the pressure in a gas to its volume. Joseph Louis Gay-Lussac in 1800 discovered the effect of temperature on a confined gas and found that when a gas was heated, the volume it occupied increased if the pressure in the gas remained constant. The realization soon followed that heat was simply the rapid movement of the tiny particles of the gas. That is, heat was kinetic energy of matter and nothing more.[17]

But something was missing. How did the sun's heat reach the earth? Were there particles along the way between the sun and the earth? Did the movement of these particles conduct the sun's heat from one place to another? The space between the sun and earth was thought to be empty so heat could not be just the motion of matter. Somehow heat could travel without the medium of matter. In this respect, it resembled another form of energy known as light.

Through the first half of the nineteenth century, many scientists began to accept the idea that heat and light were at least qualitatively identical. According to Newton, light consisted of tiny particles, or corpuscles, that were able to move through the vacuum of space. Thus it was that light traveled from the sun to the earth. Light, therefore, was defined as substance. Heat, too, was considered a substance. This was the picture up to around 1820.

But Thomas Young discovered a property of light that upset the Newtonian particle picture.[18]* He found that light particles can somehow interfere with each other. The patterns

* Young's announcement that his result supported the wave theory of light was not well received by the scientific establishment. Indeed, it was met with ridicule and hostility, because it dared to conflict with the sacrosanct Newtonian particle light theory. Henry Brougham, a British politician and amateur scientist, wrote in the *Edinburgh Review* in 1803: "[Young's] paper contains nothing which deserves the name, either of experiment or discovery, and . . . is destitute of merit. . . . We wish to raise our feeble voice against innovations, that can have no other effect than to check the progress of science, and renew all those wild phantoms of the imagination which . . . Newton put to flight from her temple." F. Rutherford, G. Holton, and F. G. Watson, *Project Physics Course* [Authorized Interim Version, 1968-69] (New York: Holt, Reinhart, & Winston, 1968), text 4, chapt. 13, p. 14.

produced by light when it traveled from its source to a screen could not be explained by light particles. What Young discovered can be seen by anyone who holds two fingers to his eye and looks at a light source (not the sun, however—it's much too bright). The retina of the eye takes the place of the screen used by Young.

Simply look through your fingers as you carefully squeeze them together. Just before you extinguish the light coming through, you will see a series of alternating light and dark bands. These bands are called an *interference pattern*. They can only be produced by light *waves*, not particles. The alternation of light and dark is due to waves of light interfering with each other.

This interference is caused by the oscillatory movement of waves. All waves are produced by vibrations within the medium holding the wave. The familiar sweet sound of a lyrical voice is nothing more than a continual repetition of air molecules vibrating against your eardrums. The familiar harmony of a barbershop quartet is the wave interference of four different vibrational frequencies, each coming from a different singer. Similarly, light waves can interfere with each other and produce a "light harmony"—the interference pattern of light and dark bands.

A dark band results when the high crests of one wave are met by the low troughs of another wave. Under normal circumstances, we do not see these interference patterns. The crests and

Thomas Young's original drawing, showing interference effects expected when waves from slits A and B overlap. (Place the eye near the left edge and sight at a grazing angle along the diagram.) At the screen on the right, no light is received where the waves from A constantly interfere destructively with the waves from B.

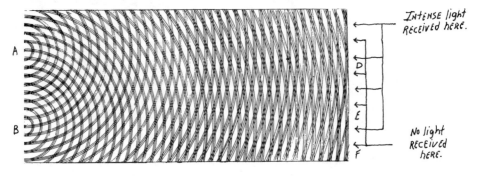

A light wave interference pattern formed when light is sent through a very narrow keyhole.

troughs of light waves are very tiny. But when they are forced to travel through a very narrow space, such as the space between your two fingers, these waves bend into each other. The pattern of light and dark is a result of this bending.

We are more familiar with the bending of sound waves. For example, we know of the presence of a moving truck around a blind corner when the truck honks its horn. The sound waves produced by the horn bend around the corner and reach our ears.

Once Young had discovered that light was a wave, heat was also imagined to be a wave phenomenon. Together the two traveled the vast distance that separated the sun and earth, moving as waves move. But there was one problem with this picture. Waves must move through something. They don't travel in a vacuum. This was obvious to the scientists of the nineteenth century. They had found that when they placed a ticking clock inside of a glass enclosure from which the air is slowly evacuated, the sound waves vanished as soon as the air in the enclosure was exhausted. Sound waves wave in air. Thus, light waves and heat waves must wave in some invisible substance that filled all of space.

Scientists called this substance "ether," drawing from the world picture the early Greeks had painted. The ether was

invisible and yet had to be a form of matter so fine that no one had yet discovered its existence. There were other indications of its existence, and these appeared as a result of two seemingly unrelated discoveries. The first discovery was that electricity could be turned into magnetism and turned back again into electricity.

Michael Faraday in England had discovered that an electrical current could produce a magnetic field. In fact, he invented the term *magnetic field*. He also constructed a device that was the forerunner of the modern electromagnetic generator. By rotating a bar magnet in the vicinity of a current-carrying wire, he showed that the magnetic field could "induce" the current. In other words, he found that the moving magnet was capable of generating the electrical current. This discovery, which made it possible to turn magnetism into electricity as well as electricity into magnetism, does not support the ether idea by itself. But it does suggest that electricity and magnetism can be interchanged, and this interchange, called *electromagnetism*, led to the theoretical discovery of electromagnetic waves.

By 1860, the idea of electromagnetism was accepted. James Clerk Maxwell, also in England, had discovered, through his attempts to make a mathematical model of Faraday's discovery, that in theory the process of turning electricity into magnetism and magnetism back into electricity could be repeated. In fact, it was theoretically possible to repeat the process very, very quickly. This led Maxwell to the idea of electromagnetic oscillations. These oscillations or vibrations were, however, only a mathematical theory. They were predicted to occur only on paper. The question was: could they be observed? What would they look like?

While pondering this mystery, it occurred to Maxwell that the light waves experimentally discovered by Young may be produced by the electromagnetic oscillations he had discovered theoretically. By playing with his equations, he found an astonishing fact: the equations describing the electromagnetic vibrations had solutions that described electromagnetic waves moving at the speed of light! Could light waves be electromagnetic vibrations? If so, what was vibrating?[19]

Maxwell's successful attempt to show that electromagnetic waves were theoretically able to travel at the speed of light and Young's experimental discovery that light could interfere with itself was convincing evidence that light was an electromagnetic wave. And since heat was also able to travel across vast spaces, it too had to be an electromagnetic wave.

In 1887, Maxwell's theory finally received support from the experiments of Heinrich Hertz. Hertz had successfully shown that an electromagnetic wave of invisible radiation was emitted by an oscillating electric current. Hertz had invented radio waves. He was also able to show that these invisible radiations were, indeed, waves exhibiting all of the characteristics of interference, wave bending, and so forth exhibited by visible light waves. Hertz's experimental detection and production of electromagnetic waves convinced everyone; light and heat must also be electromagnetic waves.

Yet the problem still remained: how did these waves travel from their sources to their places of detection? In other words, what did these waves wave in? The substance, scientists assumed, was the ether. However, no one had ever directly detected the ether. It had never been seen.

The Ether Is Missing

The first dark cloud originally mentioned by Lord Kelvin was about to make its appearance on the clear Newtonian horizon. In 1887, A. A. Michelson and E. W. Morley, two college professors from Cleveland, Ohio, attempted to measure the presence of the ether existing between the sun and the earth.[20] They were quite convinced of its presence. Young's observations and Maxwell's theoretical discovery "proved" that light was a wave. Therefore, light had to travel through a material substance that filled the space between the earth and the sun.

To perform their experiment, Michelson and Morley needed to measure the speed of the earth relative to this fixed immovable ether. If they succeeded in obtaining this measurement, the result would be convincing evidence of the existence of the ether. Unfortunately, this was not an easy experiment to carry out. The situation might be compared to a school of fish attempting to discover the water in which they live. To find the water, the fish would have to discover ripples in it. These ripples, or waves, would travel from one fish to another, but the speed at which the ripples traveled would be fixed.

Today we can observe the fixed or constant speed of water waves by observing the waves extending from the bow of a moving motor boat. These bow waves travel at a constant speed away from the boat. The boat, however, can increase its speed.

Thus, the boat can catch up with its own waves. In another example, the supersonic jets of today's high-speed society often surpass the speed of sound. That is, they travel through the air faster than their own sound waves. The well-known sound barrier concept arises because of the sound wave buildup that occurs just ahead of the jet as it approaches the speed of sound. When the jet passes through the barrier, a sonic boom is heard.

In this way, the fish underwater could measure the speed of their movements through the water, and thereby its existence, by noticing how fast they were traveling in comparison to the speed of water waves. Thus, the fish could claim that the water had to exist because they were able to observe changes in their speed through the waves that they were emitting in that water. All a fish had to do was move away from a wave and then move back toward the wave as the wave approached it. From the fish's point of view, the water wave would appear to move faster when the fish swam toward it and slower when the fish swam away from it.

Michelson and Morley were prepared to be fish in the ether. The waves they would attempt to measure were, of course, light waves. The difference they expected in the speeds of the light waves would be due to the earth's velocity through the ether. This difference in speed would at last prove the existence of the ether—that tenuous but continuous material that provided the medium for light waves.

The sad result of their experiment was failure. Even though the experiment was perfectly capable of measuring the small speed difference due to the earth's movement, no difference was detected. The two experimenters were dejected. Later on, they would be heralded as the early discoverers of the constancy of the speed of light, a cornerstone of Einstein's theory of special relativity. But at the end of the nineteenth century, there was no way to reconcile the missing ether and the wave picture of light. How light got from there to here was still a mystery.

The Ultraviolet Catastrophe

Meanwhile, a second dark cloud was appearing on the clear Newtonian horizon: hot things glow. They glow different colors as they are heated. Before light bulbs were frosted they were

clear enough to reveal their insides. The filament in a bulb was visible and it carried an electric current. As the current was increased, the filament would begin to glow and produce light. The color of that light would also change. The higher the current in the bulb, the hotter the filament got. And the hotter it got, the more the color changed. The question was why?

What was responsible for the changing color of the light? All hot bodies, such as electrified light bulb filaments and heated branding irons, emit light. Furthermore, if the light they emit is allowed to pass through a glass prism, the light will spread out into a palette of colors that blend together like a rainbow. In fact, a rainbow is nature's own palette, produced when sunlight passes through very tiny prisms made of water droplets. The spread of colors is called a *light spectrum*.

Sunlight produces a balanced spectrum of colors. There are equal amounts of all colors present. That is why sunlight appears "white" or colorless. All objects, no matter what their chemical nature or composition, send out light with the same color balance, if these objects are heated to the same temperature. It was a change in the balance of colors in the spectrum that was producing the different colors observed in the light bulb filament and elsewhere. That balance depended on how hot the glowing body became.

Thus the characteristic color of any object changes in a very predictable manner as it is slowly heated to higher temperatures. Cool objects give off no apparent light. A hot poker glows red. At a higher temperature, it starts to glow orange-yellow. At still higher temperatures, it glows blue. Look at a burning match and you will see that the flame has different colors running through it. The temperature of the flame is not the same throughout, but the bluer colors of the flame are the hottest parts, so be careful.

When the spectra from various objects are examined at different temperatures, we find that various colors are emitted in differing amounts. The shifting of these amounts of colors change the characteristic color of a glowing object. However, the hotter an object becomes, the whiter its color becomes and the more balanced its spectrum is.

The connection between the temperature of a material and the color of the light it emitted had to be a mechanical one. Since Gay-Lussac's work in 1800, it had been known that higher temperatures produce greater kinetic energy or more rapid motions of a heated material. Since the heated material was made

of atoms, the atoms had to be moving or oscillating to and fro more rapidly. Thus, it was natural to suspect that the colors of the light were somehow determined by the movements of the tiny atoms or oscillators composing the heated material. The frequency of the observed light was, or had to be, the same as the frequency of the vibrations of oscillators within the material substance.

After Maxwell's success in explaining that a light wave is an electromagnetic oscillation, scientists began to suspect that the different colors of light emitted by a heated object were caused by the different vibrational frequencies. Thus, red light was thought of as having a lower vibrational rate or frequency than blue light. Although the search for the ether had led up a blind alley, scientists still felt that color and vibrational frequency were related.

All of the above facts concerning hot glowing objects and the colors they emitted were known by the end of the nineteenth century. At that time Lord Rayleigh, a well-known expert on sound waves, attempted to explain the colors of heated objects.[21] His arguments were based upon the wave picture of light. According to this picture, the light energy emitted by a glowing body should tend to be given off at a higher frequency rather than a lower one. The reason for this is light wave economics. There is a direct relationship between the frequency of a wave and its length. The higher the frequency of the wave, the shorter its length. Light waves with very short wave lengths (in other words, very high frequencies) are able to take advantage of the space they find themselves bouncing around in. There are more ways for short waves to fit within any volume of space than for long waves. This geometric factor influences any glowing object and tends to produce short waves rather than long waves, or high frequencies rather than low ones. That meant that a red-hot poker should not be red at all, but blue. And that wasn't the end of it. A poker glowing blue shouldn't be blue—it should glow ultraviolet (a color that vibrates at a higher frequency than violet and is invisible), while an ultraviolet poker should glow at an even higher frequency, and so on. In other words, any hot poker should give off its electromagnetic energy at beyond ultraviolet frequencies.

This argument was known as "the ultraviolet catastrophe." But it was catastrophic only in theory because Rayleigh had predicted that any heated object would soon emit all of its energy at frequencies beyond visibility. However, as any person

who strikes a match can see, the colors in its flame are quite
visible. Scientists' inability to explain the light from heated
bodies using the mechanical and continuous theory of light
emission was the second dark cloud on the Newtonian horizon.

Question : Why is there an ultraviolet catastrophe using
classical mechanics?

Answer : All the energy goes into shorter and shorter
waves.

The End of the Mechanical Age

Even with two clouds partly obscuring the Newtonian mechanical landscape, the painting was not abandoned. Far too much had been invested in this picture of reality, including the following assumptions concerning the physical and therefore mechanical world:

(1) Things moved in a continuous manner. All motion, both in the large and in the small, exhibits continuity.

(2) Things moved for reasons. These reasons were based upon earlier causes for motion. Therefore, all motion was determined and everything was predictable.

(3) All motion could be analyzed or broken down into its component parts. Each part played a role in the great machine called the universe, and the complexity of this machine could be understood as the simple movement of its various parts, even those parts beyond our perception.

(4) The observer observed, never disturbed. Even the errors of a clumsy observer could be accounted for by simply analyzing the observed movements of whatever he touched.

These four assumptions would eventually be proved false. But it would take nearly fifty years for the true story to be told. The mystery of the movement of light and its unexplained behavior in relation to heated and glowing objects would start a revolution in the scientific world. The active observer would be replaced by the disturbing observer.

When
the Universe
Jumped

The Disturbing Observer

*An act of desperation ...
a theoretical explanation
had to be supplied
at all cost, whatever
the price.*

MAX PLANCK

(on the discovery of the quantum)

The Movement of Reluctant Minds

Who could have foreseen it? Who could have known that by reaching out and touching the universe we would be disturbing it? Perhaps if Zeno and Aristotle had been alive at the turn of the twentieth century, they would have forewarned us. The mechanical age had scarcely begun and already it was coming to a halt. Although machines of all types would come into existence during the twentieth century, we would lose faith in our mechanical philosophy. The world was not a machine, after all, and could not be constructed by putting together tiny parts.

By exploring the depths of matter and energy, by analyzing things both mathematically and experimentally, physicists would find that they had to abandon the Newtonian continuous mechanical picture of the physical world. The two dark clouds that had spoiled their view had forced these physicists to give up continuity. Light waves traveled without anything to wave in. Hot glowing materials emitted a continuous rainbow of light colors, and these colors were not to be explained by the reasonable assumption that the light energy was continuously emitted by the hot substance that glowed these colors.

This was only the start. By 1935, all of physical reality, the whole material universe, would once again be looked at with great wonder. Two distinct schools of thinking would appear: those who believed in the mechanical picture, in spite of the evidence, and those who welcomed the new nonmechanical picture with its "Zeno-like" discontinuous jumps. Debates are nothing new in science. This debate continues today.

Yet these discoveries would not have occurred when they did if the "new physicists" had more quickly abandoned the Newtonian and Galilean precedents for analysis. Two thousand years earlier, the Greeks had done so and failed to discover the quantum, the discontinuity of motion that is vital to all atomic and subatomic processes. It would be this discontinuity that would lead two new physicists, Werner Heisenberg and Niels Bohr, back to that earlier Greek picture of wholeness.

Heisenberg and Bohr, perhaps more than any other scientists during this period of discovery, would welcome the discontinuous quantum of energy. Because this quantum was involved in every

observation, even observation would lose its objectivity. The observer must give or take a whole quantum of energy if he is to see anything at all. This whole quantum was totally ignorable, on the large scale of everyday observances. But it could not be ignored when the observer was looking for an atom. Observation would disturb the atom, disrupting violently its desire for stasis. The act of reaching out and touching atoms led to uncontrollable disruptions. Yet these disruptions were what was experienced of this tiny atomic world.

If everytime you touched a kitten, no matter how gently, you were bitten on the hand, would you continue to imagine that this soft little cat is tame? Kittens are cute, but this one bites. Consequently, you change your model of kittens. Could the mechanical model of atoms be wrong? Reaching out and touching atoms led to an unclear picture of what was being reached for.

The story of this period of the discovery of the quantum is presented in the next five chapters. In chapter three, we will see how the quantum nature of light was discovered and how a new mathematical law of physics appeared. Light was seen both as a wave in a nonexistent substance and as a stream of particles of substance. The new law expressed the relationship between the wave and the particle. Light would act in a disruptive manner whenever it interacted with matter. This discovery began the death toll for the mechanical continuous universe.

Chapter four describes the new model of matter that was proposed. Niels Bohr applied the new wave-particle relationship to the inside of an atom and a new explanation for atomic light presented itself. This time it wasn't light coming from a solid or liquid substance; it was light coming from a gas. And that light was not continuously emitted—it was emitted from atoms themselves. The discontinuous emission spectra of light meant the atom was undergoing a discontinuous jumping motion. Chapter five reviews physicists' attempts to picture that discontinuous jumping motion in terms of waves. Physicists had hoped to salvage mechanics by making matter a continuous spread. That is, they imagined matter to be waves. Later, in America, these waves were observed directly, much to the surprise of many.

But the wave picture was not the final word. It too had a discontinuity. And like its precedents, it led to a paradox. A new understanding was sought. In chapter six we will explore scientists' attempts to come to grips logically with these new paradoxes of matter and light. The matter-wave idea was dropped. In its place came the idea that the wave was not a real

wave at all, but just a concept. This was called the *probability interpretation*. But, as you may guess, it too led to another paradox. The first third of the twentieth century had turned into a real Pandora's box and the ancient Greek idea of unbroken wholeness reappeared. To observe is to disturb, for observation breaks the wholeness of nature. This led to the philosophy of indeterminism.

But even this was not the end. New ideas in any field always meet with resistance. And the quantum was a whole too big to swallow for a large group of reactionary physicists led by one of the quantum's creators, Albert Einstein.

In chapter seven, we will look at what attempts were made to reconcile the new quantum with the old Newtonian picture of continuity. The early leaders of the action and reaction groups were Bohr and Einstein. Both groups agreed that the old ideas would no longer work. Their debates and continuing efforts to reconcile our image of the physical world with our experience of it would produce a fruitful bounty of insights.

This part of our story starts with Max Planck. Like many who would follow him, Planck would make his discovery theoretically. And like his distant predecessor Zeno, Planck would point out to us that something was wrong with our thinking.

Averting a Catastrophe with Lumps of Energy

Lord Kelvin had called the phenomenon a dark cloud obscuring the Newtonian mechanical picture of light energy. Lord Rayleigh, a long-time expert on the movements of waves, had failed to solve it. Even James Clerk Maxwell's mathematical relations, which showed that light was produced by electrical fields snaking and dancing in space with magnetic fields, had not been able to explain it. No one knew how hot things glowed.

How did heat energy become light energy? Why did hot things give off the colors they did? Everyone knew that the different colors of light indicated the presence of different wavelengths of light. Red light had longer separations between the successive crests of its waves than blue light. The shorter the wavelength, the higher or more rapid the frequency of the oscillator that produced that light wave. This much was certain.

Light was made of waves, though Michelson and Morley had failed to detect just what those waves were waving in. But no

matter. The colors of light and Young's early experiments by 1820 had convinced everyone. Light had to be a wave phenomenon. The problem was to explain how the heat added to the oscillators in the glowing solid or liquid substance was being changed into light.

On December 14, 1900, an apologetic, soft-spoken, articulate, forty-two-year-old professor presented a strange concept to the august body of the German Physical Society.[1] This date would later be regarded as the birthdate of the quantum. On that day, Professor Max Planck offered a mathematical exercise that averted the now well-known ultraviolet catastrophe. Planck explained why heat energy does not always get converted to invisible ultraviolet light waves. This explanation was, to Planck, merely a refinement, a sanding down of a rough theoretical edge. But it was this edge that brought Herr Professor Max Karl Ernst Ludwig Planck[2] before the Physical Society on that bleak winter day.

Six weeks earlier, he had called what he had done a "lucky guess."[3] His discovery did not take place in any laboratory; it took place in his mind. And he didn't believe it, even after Einstein used the idea to explain away another "rough edge" five years later. He

Planck dreaming a lucky guess.

felt somehow a mechanical justification for his "guess" would be forthcoming. He was, remember, past the age of brilliance — a careful, middle-aged academic. He fervently wished to change his guess to a "statement of real physical significance."[4] He recounted the event twenty years later during his Nobel Prize address: "After a few weeks of the most strenuous work of my life, the darkness lifted and an unexpected vista began to appear."[5]

What was his discovery? Planck was astonished to find that matter absorbed heat energy and emitted light energy discontinuously. "Discontinuously" meant in lumps, and these lumps were totally unexpected. To better grasp Planck's astonishment and the significance of his discovery, I ask you to consider an analogy. The analogy deals with the familiar experience of dropping stones into a pond. Remember that Planck's discovery was in the nature of an explanation. Planck was, like Zeno, a theoretical scientist. His job was to explain what we saw or, if our conception of what we saw was incorrect, to correct our thinking. Ideally, the new insight would lead to a better understanding and a new prediction based upon that understanding.

Throwing Stones in a Quantum Pond

In this analogy, imagine you are standing before a calm pond on a hot summer day and dropping pebbles into the water. You would certainly expect to see ripples of surface wave energy generated continuously by the falling pebbles. The more pebbles dropped per second, the more ripples produced per second. Or so you would expect.

But now imagine that some of your pebbles have just dropped through to the pond's bottom and produced no ripples at all. You are surprised when the whole pond suddenly becomes a torrent of sloshing waves and then just as quickly calms down to become a glassy mirror once again. There doesn't seem to be any direct connection between the appearance of ripples and the dropping of stones. So you stop dropping stones and wait. Sure enough, after a few more storms on the pond, it all becomes glassy again. What's going on?

Timidly, you start dropping pebbles again. You throw them out into the pond in small handfuls, but nothing disturbs the water's glassy calm. Then, quite unexpectedly, the pond boils into turbulence. You watch carefully and note that the waves being

produced undulate slowly with long separations between crests. You throw more pebbles in. As long as you throw pebbles in steady amounts, the pond continues to show its "jumpy" movement, sporadically boiling up into waves and just as quickly calming down again.

Now you increase the tempo. You throw your pebbles in faster than before. As you have come to expect, nothing happens instantly. But when the pond boils into activity again, you notice that the waves have changed. You see higher frequencies and shorter wavelengths than you saw earlier. The ripples are more closely spaced to each other.

The pond is an analogy for hot matter. The pebbles represent heat supplied to the material and the ripples are the light waves generated by the heated material. However, two surprising features make the "quantum pond" different from a real pond. The first is that the quantum pond responds sporadically to our efforts to heat it up. The waves appear to be produced in spurts of wave energy and not in any continuous way. These gaps and discontinuities in the behavior of the pond are more pronounced when we throw our pebbles languidly. Later, when we increase our tempo, the gaps between our efforts and the pond's responses decrease. Our quantum pond begins to look more like a real pond, with all kinds of waves being generated by the pebbles in a seemingly regular manner.

The second unusual feature of our quantum pond has to do with how it responds when it responds at all. It seems our pond can produce longer waves with greater aplomb than shorter ones. A real pond would not behave this way. The length of the waves and the frequencies of the waves should always depend upon the shape of the pond's boundaries as well as the energy used to excite those waves. In the quantum pond, the greater preponderance of lower frequency, longer length waves over their shorter, higher pitch counterparts is more pronounced when we are languidly tossing pebbles. But, again, as we increase our tempo, the distribution of waves appears more like a real pond. Shorter waves appear and soon dominate the pond.

Planck explained these surprising, nonmechanical, discontinuous features in a surprising manner: he invented a simple mathematical formula. Now, most nonscientists may be unable to appreciate that inventing formulae is not the usual work of scientists. Each mathematical relation must be backed up by painstaking experimental effort. Each time a discrepancy occurs in our understanding of anything physical, physicists don't simply trot out their writing pads and invent a

mathematical relation to explain their observations.

Rather, it is usually a more conservative approach that is taken. What Planck was about to propose was not a conservative idea. It was, so to speak, a crackpot idea, one that had no basis in the mechanical universe. Planck's idea related the energy given to the wave by the oscillating material to the frequency of that wave. And that was something new under the sun.

The Energy, the Whole Energy, or Nothing at All

Light waves did not behave like mechanical waves. Planck postulated that the reason for this discrepancy lay in a new understanding of the relationship between energy and wave frequency. The energy either absorbed by the material or emitted as light depended in some fashion on the frequency of the light emitted. Somehow the heat energy supplied to the glowing material failed to excite higher frequency light waves unless the temperature of that heat was very high. The high-frequency waves simply cost too much energy. So Planck created a formula that has since been named after him. That formula said simply that energy (E) equals the frequency of the light emitted (f) times a constant (h). And with this single formula, $E = hf$, the quantum age had begun.

Higher frequency meant higher energy. Consequently, unless the energy of the heat was high enough, the higher frequency light was not seen. The constant of proportionality—the h in this equation—is called *Planck's constant*. It was an entirely new idea that such a constant should exist. No mechanical model had ever predicted such a relation between the frequency of light and the energy needed to produce that light.

Planck's constant turned out to be an extremely tiny number—approximately 6.6 divided by one billion and then again divided by one billion and then once again divided by one billion. This number is so tiny that one would expect it to have unobservable consequences. No wonder the quantum nature of light remained hidden until the twentieth century.

The Planck equation of $E = hf$ explained why the high-frequency light waves were being discriminated against. And it also explained a brand-new idea. Since the quantity, hf, of energy was a certain *whole* amount of energy—not $\frac{1}{2}hf$ nor $\frac{1}{4}hf$ nor any other fraction—the energy in any given light wave

could only be a whole multiple of the basic "chunk" of energy.

Somehow the material could only produce light waves with chunks of energy, whole amounts. The idea of the quantum was first recognized by this chunk picture. Quantum means a whole amount. Energy at any particularly frequency, f, was like a candy bar. It had to be cut up into whole, equal-sized chunks with no half or quarter chunks left over. This picture also explained and supported the discrimination taking place against the high-frequency light waves. If the frequency were made higher, the energy candy bar would have to be cut up into larger chunks. And that meant fewer chunks available. Thus higher frequency waves were discriminated against appearing because there would be fewer of them emitted. The lower frequency chunks were smaller and thus more of them were produced for a given amount of energy. (The more chunks of energy, the more waves of energy, the more light seen.) In this way there were more light waves of lower frequency produced.

Energy "candy bars":

A wave could have whole pieces of energy, but not any part of a piece. The top bar has greater but fewer energy pieces. The bottom bar has smaller but more energy pieces.

The formula $E = hf$ forced Planck to explain why light waves could not be produced in a continuous manner. Again Planck offered a theoretical picture, since he could not actually watch what occurred whenever a piece of material generated a wave of light. Indeed, the light that Planck was talking about seemed perfectly continuous in its spread of colors; each color blended into the next as in a rainbow. Planck was forced to accept the discontinuous emission of light in order to explain the continuous color band of light.

But, of course, this was not the first time that a new mathematical idea had "forced" the appearance of a new and somewhat paradoxical physical picture.

Thus Planck's magic formula, though totally unexpected and not justified by any logical mechanical explanation, succeeded in explaining the heretofore unexplained behavior of light. And it did more. For the first time in the history of science, no one was able to really picture what was going on. The mathematical formula had replaced any visual experience. It worked, but it hardly made any sense.

The Reluctant Planck

With his simple formula, Max Planck started a furor. A new precedent in science, particularly in physics, had been set. There was no independent evidence for Planck's $E = hf$ formula. It was simply a mathematical construct. And the embarrassing thing was there simply was no way to explain it. There was no way to see it, visualize it, or even connect it with any other formula like it. My attempts with the quantum pond and quantum candy bar are analogies, not descriptions of what was actually happening inside a heated substance.

Thus Planck was quite reluctant to fully accept the discontinuous behavior of matter when it was involved with the emission of light or the absorption of heat energy. Despite his disavowal of his own discovery, it was too late. Another physicist, a little younger and perhaps a little braver than Planck, would take the idea seriously. His name was Albert Einstein, and he was destined to give a new insight into the energy E in Planck's formula. The E stood for the energy of an undiscovered particle, a particle of light.

Einstein Draws a Picture: The Photon Is Born

Einstein upset the applecarts of the Newtonian mechanical landscape and replaced them by the Einsteinian mechanical picture.[6] A new mechanical picture, one that provided an even firmer grip on the movements of matter and light, was offered by Einstein. But as new and outrageous as these ideas of relativity were, they were still mechanical. Cause produced effect, even if clocks and yardsticks were no longer as fixed as we had previously thought them.

Yet Einstein also sowed, during this same year, the seeds of a new nonmechanical apple tree.[7] He took Planck's theoretical discontinuities to heart. He reasoned that the cause of the discontinuities in the emission and absorption of light and heat were not to be found in the oscillating bits of matter producing that heat and light. They were instead in the heat and light energy. He felt that somehow, even though the wave theory of light was successful, light was not fundamentally made of waves. The light only appeared as waves if one observed it over fairly long time intervals. If one could just freeze the moment, stop the picture of the steady progression of these light waves long enough, one would see that the waves were made up of tiny granules of light.[8]

These granules are what actually interact with the oscillating bits of matter in the glowing heated material. That is why the process is so disruptive and discontinuous. The oscillators aren't actually making waves, they are emitting light granules. By analogy, if we imagine each oscillating bit of matter to be a person singing a song, the melodies are coming from the singers' mouths in the form of blown-out watermelon seeds rather than smooth, continuous sound waves.

Einstein had not fully realized that he was sowing the seeds of the destruction of the mechanical universe with this picture. It still seemed mechanical to him. Light waves were made of stuff. Each bit of that stuff had an energy E. These bits, just like any old bits of matter, did what all pieces of matter do. They move, they have momentum and they have energy. The light bits did just the same thing. Einstein even called these bits by the name *quanta*[9] to indicate their countability, their appearances as separate things, as quantities of stuff.

But, according to $E = hf$, the energy of each bit somehow still had to depend on the frequency of the light wave. And that was not explainable by any mechanical picture so far. I'm

sure that even Einstein's picture would have been dropped if it hadn't been able to account for another mystery.

That mystery was the sudden appearance of electrons of matter outside of the boundary surfaces of cold metals whenever light was shined on those surfaces. Not only could hot metals glow and emit light, but they also were able to "boil out" chunks of tiny matter. These chunks were discovered to be electrons, tiny bits of solid matter, each of which possessed a minuscule electrical charge of negative electricity.

That was no surprise. Heating up the bacon was always a spattering affair. What surprised everyone was that heat energy was not involved. The electrons were boiling out without any heat energy being added. Einstein's quanta idea explained why.

Each grain of light either smacked into an electron in the metal or passed through without incident. If a collision occurred, it was catastrophic for the electron. The tiny electron was then hurtled out of the metal as if it had been shot from a cannon. All of the light quantum's energy went into the effort. It gave up all of its energy to the electron in one instantaneous moment.

Einstein saw grains of light, later called photons, the first quantums.

By refining the experiment, physicists saw that Einstein's use of $E = hf$ was correct. When they changed the frequency of the light shined on the metal surface, they observed that the electron's energy also changed. By using high-frequency blue light, the electron's energy was observed to be greater than when they used red light, which had a lower frequency.

Later Einstein's quanta would be called *photons*. The cold emission of electrons would be called the *photoelectric effect*. For

a

b

A series of photographs showing the picture quality obtainable from various numbers of photons.

e

providing the correct theoretical explanation for the photoelectric effect, Einstein won the Nobel Prize in 1921.

Like Planck before him, Einstein's contribution was theoretical. Both of these men explained what had been unexplainable, and both were lauded for their mathematical discoveries. This in itself was a new trend in physics. New ideas were being entertained in many phases of society. Could the new Planck-Einstein idea be put to use anywhere else?

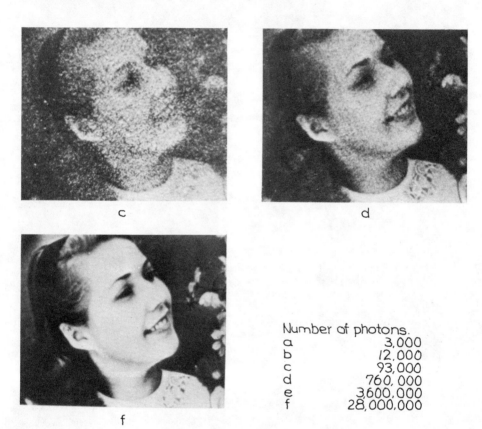

c

d

f

Number of photons.

a	3,000
b	12,000
c	93,000
d	760,000
e	3,600,000
f	28,000,000

Quantum Jumps

*"The time has come,"
the walrus said,
"To talk of many things:
Of shoes – and ships –
and sealing wax
Of cabbages – and kings –
And why the sea is
boiling hot
And whether pigs
have wings."*

LEWIS CARROLL

A Lord Eats a Raisin Pudding Atom

Planck and Einstein had set the stage. By 1911, the quantum nature of light was already making its way into respectability. Light was a wave that somehow had a particulate graininess associated with it. Using highly developed vacuum techniques and the newest electrical equipment, scientists played with electrical discharges in gases that were sufficiently rarefied to be studied. They were also looking at the light that these electrical discharges produced. Today we call such phenomena "neon signs."

In 1896, J. J. Thomson had discovered the electron by using the vacuum and electrical discharge technique. This discovery was hailed as monumental. The secret of electricity was contained in this tiny bit of matter. By using electric and magnetic fields, Thomson was able to focus and steer a beam of electrons, thus determining the electrical charge and, later, the mass of each electron. These tiny bits were found to be extremely light in weight when compared to atoms of a gas. One atom of hydrogen, the lightest atom known, weighed nearly two thousand times as much as an electron. Thus it seemed natural to suppose that electrons were parts of atoms. Indeed, it was taken for granted that the electrical power used in the electrical discharge in the gases ripped the atomic gases apart and thus produced electrons.

Since matter was assumed to be made of atoms, it was also natural to imagine that heated solid or liquid matter glowed because of the movements of the lighter electrons. These electrons were thought to oscillate back and forth inside of their respective atoms. And these oscillations, it was supposed, broadcast light waves just as Hertz had demonstrated in 1887 that his electrical oscillations broadcast radio waves. The only question was how to picture this. Remember, the Newtonian classical world view of physical processes still persisted in spite of the Planck-Einstein $E = hf$ formula.

The size of the atom was known. It was less than two billionths of an inch in diameter. This diameter is so tiny that it is nearly inconceivable. To grasp how tiny an atom actually is, consider the following imaginative exercise. Suppose you had a golf ball in your hand. And suppose that you could inflate this

73

golf ball—that is, blow it up like a balloon until it was large enough to enable you to see an atom within the golf ball. To be specific, supposed that you wished to blow the golf ball up until one of its atoms was as big as a normal sized golf ball. For that atom to become big enough to hold in your hand, the original golf ball would have to be inflated to the size of our earth! No wonder no one knew what an atom looked like or, in particular, how electrons fit inside of it.

By 1911, J. J. Thomson had become Sir Thomson. He had his own laboratory in England. He was the director of the world-famous Cavendish Laboratory. He also was the leader of a certain school of thought regarding the structure of atoms and the whereabouts of electrons within.

Thomson's atom was pictured as a tiny raisin pudding. Embedded within this "pudding" were even tinier electron "raisins." The number of electrons depended on the particular variety of atom. Hydrogen had just one electron raisin, one bit of negative electrical charge to balance out the observed positive charge and make the atom electrically neutral. By putting the atom into an electrical discharge, that single, negatively charged electron could be pulled out of the pudding and leave behind a positively charged atom "pudding." The result was a hydrogen ion. Helium ions were observed to be doubly charged; thus, it was clear that a helium atom had to have two electrons within it to balance out its charge. And so on.

Another school of thought held that the atom looked more like a miniature solar system than a raisin pudding. Each electron in any given atom was pictured as a planet that moved in a closed orbit about a tiny nucleus at the atom's center. Instead of a more or less random distribution of electron raisins embedded in the large and somewhat soft, tenuous background of a positively charged pudding, there was a well-organized series of electron planets, each in its own orbit, following a well-defined mechanical and repeatable movement. These electron planets moved like real planets. Each had its own respective "years." In other words, there was a periodicity or frequency to their motions. The deciding feature between these two models had to do with the rest of the atom, the positive matter that held the electrons within.

The correctness of the pudding or planetary model of the atom could not be determined from the light emitted by atoms. Nor could anyone shine light on an atom and take a look. Atoms were much too small. The wave lengths of light were thousands of times longer than the diameters of atoms. Such details as the

location of electrons or the distribution of the heavier, positively charged atomic matter would never be seen by using light waves. But there were other ways to explore an atom. You could throw other atomic particles at it and observe the scattering and atomic debris that would result from a collision. Just as the debris from a midair collision between airplanes can reveal the cause of the accident, atomic debris can reveal what the insides of the atom look like.

The question of whether matter in an atom was spread out like a pudding or gathered together in a tiny sunlike nucleus at the atom's center was finally given an experimental test in 1911. Within a vacuum enclosure, a beam of helium ions was fired at a very thin foil of gold, and the truth was discovered. The helium ions scattered from the atoms within the gold foil with a pattern that suggested that the atoms of gold had nuclei. The pudding model was dropped.

The new atomic model was definitely planetary. The surprising thing of the planetary model was how small the nucleus appeared. If the golf ball-sized atom was once again inflated, this time to the size of a modern sports arena or football stadium, the nucleus of that atom would be the size of a grain of rice. Somehow the electrons whirled about, filling in the vast space within the tiny atomic world.

These experiments were carried out by Lord Ernest Rutherford and his assistant Ernest Marsden.[1] Rutherford was also given his own laboratory in the industrial Midlands of Manchester, England. With the success of what is now called the *Rutherford nuclear atom*, Lord Rutherford led his group of scientists in an attempt to picture how the electron "planets" were able to maintain themselves in orbit and yet radiate energy in the form of light waves. Rutherford's success was, I'm sure, not too palatable for his counterpart, Lord Thomson, down south.

Into this slight animosity a young innocent was about to step. His name was Niels Bohr.

Bohr's Quantum Atom

Dr. Bohr had just completed his doctoral thesis in Copenhagen, Denmark, when he reported to work for J. J. Thomson at the "Cavendish." Lord Thomson, Bohr's first employer, probably

Historical Events

1800

LOUISIANA PURCHASE
NAPOLEONIC EMPIRE
BATTLE OF WATERLOO
MONROE DOCTRINE
DISCOVERY OF ELECTROMAGNETIC INDUCTION
MEXICAN WAR
COMMUNIST MANIFESTO

1850

THE ORIGIN OF THE SPECIES
AMERICAN CIVIL WAR
ALASKA PURCHASE
TELEPHONE INVENTED
SPANISH-AMERICAN WAR
BOER WAR
THEORY OF RELATIVITY

1900

WORLD WAR I
RUSSIAN REVOLUTION
LEAGUE OF NATIONS
LINDBERGH'S FLIGHT
WORLD WAR II
HIROSHIMA BOMBED
UNITED NATIONS
INDEPENDENCE OF INDIA
LAUNCHING OF SPUTNIK

1950

Bohr 1885 1962

Government

Victoria, Queen of England
Abraham Lincoln
Nikolai Lenin
Franklin D. Roosevelt
John F. Kennedy

Science

Thomas Young
John Dalton
Hans Christian Oersted
Michael Faraday
Charles Darwin
Gregor Mendel
Dmitri Mendeleev
William Roentgen
Thomas Alva Edison
Marie Curie
Ernest Rutherford
Albert Einstein
Erwin Schroedinger
Enrico Fermi
Jonas Salk

Philosophy and Social Science

John Stuart Mill — Karl Marx — Friedrich Nietzsche — Alfred North Whitehead — Pope John XXIII — Bertrand Russell — John-Paul Sartre

Literature

John Keats — Mark Twain — Ralph Waldo Emerson — Charles Dickens — George Bernard Shaw — T. S. Eliot — Robert Frost — Ernest Hemingway — James Joyce

Art

Claude Monet — Pablo Picasso — Frank Lloyd Wright

Music

Franz Schubert — Pëtr Tchaikovsky — Johannes Brahms — Richard Wagner — Sergei Prokofiev

felt less than enthusiastic over meeting the twenty-six-year-old
Bohr. Besides possessing an incredible mind, Bohr was quite
forthright and outspoken. Thomson's model for an electron had
been the subject of Bohr's thesis, and Bohr immediately pointed
out some mathematical errors in Thomson's earlier work.

By the autumn of 1911, Bohr found himself, much to
Thomson's urging, on his way to Manchester to join Rutherford's
group. He quickly joined in with this newly excited group of
physicists and began his own search for the electrons within
atoms.

The simplest and lightest-known atom in the universe was
hydrogen. It contained, according to Rutherford, a tiny nucleus
and a single electron orbiting that nucleus. It was hoped that, if a
successful model of this atom could be made, all other atoms
would fall into line and be explained. So Bohr attempted to
make a model of the hydrogen atom.

There was, however, a severe stumbling block in the way of
the planetary picture of an atom. The problem was how could the
electron keep a stable orbit? If the atom was as big as it appeared
to be, its electron would necessarily be whirling around inside it
with greatly accelerated changes in speed and direction, filling
out the space like the tip of a whirling propeller blade fills out a
circle. The electron would have to do this and *not* emit any
energy. Certainly, it could not emit its energy continuously. To
do so would be a disaster for the model. The reason for this is
that the planetary model predicts a spiraling motion of the planet
into the sun for any planet that gives up energy continuously.
That would mean the electron would crash into its nucleus every
time it emitted its light energy. The whole atom would be
suddenly deflated and all matter would undergo a rapid collapse.
It is amazing to consider how tiny atoms would be if the atomic
electrons were gobbled up by their nuclei. A football stadium
would be shrunk to a grain of rice. The earth would be shrunk
to the size of a football stadium! All matter would thus appear
with enormous density. (Neutron stars do appear in our universe
with these densities. The force of gravity crushes the atoms
together.) And all matter would be dead and lifeless. The light
would be gone.

But if the electron could not emit energy continuously, how
was it to radiate any light? Light emission took energy. The
electron would have to radiate energy sometime or no light would
ever be seen. The question was how to make up a planetary
model in which the electron would only radiate energy
sporadically or in a discontinuous manner. Thus Bohr attempted

to visualize under what circumstances the electron would be "allowed" to radiate energy and under what circumstances it would be "forbidden" to do so. This was not an easy decision to make. Bohr's model would have to show a reason for the discontinuity. How could Bohr explain it?

He explained it very simply. He postulated that an atom would only be allowed the privilege of emitting light when an electron jumped discontinuously from one orbit to another. It would be forbidden from doing so otherwise. Like Planck and Einstein before him, Bohr was setting out on a bold path. In fact, he was encouraged by their example. He felt that somehow Planck's h factor had to be involved in the process. He knew that h had been used by both Planck and Einstein to point to the discontinuous movement of light energy in solid matter. Perhaps it could also be used inside of an atom. But how? Bohr found out.

This new secret was actually no mystery to anyone familiar with physics. It had to do with something that physicists call *units*. A unit is a measure of a physical quantity. Any unit can also be composd of other units. Take the common example of a monetary unit. An American dollar is a unit of money, and it is composed of other units as well. For example, a dollar is ten units called dimes, or one hundred units called pennies. Similarly, it is also one-tenth of a unit called a ten dollar bill.

Planck's constant h also was a unit. And it too could be made up of other units. It was a unit of energy-time, something that physicists call *action*, and it was a unit of momentum-distance, just as a dollar is also ten dime units. But Bohr had noticed that h could be viewed as a unit of angular momentum and that observation had a direct bearing on his atomic model.

Angular momentum is a familiar experience for children. It results whenever a moving object passes a fixed point in space. If the moving object joins or connects with the point it is moving past, the object begins to whirl in a circle. Angular momentum can be thought of as momentum moving in a circle. When children run towards a tether ball hanging from a pole, they often leap and swing in a circle about the pole. By hanging on to the tether the children exhibit their angular momentum "about" the pole. Angular momentum is the product of ordinary or linear momentum and the radius or distance from the object to the reference point. Since Bohr's electron was traveling in an orbit about the nucleus, it too was tethered, held to that nucleus by an invisible tether of electrical attraction between the electron and the atomic nucleus. Thus the electron had angular

momentum. Could Planck's constant h be used as a unit of the electron's angular momentum?

To grasp the significance of this question, imagine that you have a ball attached to a string. Holding the loose end of the string in your hand, whirl the ball around over your head, cowboy style, as if you were about to rope a calf. The faster you whirl the ball, the greater the force you feel, holding on to the rope. When you whirl the ball faster, you increase its angular momentum.

Now picture an ice skater whirling in a spin. Notice that as the skater brings her arms toward her body, she whirls faster. Her arms are acting like balls attached to ropes. But, unlike the whirling balls, although she is spinning faster, her angular momentum remains the same. This is because the distance from her spin axis to her arms has decreased to compensate for her increased speed of rotation.

If you now picture the tiny electron whirling around in its orbit, you will realize that for a given force holding it to its circular path and for a given *fixed* amount of angular momentum, the speed of the electron is determined. The radius of the orbit is also determined. Everything depends on the delicate balance provided by the amount of angular momentum the electron is allowed to possess.

Bohr tried out a calculation imagining a circular orbit for the electron with one unit of angular momentum. He calculated the size of the orbit requiring that the electron have one unit of h. The orbit was the correct size; it filled out the atom. He then tried a new orbit with two units of h. It proved to be a new orbit with a larger diameter, four times the original orbit. When Bohr calculated an orbit for the electron with three units of h, the orbit grew in size to nine times the original orbit. Bohr had discovered a new model for the atom.

In this model there were only certain allowed orbits. By restricting the electron to these special or "quantized" orbits, as they were later called, Bohr successfully predicted the correct size for the atom. Each orbit grew in size as the electron increased its angular momentum. But the scale was correct.

This wasn't the only discovery. Bohr also discovered why the electron wasn't radiating as it whirled in its orbit. In other words he found a reason for the atom's stability. By allowing the electron to have only whole units of h and not any other amounts of angular momentum, Bohr discovered the rule that kept the electron in a stable orbit. Only electrons with whole amounts of angular momentum (i.e., integer multiples of Planck's

Bohr and his atom:

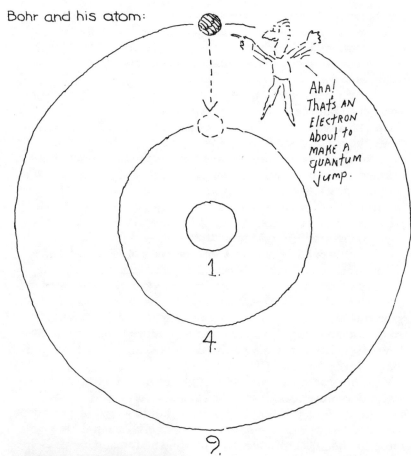

Aha! That's AN ELECTRON About to MAKE A quantum jump.

1.

4.

9.

Each circle represents an orbit for a planetary electron. The orbital diameters are in the ratio 1:4:9. In orbit one, the electron has one unit of h, in orbit two (diameter 4) it has two units of h, and in orbit three (diameter 9) it has three units of h.

constant: $1h$, $2h$, $3h$, etc.) would be allowed the privilege of orbiting peacefully inside of the atom. These quantized orbits were known as *Bohr orbits*. The integers of 1, 2, 3, and so forth were called the *quantum numbers* of the orbits. A quantum model of the atom had appeared.

The only thing still needed was the "rule" that allowed the electron to radiate light energy. Again, there was no physical reason for the quantization rule that held the electron in a stable orbit. Bohr had made it up. So Bohr again postulated that the electron would radiate light whenever it changed from one orbit to another. He calculated the energy of the electron in each of its possible orbits. By comparing the difference in energies between the orbits and using Planck's $E = hf$ formula, Bohr successfully predicted the frequencies of the light observed whenever an electron made an orbital "jump."

In January of 1913, a former classmate of Bohr's showed him a paper written by a Swiss schoolteacher named Johann Balmer. Balmer had observed light coming from hydrogen gas in 1880. Instead of a continuous spread of colors, the light from hydrogen showed missing colors when it was passed through a prism and analyzed. The spectrum it produced appeared as a horizontal strip containing several vertical lines, like teeth in a comb. Only some teeth were missing. Ordinarily, the light we see—for example, sunlight or light from an incandescent bulb—does not break down into such a spectrum. Instead, sunlight or light from any hot solid or liquid shows a continuous spread of colors like a rainbow. But Balmer's incomplete spectrum had been produced by hydrogen atoms in a gas. Bohr read Balmer's paper on atomic light and became very excited. Not only could he calculate the energy of the electron in each atomic orbit, but he could also calculate the energy that the electron radiated away when it changed orbits.

Balmer's hydrogen spectrum had missing "teeth" because the energy given out by the jumping electron was so well prescribed. Since there were only certain orbits for the electron, there had to be only certain frequencies for the light. The frequency of the light depended on the difference in energies of the electron involved in the quantum jump from one orbit to another. Balmer's atomic light was explained.

All well and good. However, Bohr's successful prediction was based on a very disturbing picture. The electron making the light was not oscillating or orbiting the nucleus to make the light. In fact, it wasn't doing anything that anyone could really imagine. To make the light, it had to jump. It leaped like a

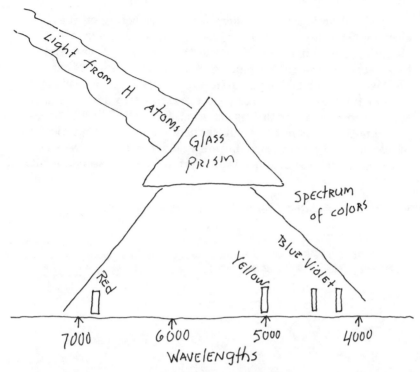

What Balmer saw: Light from hydrogen atoms
 breaks into a spectrum
 of colors.

desperate superman from one orbit to another inside the atom.
It was not allowed to move in between orbits. Bohr tried to
calculate that and failed. The best picture he could come up with
was that of a quantum jump, a leap from one place to another
without passing in between. As unreasonable as this picture was,
it replaced any completely classical mechanical picture of that
process.

 Yet Newton's mechanics were not to be completely aban-
doned. Some features of the classical picture were not abandoned
at all. First of all, the idea of an orbit and a planetary atom were
still classical pictures based upon a continuous movement of the
electron. What was not classical was the refusal of the electron to
radiate when it was in a Bohr orbit. This was entirely unreason-
able for a very important reason: all accelerating electrons have
been observed to radiate energy. Either the Bohr-orbiting
electrons were accelerating or Newton's second law was being
repealed.

According to Newton, there was a force acting on the electron. That force pulled the electron into a circular orbit, changing the momentum of the electron. Therefore, there had to be an acceleration of the electron. And it also followed that, because the electron was a particle of electricity, the electron had to give out energy whenever it accelerated. Bohr's picture did not seem to correspond with this observed fact.

But Bohr was not to be dissuaded. He noticed that his rule of allowed and forbidden radiation was dependent on the size of the electron's quantum jump. A jump from the second orbit

What looks continuous is really discontinuous.

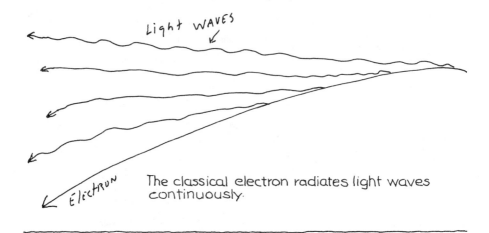

Light WAVES

Electron

The classical electron radiates light waves continuously.

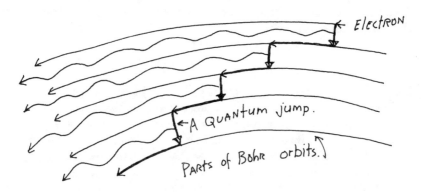

Electron

←A Quantum jump.

Parts of Bohr orbits.

The Bohr electron follows a discontinuous path of quantum jumps.

to the first was extremely tiny, but a sizable change on the scale of the first orbital diameter. It was, therefore, a relatively enormous jump. On the other hand, a jump from orbit 10,000 to orbit 9,999 was very large when compared to the first orbital diameter, but an extremely small change in orbit on the scale of the 10,000th orbital diameter. Thus, it was a relatively tiny jump. When Bohr calculated the radiation from a change in orbits between large atomic diameter orbits, the result he found was in agreement with classically predicted results. In other words, the smaller the relative change, the more classical and continuous the result seemed to be.

Bohr had determined another exciting feature of quantum mechanics. It applied just where it was necessary. Wherever the world appeared to be continuous, the quantum "rules" corresponded with classical rules. This was called the *Principle of Correspondence*. Bohr felt very encouraged. He believed that he was on to one of God's secrets. He knew why the world appeared continuous even though it was fundamentally a discontinuous and quantum jumping world. It was all a question of relative scale. To Bohr, discontinuity was a fundamental truth.

But neither were the continuists to be dissuaded. They weren't ready to throw the whole classical towel into the ring. Although Bohr, in his excitement over the correspondence rule, was ready to drop all classical pictures, the continuists felt equally encouraged to find a classical reason for the jumps. Little did they know then that they would have to give up the particle world of matter in their attempts to rid themselves of quantum jumps.

When a Particle Is a Wave

I never saw a moor
I never saw the sea;
Yet I know how the
heather looks
And what a wave must be.

EMILY DICKINSON

A Prince Imagines a Wave

The flame of desire for a mechanical model of the atom was about
to be refueled. Bohr's orbits were too disturbing. Electrons
should have some physical reason for not radiating whenever
they are confined to such periodic movements. Furthermore,
there must be a natural and physical reason for Planck's
mysterious $E = hf$ formula that would relate the energy of
Einstein's photon of light with the frequency of that light's wave
motion. But what explanation could there be? While classical
Newtonian mechanics did not provide any insights, perhaps the
"new" mechanics of Einstein's special theory of relativity would
shed some light on light. And perhaps this was the desire of one
well-to-do prince of the French aristocracy, Louis Victor
de Broglie.

De Broglie came from a long line of French royalty.[1]
His notable family dated back to the American Revolutionary
war, where his ancestors fought for the revolutionaries. Although
he completed his education in history by 1910, his brother,
a well-known physicist, persuaded him to return to school and
study physics. De Broglie soon became fascinated with the
quantum controversy and the ideas of Albert Einstein. By 1922,
after interrupting his studies to fight in World War I, he
published two papers on Einstein's wave-particle concept of
light.[2] He called attention to the dual behavior of light. One
type of observation, in which the time for observing is spread
over many millions of cycles of wave oscillation, shows that light
is a wave. Another type of observation, in which there is an
instantaneous transfer of energy from light to matter or vice
versa, showed that light consisted of particles called *photons*.

De Broglie wished to provide a mechanical explanation for
the wave-particle duality of light. Thus, he needed to find a
mechanical reason for the photons in the wave to have an energy
that was determined by the frequency of that wave. It was while
thinking about light that the idea occurred to de Broglie that
matter, too, might have a wave nature.

He knew of Bohr's strange result. The electron in a hydrogen
atom would orbit its nucleus only in special orbits. In each orbit,
the electron had to have a whole number of angular momentum

units, multiples of Planck's constant h. De Broglie was struck with another wave analogy. He remembered *standing waves*.

If we consider a violin string for a moment, we will see de Broglie's analogy. When the string is plucked or bowed, it vibrates. The string moves up and down in a characteristic manner. The ends of the string, of course, are held down tightly with pegs. If we watch carefully, we will see that the string resembles a wave. The middle of the string vibrates up and down. This kind of wave is called a *standing wave*. It oscillates up and down, but does not move along the string. The sound of the violin string is produced by this standing wave pattern.

It is also possible to see and hear another vibration on this same string. In this second example, the middle of the string remains at rest while the rest of the string, not including the fixed ends, vibrates. The sound we hear is an octave higher. This standing wave pattern, called the second harmonic, has a higher frequency than the first one. Again, by watching closely we see that there are two up-and-down movements, one on each side of the fixed middle point.

A third harmonic occurs when there are two points along the string, in addition to the endpoints, that remain at rest when the string vibrates. Each resting point on the string is called a node. As the number of nodes on the string increases, the frequency of the standing wave increases and the pitch of the sound wave it produces increases.

De Broglie noticed a connection between the angular momentum of the electron in a Bohr orbit and the number of nodes in a standing wave pattern. The orbiting electron could only have one unit of h, two units of h, etc. Could these discontinuous changes in the electron's angular momentum, these changes in the amount of h allowed, be due somehow to a similar change in standing wave patterns?

What de Broglie had noticed in analogy was that the number of nodes was a whole number for any standing wave pattern. The lowest frequency standing wave had two nodes, the end points of the string. The next higher frequency had three nodes. The next wave had to have four nodes, and so on. Since, according to Planck's $E = hf$ formula, energy was frequency, could the higher energy orbits in the hydrogen atom correspond to higher harmonic matter-wave frequencies?

De Broglie realized that the Bohr orbit could be seen as a circular violin string, a snake swallowing its own tail. Would the orbit size predicted by his standing "matter waves" correspond with Bohr's calculated circles? In other words, what would his waves do if they were confined in a circle?

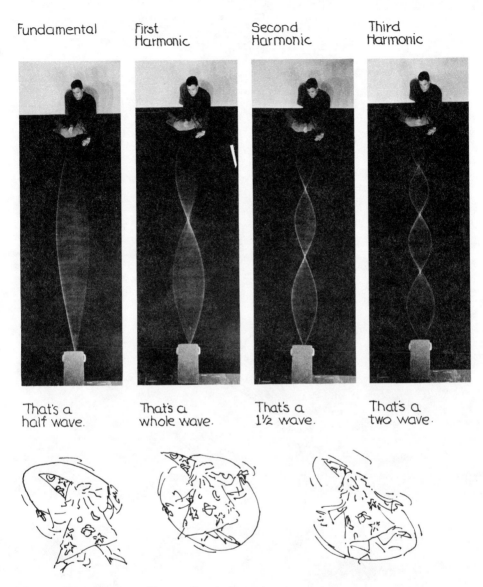

Fundamental | First Harmonic | Second Harmonic | Third Harmonic

That's a half wave. | That's a whole wave. | That's a 1½ wave. | That's a two wave.

Standing wave patterns for a jump rope.

De Broglie discovered that his matter waves fit Bohr's orbits exactly. When he calculated the wavelength of the lowest orbit, he discovered another astonishing mathematical connection between the wave and the particle. The momentum of the orbiting electron equaled Planck's constant divided by the wavelength. He quickly reviewed his calculation and looked at the next orbit. It had a higher energy. It also checked out the

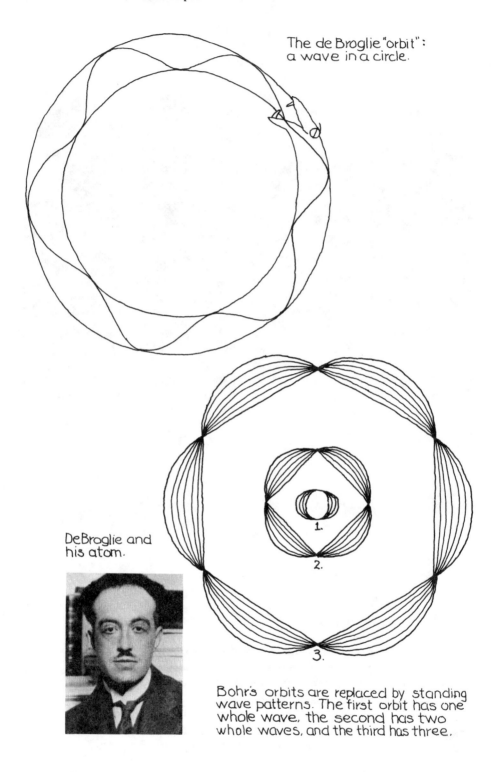

The de Broglie "orbit":
a wave in a circle.

De Broglie and
his atom.

Bohr's orbits are replaced by standing
wave patterns. The first orbit has one
whole wave, the second has two
whole waves, and the third has three.

same. For each Bohr orbit, the electron's momentum equaled h divided by the standing wave's wavelength.

De Broglie had discovered a new formula, one as startling and revolutionary as Planck's formula. It stated that the momentum of a particle p was equal to Planck's constant h, divided by the wavelength L. That is, $p = h/L$.

With this new mathematical discovery, Bohr's orbits could be explained. Each orbit was a standing wave pattern. The lowest orbit had two nodes. The next one had to have four nodes, since an orbit with three nodes would cancel itself out. The third orbit had to have six nodes, and so on. The energy of the electron in each orbit was given by h times the wave frequency. The momentum of the electron in each orbit was given by h divided by the wavelength. The mathematics worked out.

The atom was a tiny tuned instrument. These mathematical relations balanced the tiny electron into a tuned standing wave pattern. Orbits had determined and fixed sizes in order that these distinct, "quantized" *wave patterns* could exist.

Louis de Broglie published his results as a thesis dissertation for his doctorate in physics. He presented it, somewhat reluctantly before the Faculty of Sciences at the University of Paris in 1923.[3] His thesis was certainly original, perhaps a little too original. The study of atoms was a branch of physics, not musical composition. There was no experimental justification for this "crazy" idea. In fact, using such an absurd idea to explain Bohr's absurdity was a little too much for the reserved faculty.

Albert Einstein was called in. Einstein replied, "It may look crazy, but it is really sound!" The thesis was accepted, and a while later, the prince was awarded a Nobel Prize for his dissertation. Someone in America had actually discovered a de Broglie wave.

American Grains of Waves

Einstein welcomed de Broglie's picture. It was a return to continuous mechanism. The wave that guided the electron in the atom had been undetected so far. De Broglie's calculation of the momentum indicated that, for the light-weight, high-speed electron, the wavelength L would be extremely short. In fact, these tiny waves confined to the minuscule orbits within atoms were less than two billionths of an inch long. Even light waves were about five thousand times longer.

De Broglie's wave was envisioned as accompanying any particle wherever the particle went. Like a shadow, the matter wave traveled alongside its particle. The two belonged together. The frequency of the wave could always be determined by the particle energy; the wavelength could be determined from the momentum of the particle. Matter, like light, had a dual nature. This was the wave-particle duality.

Although these new discoveries were sweeping European science back and forth, little of the furor crossed the Atlantic to the United States. Americans were more concerned with practical discoveries. The Bell telephone laboratories exemplified the practical side of American research. But Clinton Davisson, who worked for Bell,[4] had noticed a peculiarity in his research. He had found that the electrons he was using in his experiments were reflecting from the clean surfaces of nickel crystals in an unexpected pattern. Trusting his results, he published them without offering any explanation.

Davisson's results made their way across the Atlantic. Two German physicists, James Franck and Walter Elsasser, grew excited when they saw these electron reflection patterns.[5] The patterns did not appear to make any sense unless they were wave interference patterns produced by the electron matter waves reflecting from the nickel atoms. By checking the momenta of the electrons that Davisson had used, Franck and Elsasser were able to determine a reflection pattern for the electrons. That pattern depended on the de Broglie calculation of the wavelength in his $p = h/L$ formula. The calculated pattern matched Davisson's measured results. De Broglie's waves had been detected.

Other experiments followed. With the discovery of the neutron, a new particle contained within the atomic nucleus, physicists made neutron diffraction patterns that appeared just like the electron patterns observed by Davisson. Scientists soon realized that any kind of particle would produce a wave pattern if a beam of those particles were directed to an appropriately sized crystal that would allow the waves to interfere with each other.

Matter waves were now accepted. In fact, they were accepted so completely that physicists began to doubt even the existence of particles. Perhaps the waves could be made to interfere with each other and, in so doing, produce a particle. Could this idea be backed up by a careful mathematical analysis?

Such an analysis was needed for another reason as well. De Broglie's waves only held for particle beams and closed Bohr

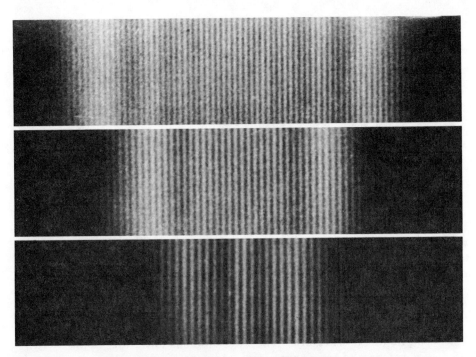

Matter wave interference patterns. By changing the momentum of each electron, the wavelength changes. The separation between the "teeth" increases as the wavelength gets longer.

orbits. But how does an electron change from one orbit to the next? What is mechanically and continuously going on inside the atom? Newtonian mechanics was not dead; it had only been modified to accommodate a new form of matter—the matter wave. Somehow there had to be a way to describe the movement inside of an atom that would allow the electron to change orbits and radiate away its excess energy as light. To find such an answer, an expert on waves was needed.

Schroedinger's Unimaginable Waves: The End of Pictures

There was certainly something to be said for de Broglie's waves: at least they offered a picture of what was going on inside of an atom. However, more was needed. A way to visualize the shifting

patterns of the wave when it changed its energy and produced light was needed. Neither Bohr's jumping electron particles nor de Broglie's wave patterns were enough to explain the light coming from different atoms. But Erwin Schroedinger, an Austrian physicist, found a mathematical equation that explained the changing wave patterns inside an atom.[6]

Schroedinger's equation provided a continuous mathematical description. He viewed the atom as analogous to the vibrating violin string. The movement of the electron from one orbit to another lower energy orbit was a simple change of notes. As a violin string undergoes such a change, there is a moment when both harmonics can be heard. This results in the well-known experience of harmony or, as wave scientists call it, the phenomenon of *beats*. The beats between two notes are what we hear as the harmony. These beats are perceived as a third sound. The vibrational pattern of the beats is determined by the difference in the frequencies of the two harmonics.

This was just what was needed to explain the observed frequency of the light waves or photons emitted when the electron in the atom undergoes a change from one orbit to the other. The light was a beat, a harmony, between the lower and upper harmonics of the Schroedinger-de Broglie waves. When we see atomic light, we are observing an atom singing harmony. With this explanation, Schroedinger hoped to save the continuity of physical processes.

Schroedinger's dancing mathematical waves were in his mind.

However, physicists were not altogether comfortable with his wave equation. No one could imagine what the waves looked like. They had no medium to wave in, and they had no recognizable form in physical space. They didn't look like water waves or sound waves. Instead, they were abstract, mathematical waves described by mathematical functions.

Although a physical picture of a mathematical function is difficult to imagine, it is not impossible. If you have ever stepped into a shallow wading pool—one that has been recently visited by young children—you may have experienced a disconcerting physical manifestation of a mathematical function due to the children's unfortunate lack of bladder control. As you moved from one place to another in the pool, you undoubtedly noticed that there were warm spots and cold spots. The temperature of the water was not the same everywhere. Temperature was a mathematical function of location in the water. In time, the temperature could even change at a given point in the water. Temperature was also a function of the time of observation. In other words, the temperature was a mathematical function of space and time.

Similarly, Schroedinger's wave was a mathematical function of space and time. The only problem was that no one knew how to look for its "warm and cold spots"—in other words, its troughs and crests. Furthermore, as the atom became more complicated, the wave also became more complicated. For example, the wave

Schroedinger's hydrogen atom: A pattern of probability.

ONE ELECTRON IS EVERYWHERE IN THE ATOM.

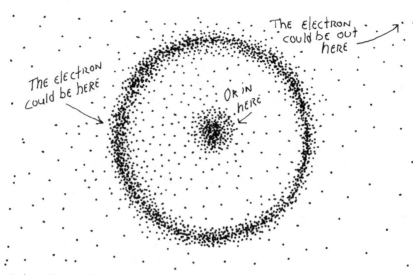

The electron could be here

The electron could be out here

Or in here

Schroedinger's hydrogen atom: Just before it radiates.

describing one electron is a function of that electron's location in space and time. That's not too difficult. But if we are looking at a helium atom, there are two electrons present, but only one wave. The wave behavior, then, depends on the location of both electrons at the same time. And as the atomic number of an atom increases, the number of electrons contained within that atom increases. Uranium, which has an atomic number of 92, has 92 electrons and only one wave function describing it all. There was simply no convenient way to picture this wave.

But despite its unimaginability, Schroedinger's wave proved indispensable. For it explained a great many physical phenomena to which the classical model could no longer be applied. It was a successful mathematical way to explain light from any atom, molecular vibrations, and the ability of gases to absorb heat at extremely low temperatures. Physicists were excited and eager to apply Schroedinger's mathematics to anything they could get their hands on. They were like a gang of kids who had invaded the kitchen and, after many disappointing attempts to bake a cake, had suddenly discovered mother's cookbook. Schroedinger's formula gave the correct recipe in every physical application imaginable.

Everyone believed in Schroedinger's wave, even if no one knew how it waved in space and time. Somehow the wave had to exist. But even without a picture, the mathematics was enough— provided you knew how to read the mathematics cookbook. Could

the wave make a particle? Was there a way to use the Schroedinger cookbook to bake a particle? Even that was not impossible for the master chef. But how could one use waves to make a particle? The answer lies in our concept of a particle. It is a tiny object distinguished from a wave by one outstanding characteristic: it is localized. It occupies a well-defined region of space. It moves from one region of space to another. You always know where it is. It exists at one place only at any given time.

Waves are different; they are not localized. They are spread over wide regions of space and can, in fact, occupy any region of space containing many locations at the same instant of time.

But waves can be added together. And when many waves are added, surprising results can be achieved. Schroedinger waves were no exception to the rule. Schroedinger waves could be added like ingredients to a recipe and produce a *Schroedinger pulse*.

A pulse is a special kind of wave. If you attach one end of a jump rope to a wall and take the other end in your hand, you can make a pulse by stretching the rope taut and giving it a sudden up-and-down movement. The pulse travels from your hand toward the wall and then reflects from the wall. This action resembles that of a ball thrown against the wall and bouncing from it. Perhaps that's all there was to an electron. It was a pulse on an invisible rope.

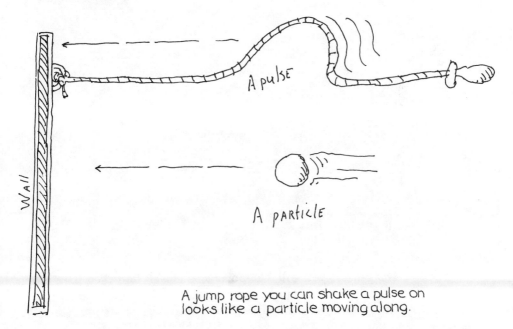

A jump rope you can shake a pulse on looks like a particle moving along.

But there was something awfully embarrassing about the idea of a Schroedinger pulse: it got fatter as it got older. That is, it spread out and became wider each second it existed. The problem was it had nothing to hold it together. It was made up of other waves, and each of these waves had its own speed. With time, each wave would move apart from the others. The pulse would stay together only so long as the waves remained in harmony with each other.

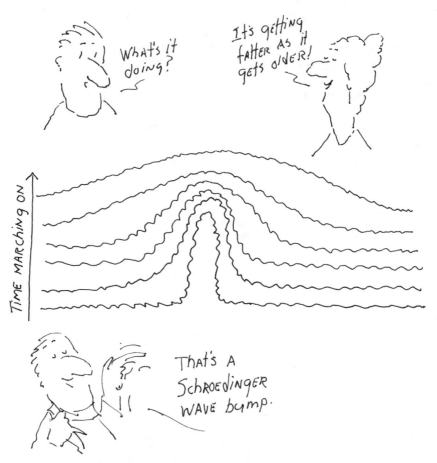

Schroedinger's free particle: The instant after you find it, it spreads.

Imagine, if you will, the pulse as a closely bunched herd of horses galloping around a racetrack bend. The horses can stay together for only a short time. Eventually, the group spreads out

as each horse assumes its own pace. The slowest horses fall to the rear of the group, while the fastest ones move to the front. As time goes on, the distance between the slowest and fastest horses lengthens. In a similar manner, the pulse grows fatter as its slower waves fall out of synchronization with its faster waves.

Though big objects, like baseballs, also were made of waves, the larger the object was initially, the slower its waves spread. Thus a baseball maintained its shape because it was so big to begin with. The Schroedinger pulse describing the baseball was no embarrassment.

But an electron was a horse of a different color. While it was confined within an atom, the electrical forces of the atomic nucleus held its waves in rein. Its waves were only allowed to spread over a region the size of the atom, no further. But when an electron was no longer in such confinement, when it was set free, the waves making up its tiny pulse-particle size would begin to spread at an extremely rapid rate. In less than a millionth of a second, the electron pulse-particle would become as big as the nearest football stadium! But, of course, no one has ever seen an electron that big. All electrons appear, whenever they appear, as tiny spots.

This contradiction between our observations of electrons and Schroedinger's mathematical description of them uncovered a new problem: what prevented Schroedinger's pulses from growing so large? Little did anyone realize that question was to open the doors of paradox and mystery and lead us to a quite different picture of the universe. The answer to the question was: human observation kept them from growing so large. We were on the verge of the discovery of a new discontinuity.

A "skinny" Schroedinger pulse gets wider as time marches on.

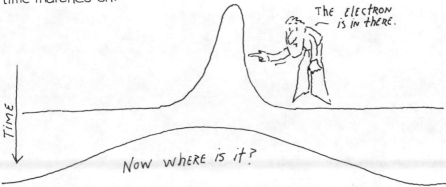

No One Has Seen the Wind

The universe is not only queerer than we imagine, but it is queerer than we can imagine.

J. B. S. HALDANE

God Shoots Dice: The Probability Interpretation

It may be difficult for the nonscientist to imagine how repugnant the idea of a discontinuous movement of matter is to physicists who desire continuity. Starting with Einstein, the discontinuity in the movement of light was connected with a mechanical picture. Light consisted of granules. But then came Bohr and his quantum jumping electron inside of the tiny atom. This concept upset continuists because they could not understand how a particle could behave in this fashion. When de Broglie and Schroedinger appeared with their wave interpretation, the continuists breathed a sigh of relief.

Schroedinger's picture of the atom, although complicated and dependent upon a nearly unimaginable wave function, was nevertheless quite reasonable. The atom's electron *was* a wave. The atom radiated, not because its electrons jumped from orbit to orbit, but because of a continuous process of harmonic beats. The light was given out when the atom "music box" played both the upper energy and lower energy frequencies at the same time. The difference between the two electron matter-wave frequencies, which corresponded in Bohr's conception of the atom to the difference in the electron's orbital energies, was exactly the frequency of the light waves observed.

Gradually the upper frequency matter-wave tone quieted down, leaving only the lower harmonic. Thus the atom stopped radiating light. There was no longer a higher harmonic to beat against. The atom simply continued vibrating its electron wave at the lower frequency, which (according to the Planck $E = hf$ formula and the de Broglie $p = h/L$ formula) had to be unobservable and tucked safely away inside of the atom.

Later, Schroedinger's picture would be destroyed, but his equation, his mathematical law, would remain. And he would express to Bohr, after days of long and arduous discussion, his disgust with ever having been involved in this quantum jumping thing. The problem was that, no matter how the wave shook and danced, there still had to be a particle somewhere. Max Born would be the first to provide an interpretation of this "particle" discontinuity. The wave was not the electron. It was a wave of probability.

In 1954, Professor Max Born was awarded the Nobel Prize for his interpretation of the wave function. The award came nearly thirty years after he first offered the interpretation.[1] But then, Nobel Prizes come more slowly for ideas in physics than for experimental discoveries. Born explained his motives for opposing Schroedinger's picture of the atom.[2] He simply had too much connection with experimental work. He knew of the collision experiments being carried out in his own institute at Gottingen, Germany. Sophisticated refinements with vacuum techniques and electrical focusing of beams of electron particles had led to detailed studies of collisions between atoms and electrons. Despite the discovery of electron waves, these collision experiments were convincing evidence that the electron was still very much a tiny particle—literally, a hard nut to crack.

There was no doubt that Schroedinger's mathematics worked. His equation described correctly all observable atomic phenomena. But how could the Schroedinger equation be used in those very same experimental collision studies at Born's institute? In other words, what kind of wave function describes an electron beam colliding with a rarefied gas of atoms? Since the electrons in the beam were not confined within any atoms, they moved freely through space toward their eventual target, atoms.

Schroedinger's pulse describing a single electron was inadequate. It just got too big too quickly. It couldn't be a real tiny electron, the kind seen every day in Born's laboratory. But Born knew his mathematics. Wide electron pulses spread slowly. So if a pulse was wide to begin with, it would hardly spread at all as it moved from one end of the apparatus to the other end. However, since the pulses had to be many times wider than an atom, how could the electron fit inside of an atom?

Born realized that, in the experiments at Gottingen, no one was really able to locate a single electron in a beam of electrons. Could it be that the width of the wave pulse was connected somehow with our knowledge of the location of each electron? When Born allowed the pulses in his mathematical equations to be as wide as the dimensions of the beam, he found that the spreads of the pulses virtually vanished.

Born's efforts suggested that the time had come for a new interpretation of the meaning of the wave. The wave was not the real particle. Somehow the wave was connected with our knowledge of electron locations. It was, in fact, a probability function.

Probability functions are familiar today. They are used to describe the distribution of likely occurrences. A typical example

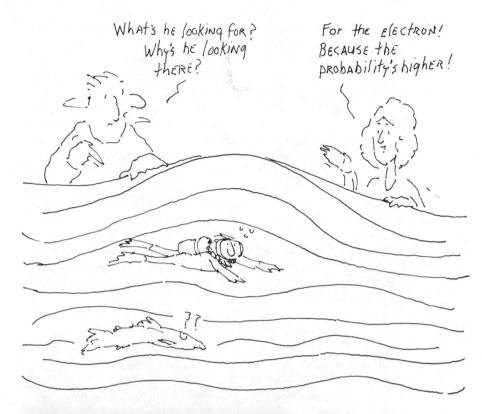

Max Born viewed
Schroedinger's
wave as probability
in space for finding
the electron.

is the probability function for a coin that is spinning in the air. As it falls, the probability function for it to land heads up is .50. Once the coin has landed, the probability function changes. If it has landed heads up, the probability function becomes 1. If it has landed tails up, the probability function becomes 0.

Insurance companies use probability functions to describe the distribution of automobile accidents. The stream of motorists driving into San Francisco each day is intense. That means the probability for any one car to collide with another is large. And the greater the intensity of the stream of motorists, the higher the probability of a collision. The situation is less intense, automotively speaking, in San Diego. Therefore, the probability density or distribution is lower for a collision to occur in that area. If we were to view the entire state of California from a satellite and watch all of the cars driving about, it would be quite easy for us to predict where collisions would be most likely to occur. We would simply note those areas where the flow of traffic was greatest—that is, most intense.

Born pictured the flow of electrons in much the same manner. Wherever there was a greater concentration of electrons in the beam, the Schroedinger wave had a greater intensity. By calculating that intensity, Born found he could predict the probability of a collision between an electron and an atom.

Born's picture made a tremendous impression on his fellow physicists. Again, sighs of relief were heard coming from physics labs all across Europe. But the picture still had a hole in it. Born's system made sense so long as it was applied to a beam or a concentration of actual numbers of particles. Physicists, like insurance actuaries, were quite used to probability ideas when they were dealing with a large number of practically uncountable events. In the experiments at Gottingen, the events were uncountable. But what about just one electron? One atom? How should the Schroedinger wave be interpreted in that case? Did the wave describe a single electron?

Was there a wave in these isolated cases? Was it, in other words, a real wave? And if the wave was a fundamental part of nature that belonged to each individual particle of nature, then who determined where the electron was to be found? Was nature essentially a probability game? Did God play dice with the universe?

A new interpretation was sought. Something was wrong with the probability picture. But what could replace it? The answer to this question had been brewing in Germany since the end of World War I. A new and revolutionary principle of reality was

occurring to one man, a principle that was to completely change our thinking about the physical world.

Heisenberg's Uncertainty Principle: The End of Mechanical Models

If I had a time machine and could return to any period of time, which period would I choose? I would pick the Roaring Twenties; however, it would not be the United States that I would return to. No, indeed. Instead, I would go to post–World War I Germany. And because I am fascinated by pseudodecadence and café society, you would find me among such contemporaries as Bertold Brecht and Thomas Mann. Bauhaus art and design would be flourishing and outrageous Dada art would be creating "authentic reality" through the abolition of traditional cultural and aesthetic forms by the technique of comic derision. For, during that period, irrationality, chance, and intuition were guiding principles. Freud was out. Jung and Adler were in. Life had a certain cabaret feeling.

Now add the physicists. Though they numbered perhaps less than a hundred, a new breed of young, enthusiastic fellows was making its way into the new physics. Planck was past sixty. Einstein had seen his fortieth birthday. Bohr was a middle-aged thirty-five. These older and wiser moderates were to be the guiding lights for the new breed. It was time for Dada physics, and it was happening in Gottingen, Germany. In early summer, 1922, Professor Niels Bohr, who then headed a brand-new institute of physics in Denmark called the Copenhagen School, had come to give a lecture.

Among the students who had gathered to hear Bohr was twenty-year-old Werner Heisenberg. This occasion would be the first of many meetings between Heisenberg and Bohr. Together these two would change the meaning of physics. Eager to rid physics of mechanical models, they would herald a new school, a school of discontinuists. Their interpretations would lead to a revolution of thought.

Heisenberg wrote of this first meeting with Bohr in his book, *Physics and Beyond*. After some remarks concerning Bohr's atomic theory, he wrote:

> Bohr must have gathered that my remarks sprang from profound interest in his atomic theory. . . . He replied hesitantly . . . and asked

me to join him that afternoon on a walk over the Hain Mountain. . . .
This walk was to have profound repercussions on my scientific career,
or perhaps it is more correct to say that my real scientific career only
began that afternoon. . . . Bohr's remark [that afternoon] reminded
me that atoms were not things. . . .[3]

But if atoms were not "things," then what were they?
Heisenberg's answer was that all classical ideas about the world
had to be abandoned. Motion could no longer be described in terms
of the classical concept of a thing moving continuously from one
place to another. This idea only made sense for large objects; it did
not make sense if the "thing" was atom-sized. In other words,
concepts are reasonable only when they describe our actual
observations rather than our ideas about what we *think* is
happening. Since an atom was not seen, it was not a meaningful
concept.

Heisenberg's thoughts had been influenced by Einstein. In
1905, Einstein had carefully laid out the steps to relativity. He

Young Heisenberg: A vison of uncertainty?

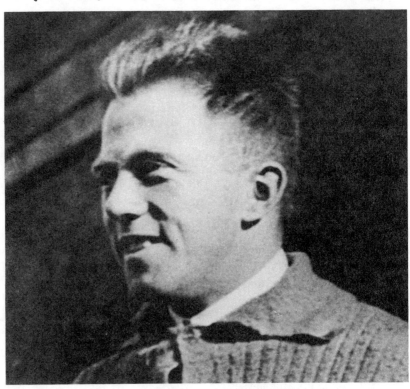

had recognized that, in order to speak about such notions as space and time, one must provide operational definitions — definitions that detailed how these things were measured. For example, space is what a ruler measures and time is what a clock measures. For anyone armed with these empirical and objective forms, space and time lose their mystery. Everyone holding rulers and clocks can agree on the definitions, because they can agree on which operations to do with these instruments.

A concept is useful when we all know how its measurement is to be accomplished. This viewpoint led Heisenberg to question any concept that had no operational definition. Atoms were not observable, but the light coming from them was observable. Thus, Heisenberg developed a new form of mathematical tools based upon the frequencies of the light that was seen, rather than the position and momentum of an unobservable electron within an unseen atom. These new mathematical tools were developed from the mathematics of *operators* and not the mathematics of numbers.

An operator in mathematics performs a duty. It changes or modifies a mathematical function in a defined way. For example, the operator called "square" will multiply any mathematical function by itself. (Thus when "square" operates on "x," it makes "x^2." When it operates on 5, it makes 25, etc. Operators are also capable of being operated upon. Thus "square" can be multiplied by the number 3, which can be an operator as well as a simple number. This makes "3•square," a new operator. When "three•square" operates upon 5 it makes 75 instead of 25. Two or more operators can also be multiplied together.) Heisenberg discovered, with the help of Max Born, that his mathematical operators, which corresponded to the observed frequencies and intensities of the light from atoms, obeyed a strange law of multiplication. The order in which you multiplied the operators was important. If the operators were, for example, A and B, then AB did not equal BA. (If we use the previous example of "three•square," we see that "three•square" is not the same as "square•three." For when "three•square" operates on 5 it gives 75, but "square•three" operating on 5 gives the result of multiplying 3 times 5 and then squaring. This gives 225, instead. Thus "three•square does not equal "square•three.") Did that mean that the physical world depended as well upon the order in which you observed things?

Later, Born and Pascual Jordan carried Heisenberg's mathematics a step further. They were guided by Bohr's Principle of Correspondence that showed that the classical mechanical

viewpoint would correspond with the quantum mechanical viewpoint whenever the quantum numbers describing the old Bohr orbits were quite large compared with 1. By following this principle, they were able to find mathematical operators for the position and the momentum of the electron instead of the frequencies and intensities used by Heisenberg. The surprising fact was that these operators, too, depended on the order in which they were carried out. A new and previously unsuspected picture of the universe was emerging.

The new tools of operator algebra were later found to be related to the mathematics of matrices. A matrix, an array of numbers, must be handled in a careful, well-defined way. The rules governing the use of matrices were found to be identical to the mathematical rules used to handle operators. Consequently, Heisenberg's development of quantum mechanics came to be called *matrix mechanics*. The wave mechanics of de Broglie and Schroedinger was still being investigated, however, and eventually it became apparent that the two forms of mathematical expression were simply disguised versions of the same thing. Schroedinger discovered this[4] and offered formal mathematical proof of their equivalence. For a while, interest in the purely operational matrix mechanics dropped.

Yet Heisenberg wasn't ready to dismiss the insights he had garnered from his matrix mechanics. He began to explore his observational basis for reality using the Schroedinger wave. Born's probability interpretation suggested how he should proceed, and, following the tradition of Einstein, Heisenberg attempted to describe the method by which the position and momentum of an atom-sized object could be measured.

To see something, we must shine light on it. Determining the location of an electron would require our sense of sight. But for so tiny an object as an electron, Heisenberg knew a special kind of microscope would be needed. A microscope magnifies images by catching light rays, which were originally moving in different directions, and forcing them all to move in much the same direction toward the awaiting open eye. The larger the aperture or lens opening, the more rays of light there are to catch. In this way, a better image is obtained, but the viewer pays a price for that better image.

The price is that we don't know the precise path taken by the light ray after it leaves the object we were trying to view in the first place. Oh, we will see it all right—a fraction after its collision with the little light photon that was gathered up by the

microscope. But was that photon heading north before it was corralled by the lens, was it heading south, or southwest? Once the photon is gathered in, that information gets lost.

But so what? We do get an exact measurement of the position of the electron. We can point out just where it was. Well, not exactly. We still must worry about the kind of light we use. Try to imagine painting a fine portrait the size of a Lincoln penny. What kind of brush would you use? The finer the hairs of your brush, the better your ability to create the miniature. If you were to reduce the size of the portrait even further, you would need an even finer brush.

Different kinds of light vary in their wavelengths in much the same way that brushes vary in the fineness of their hairs. To see something very tiny, you need to use light with a small wavelength. The smaller the object you are looking for, the tinier the wavelength you will need. Since an electron is very tiny, Heisenberg needed to use a kind of light that has a very small wavelength. This light is beyond our normal range of vision, though still detectable in a way similar to ordinary light. But according to de Broglie's formula, the smaller the wavelength of the light, the greater the momentum of the photon. Therefore, for Heisenberg to see the electron, the photon would have to hit it with a tremendous amount of momentum.

In Zen Buddhism, one speaks of using a thorn to remove a thorn as the process of finding out what is real. In Heisenberg's microscope, the tiny wavelengthed photon is as big a thorn as the electron it is inspecting. Thus, if we are able to catch the photon ray in the wide open lens of the microscope and if we are consequently able to "see" the position of the electron, we will have absolutely no idea of where the electron will be next. Our act of viewing the electron disrupts its motion. Though we learn the electron's position, we are left uncertain of its momentum; we simply do not know how fast or in what direction the electron was moving at the instant of impact.

We may attempt to remedy the situation by doing one of two things. First, we can use photons that do not give the electron so big a "kick." That is, we can use light that has a longer wavelength. But this remedy has a disadvantage: we lose information about the precise location of the electron. Like the painter with a brush of coarse hairs, we cannot manage the details of our electron portrait. Our second option is to make the lens opening, the aperture, smaller. For by taking in less light, we are able to determine more accurately the direction the photon takes after its

How diffraction blurs the image of the electrons.

Short=length light WAVES show where the ELECTRONS ARE, but the WAVES disturb them so that WE CANNOT predict where they will be.

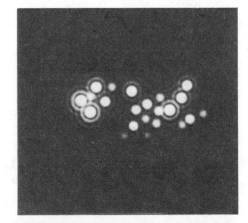

Medium=length light WAVES don't give AS MUCH deTAil AS short=length ONE,s but they don't disturb the electRONS too much.

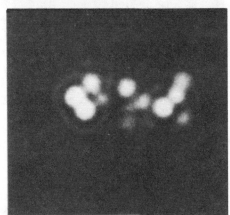

Long=length light WAVES blur the image so that WE don't KNOW where the electRONS ARE. But they don't WANDER off VERY fAR either.

collision with the electron. Unfortunately, this remedy also has a disadvantage. Light behaves very much like a wave with respect to the aperture. That means it bends or diffracts as it passes through the hole. The narrower the space offered to the light, the worse the bending. Consequently, narrowing the aperture brings us less information about the location of the electron, because the image we receive is distorted by the bent light rays.

If you have ever tried to convince someone to change his way of life, you may have noticed how he had some good reason why the change you suggested could never work. Even though the person sought your advice, he had a ready answer defeating your marvelous idea as soon as you offered it. Your stubborn friend, you probably realized, had simply made up his mind in advance. Similarly, Heisenberg had discovered nature's stubborn streak. Yet there seemed no way to catch her in her act. The more one knew of the position of the electron, the less one knew of its path to the future, its momentum. And the inverse was also true. But was nature just hiding from us? Heisenberg didn't think so.

Remember that we began this section with the premise that we can define only what we can measure. Since we cannot measure both the position and the momentum of any object in this universe with exact precision, the very concepts of "position" and "momentum" are in doubt. So how can these concepts be given any meaning? Heisenberg contended that although the notion of "path" implies clear knowledge of both "position" and "momentum" simultaneously, it could be retained in quantum physics. His rationale was extremely provocative. He said, "The path comes into existence only when we observe it."[5]

To grasp Heisenberg's statement, let us take another look at the Bohr atomic model. Accordingly, if an electron is in an orbit with a large quantum number—say, orbit 10,000—it will behave in a nearly classical manner. The size of this orbit is quite visible with ordinary light, for its diameter is about one-half inch in length. However, the correspondence principle warns us that it will be quite difficult to see any difference between orbit 10,050 and orbit 10,000. These orbits are too close together for us to perceive the difference with ordinary light. Thus, if we shine ordinary light on the atom when the electron has a large orbit, we cannot be certain which orbit we are witnessing.

Is the electron in a specific orbit? In other words, does the electron occupy a given point in space at a given time, and does it follow a smooth and continuous trajectory to the future point along that trajectory? According to our observation, we will not

be able to determine the actual orbit for the electron. But shall we still assume that it has such an orbit? Certainly we know more about the electron after we observe it than we did before we observed it.

But how did we gain this knowledge? According to Born's interpretation of the Schroedinger wave, the wave describing the electron is a description of our knowledge. In other words, the wave shape and size tell us where the electron is likely to be observed. But, if after we actually observe an electron we know more than we did before we observed it, the Schroedinger wave must have changed its shape and size to correspond to our change of knowledge. But what caused the Schroedinger wave to change, and how?

If we imagine that no attempt was made to observe the electron, then the wave pulse composed of those Schroedinger waves, which satisfy the Schroedinger equation, would continue to spread. In fact, they would continue to spread indefinitely. Meanwhile, we are losing information concerning the location of the electron. Even though the light we use is not a very precise guide to determining the electron's location, it is better to light one little match than curse the darkness.

Once we see the light reflecting from the electron, we have a much better idea of its actual location. With our location of the electron, there is a corresponding change in size of the Schroedinger pulse describing the electron. Following Born's interpretation, the size of the pulse is a measure of our knowledge of the electron's location. Since we now have a better knowledge of the electron's location, we must have a correspondingly more narrow Schroedinger pulse describing that electron. But that would mean the Schroedinger pulse describing the electron must have gotten thinner as a result of our observing the electron. It had to thin down because we have more information with the light on than we did without observing the electron. We can see, for example, that the electron is on the right side rather than the left side of an observing screen. Our observation process has somehow reduced the pulse to a smaller size.

This reduction in pulse size is *not* part of the mathematical description of the electron. We cannot use the Schroedinger wave equation to tell us just where we will find the electron when we observe it. The Schroedinger equation can only tell us about the pulse that is unobserved. It tells us where we are likely to observe the electron. After our observation of the electron, the pulse undergoes a discontinuous change brought on by our observation.

An unobserved electron pulse moves along...

getting wider and spreading as it moves...

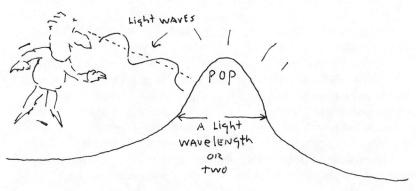

until the observer sees it. Then it "collapses" down to size.

If our observation used long wavelength light, the pulse would not have been too thin to start with. Since unobserved, wide pulses do not grow much wider very quickly, our loss of information concerning the location of the electron is not too severe.

In today's electronics industry, electrons are used in a variety of tasks. Engineers have good control of electrons because they work with extremely wide electron wave pulses. Of course, we mean "wide" on an atomic scale. These atomically wide pulses are nevertheless quite definable on a large industrial scale. For example, electrons are used inside of the big cathode

ray tube in a typical television set. The Schroedinger pulse describing the electron must travel the length of the tube in about ten billionths of a second. This time is short enough to prevent the electron pulse from spreading too much; particularly since the initial pulse need only be several thousandths of an inch in width. This tiny macroscopic, or large-scale size, is more than a million times larger than an atom. Our modern use of electron microscopes is based not upon the wave nature of the electron, but upon its ability to be a particle for very short time periods and our noninsistence that the electron's wave pulse be too small to begin with.

These practical considerations make the electron appear to be a solid particle. Practical considerations also make nearly every other object that exists on a human-size scale appear "normal." The *spreading time* (that is, the time it takes for a pulse to double its size) depends as well on the mass of the object observed. Large-mass objects on the scale of grams, even if their initial pulses were defined within a millionth of an inch, would need the age of eternity, billions of years, to spread any amount at all. However, such big and heavy pulses are not needed. What about thin and light-weight pulses? Here quantum physics takes its toll. They spread quickly.

When we are dealing with electrons and atoms, we need to consider such things as spreading time. It is just when this time concerns us that we begin to lose our picture of what is going on. The reduction of a fat pulse to a thin pulse is necessary for *any* observation to take place. It is a vital and mysterious process that is ignorable for fat and heavy pulses, but not for initially thin and light-weight pulses. Of course, I am referring to pulses that describe a light-mass particle with only a limited range of possible locations. With such objects, information is lost very quickly. The Schroedinger equation is the only mathematical tool we have to keep track of such objects. But it doesn't do a good job; it simply tells us how we lose information. Once we actually perform an observation, we gain back some of what we lost. This process of gaining back is a discontinuous process.

If we insist that the universe is composed of such tiny objects, then the whole universe comes into existence whenever we observe it. Furthermore, we pay a price for our acts of observation. Each act is a compromise. The more we attempt to measure the position of an electron, the less we can determine its momentum, and vice versa. The Born interpretation was a measure of our uncertainty in this regard.

This uncertainty meant that no matter how accurately one tried to measure the classical quantities of position and momentum, there would always be an uncertainty in the measurement. Predicting or determining the future of atomic objects would be impossible under these circumstances. This was called the Heisenberg Principle of Uncertainty or the Principle of Indeterminism. It had little relevance in the world of ordinary-sized objects. They were hardly bothered by disturbances produced through observation. But the uncertainty principle was serious business when it came to electrons. Indeed, it was so serious that it brought the very existence of electrons into question.

Later the principle was found to apply to any pair of observations, provided that pair of observations never produced the same result when carried out in a reverse order. This included the energy of a particle and the time span over which that energy was to be measured.

As you can expect, the uncertainty principle was quite an upset to the continuists. It signaled the end of mechanical models. How could there be a mechanical universe out there, if the universe changed every time we altered how we observed it? First locating an electron and then finding out how fast it is moving gave an entirely different result than determining the electron's speed and then locating its position. How could a mechanical universe be fundamentally indeterminate?

To answer these questions would require as clear a statement of the issues as possible. That meant a debate. The outcome was destined to affect the entire history of physics.

Resistance to Uncertainty

*There is no law
except the law that there
is no law.*

JOHN A. WHEELER

Heisenberg's Principle of Uncertainty could be interpreted another way: to observe is to disturb. Up to the time of Heisenberg's principle, it was assumed that the "out there" universe existed quite independently of the observer who measures it. To have a universe that depends upon the observer who measures it is disturbing on both physical and mental accounts. After two thousand years, modern physics was faced with the same dilemma as the early Greeks. It was the old story of Zeno and the arrow. How did the arrow move? Continually, said the continuists, with no help from the observer. In jumps, said the discontinuists, with a little and unavoidable help from the observer.

By October, 1927, the issue of the role of the observer had brought together thirty or more well-known physicists. They were gathered for the fifth Solvay conference (named after Belgian industrialist Ernest Solvay, who had sponsored it and offered considerable financial support). The first four conferences had also dealt with the new quantum mechanics, but this conference promised to be a real showdown. It was the start of the strangest debate in the history of the understanding of the world. Its protagonists were Niels Bohr for the discontinuists and Albert Einstein for the continuists. Also included were Born, de Broglie, Heisenberg, Planck, and Schroedinger. For this was to be a top-level discussion on one of the most important problems of the time: the meaning of the new quantum theory.

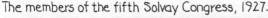
The members of the fifth Solvay Congress, 1927.

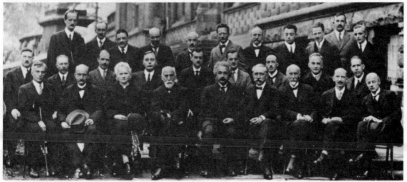

The first to enter the arena was de Broglie. He argued for the reality of the matter wave. Certainly it was a wave of probability, but it also was a guiding wave determining the real trajectory of the particle in its journey through space and time. The vote was thumbs down. To vote against an idea in such circles is easy enough; all one had to do was not discuss the idea. A year later, de Broglie abandoned his "pilot wave" theory. In fact, in the fall of 1928, when he assumed his post at the Paris Faculty of Sciences, he thought it unjustified to teach in his own course.

After de Broglie, Born and Heisenberg presented their paper on the probability interpretation of the Schroedinger wave. The vote was thumbs up. Next, Schroedinger presented his wave mechanics for a system composed of many bodies in interaction. The climax of the meeting was a general debate. The preliminary bouts were over. The ringmaster Hendrik A. Lorentz opened with his dissatisfaction over the rejection of determinism proposed by the majority of speakers. But it was time for the main bout. Lorentz called on Bohr to address the assembled. Bohr presented his latest ideas on the wave-particle duality for his opening gambit. His words were clearly intended for the ears of one man. Albert Einstein had never before heard Bohr's new ideas on wave-particle duality, a concept that Bohr called *complementarity*.[1] Einstein had not even taken part in any of the preliminary bouts. Even now, at the end of Bohr's presentation, he remained silent.

Several others piped up. Born asked the group to consider the question of reconciling the particle character of matter with the wave character. He referred to the Heisenberg example of observing an electron in an atom. Each time the electron was "seen" the pulse instantly thinned down, redefined within the limits set by the wavelengths of the light. The longer the wavelengths of the light used, the softer the light's impact upon the orbiting electron. The position of the electron was not well defined. Its Schroedinger pulse was large enough to encompass several possible orbits for the electron particle. Somehow the picture was consistent. The particle was defined in its location by the act of observing it.

But how did this take place? The pulse would, according to the Schroedinger equation, continue to spread, even after the light interacted with it. The Schroedinger equation did not describe what we would see by shining light on the orbiting electron. It only told of the probability of observing the electron. The actual experience determined the location of the electron insofar as the light's wavelengths could paint the picture. In

other words, Schroedinger's equation did not describe actuality, only potentiality.

The question was how did the spreading waves regroup when an observation took place? This phenomenon was known as the *collapse of the wave function.* The collapse was not contained within the mathematical formulation of quantum mechanics. Yet if the wave description was a reality, the collapse had to occur. Several physicists in attendance attempted to explain the collapse, and someone offered an explanation of an alternative multidimensional space in which no collapse of the wave occurs. But as Born admitted, "This does not lead us very far concerning the basic problem."[2]

It was then that Einstein entered the ring. Rising from his seat, he told the assembly, "I have to apologize for not having gone deeply into quantum mechanics. Nevertheless, I would like to make some general remarks."[3] The seeds of what was to develop had been planted seven years earlier, in the spring of 1920. Now the debate had officially begun. Einstein was clear where Bohr was obscure. Einstein asked the members to consider an experiment, the first of a series of "gedanken (thought) experiments." It was a simple thought experiment in which the group was asked to imagine a particle passing through a very narrow slit. Accordingly, the wave associated with the particle must be diffracted, and like ripples from a dropped pebble in a pond, the wave will spread. Behind the slit is a sensitized screen shaped in the form of a hemisphere. This hemisphere will act as a detector of the particle, for after passing through the slit, the particle must arrive somewhere on the screen. The arrival of the particle is an event whose probability of occurrence at any particular point on the screen depends on the intensity of the wave.

Everyone agreed with these statements, even Bohr. But, Einstein continued, there are two different viewpoints as to what is actually happening. According to the first viewpoint, the wave does not represent a single isolated particle, but rather an ensemble of particles, all of which are distributed through space. The wave intensity corresponds to our usual interpretation of multitudes of similar events: it is a probability distribution no more mysterious than an actuarial table or a census giving the distribution of age and sex among the states and cities. If this first is correct, then the wave describes our real ignorance of things, nothing more, and matter is really material behaving causally and moving so within space and time. But a second view is also possible.

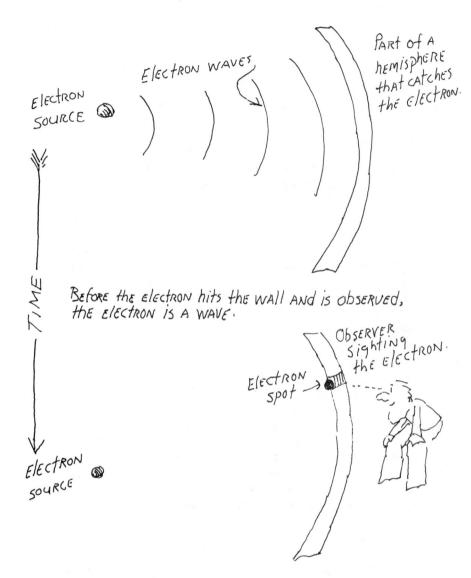

ELECTRON SOURCE

ELECTRON WAVES

PARt of A hemisphere that catches the ELECTRON.

TIME

Before the electron hits the wall and is observed, the electron is a wave.

ObSERVER Sighting the ELECTRON.

ELECTRON spot →

ELECTRON SOURCE

After the electron hits the wall and is observed, the electron is a particle.

Einstein's thought experiment.

According to this second viewpoint, we are not ignorant of **anything, and quantum mechanics is complete in its description of individual events. The particle is a wave moving towards the screen.** Thus, Einstein objected, the particle is potentially

present at every point on the screen, with nearly equal probability of appearing anywhere thereon. However, at some point, it becomes localized and appears suddenly to pop up at a single isolated point. "It seems to me," Einstein continued,

> that this difficulty cannot be overcome unless the description of the process in terms of Schroedinger's wave is supplemented by some detailed specification of the localization of the particle. . . . [The second viewpoint] contradicts the postulate of relativity.[4]

It was the collapse of the wave that most disturbed Einstein. He imagined the wave impinging on the screen like surf on a beach. According to the second viewpoint, a peculiar action-at-a-distance takes place, which prevents the wave from hitting the beach at two or more points at the same time. As a result, the whole wave collapses like a genie into a bottle and beaches itself at one point on the shoreline. Consequently, Einstein favored the first viewpoint.

The difference between the two viewpoints was the key fulcrum upon which hung the delicate balance of reality. Though it might not have experimental consequences, still it would have far-reaching effects. The first view suggests unidentified, mechanical, controlling factors called *hidden variables*. The second view denies that anything further can be said. It denies the very need for such factors.

These two views, although couched in the modern terminology of quantum mechanics, were nothing more than the ancient Greek views of continuity and wholeness versus discontinuity and wholeness. The continuists state that the whole is its sum of parts and that any apparent discontinuities can be explained by a continual movement, a smooth mathematical transition from one point to the next. On this, Einstein and Aristotle agreed. Their point of view reaffirms causality, continuity, and a deterministic universe.

The second viewpoint, which Bohr presented and Zeno would have accepted, denies these things. There is no need to explain the collapse of the wave. The wave is not the ultimate reality. The particle is not the ultimate reality. Reality is not the ultimate reality. There is, instead, one unbroken wholeness that appears paradoxical as soon as we observers attempt to analyze it. We can't help but disrupt the universe in our efforts to take things apart. To Bohr, there was no wave to collapse unless the wave was observed, and then no collapse would be seen. He viewed analysis as observation, and observation was fundamentally a discontinuous event. It could not be connected to any past

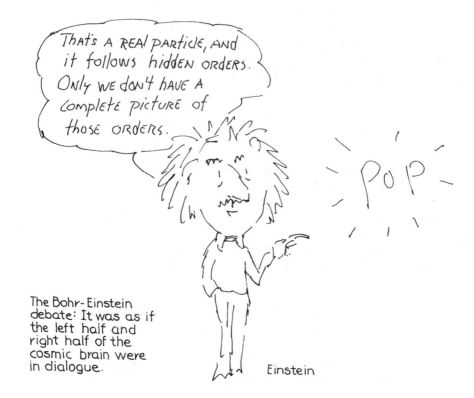

That's A REAL PARTICLE, AND it follows hidden ORDERS. Only we don't have A complete picture of those ORDERS.

POP

The Bohr-Einstein debate: It was as if the left half and right half of the cosmic brain were in dialogue.

Einstein

occurrence. The connection with the past was not a reality.

Although Bohr's position was obscure and difficult to pin down, it provided the groundwork for what is today called the *Copenhagen interpretation of quantum mechanics*. This interpretation is the officially accepted understanding, and it presents a reality that is stranger than we can imagine it to be. Our brains are filled with memories, with a desire for security. Therefore, we have a natural, built-in desire for continuity in all things. But all of this is denied to us by the Principle of Uncertainty. All physical processes are impossible to envision. All physical processes are incompatible with the properties of mechanical models.

This does not mean that we should throw away all of our machines. Just the opposite is true. Our mechanical models work beautifully for large objects because of the smallness of Planck's constant. God's gift is a tiny h. But we must remember that we are the artists in the game of the universe. If h were any larger, the ultimate chaos would overwhelm us. With such a small unit of action, we have just the right amount of freedom to create

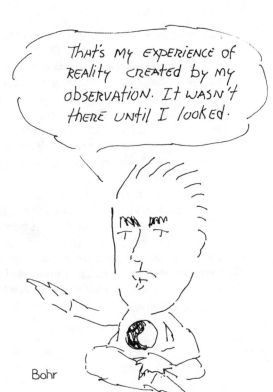

Bohr

nearly whatever we want. Just exactly what our limits are is a subject that is still being explored.

Things are only an approximate description of reality. The limits of our description are discovered in the Heisenberg uncertainty principle. Bohr called his philosophy the Principle of Complementarity. The wave-particle duality and the pictures associated with this duality, such as the collapse of the wave and the jumping of the particle, were a result of the fundamental clash between two contrasting mental constructs of the appearance of reality.

Bohr's complementarity views need much room for airing. They are presented in chapter eight. Einstein did not give in to these views. Instead, he adhered to the idea of an orderly universe. God did not play dice, he asserted, and in his later years, Einstein provided the devil's advocacy against Bohr's fundamentally discontinuist view.

Bohr's views offered a new vision of the world. And he carried his ideas of complementarity over into the life sciences. He felt that there was no real contradiction between the

humanistic sciences and the natural sciences. The apparent conflict was nothing more than a complex form of the wave-particle duality. In anthropology, for example, there are two modes of behavior: that based upon instinct and that based upon reason. Instinct could be viewed as a sudden discontinuity having no history. Reason, on the other hand, was a process founded upon logic and continuity. In the study of primitive cultures, the observer must be aware of the disturbances he brings into those cultures if he is to extract the "reasons" for those cultures.

In the remaining chapters, we shall further contrast the Bohr and Einstein views. The resistance that each view offered the other resulted in a great deal of new thinking. Scientists would construct exciting parallels between many avenues of life that were previously thought of as very different. However, the debate between Bohr and Einstein has still not ended, though both are now dead. Indeed, the battle of continuity versus discontinuity may never end.

Is There an "Out There" Out There?

Complements of the Cosmic House

Do I contradict myself?
Very well then
I contradict myself,
I am large, I contain
multitudes.

WALT WHITMAN

The Act of Creation: Observation

What do we mean when we speak of "reality"? We usually mean the world that we sense. That world out there is made up of things that we can see, hear, taste, smell, and touch—real, solid, substantial objects of our everyday existence. We take it for granted that these things would exist in their same sensible form even if we were not there to observe them. Our observations simply verify an already existing reality.

Yet, that isn't what quantum mechanics seems to be telling us. It appears to indicate a drastic departure from what we could call our classical mechanical heritage. Certainly this is the position of what later came to be known as the Copenhagen School or the Bohr Principle of Complementarity. According to the tenets of the complementarity principle, there is no reality until that reality is perceived. Our perceptions of reality will, consequently, appear somewhat contradictory, dualistic, and paradoxical. The instantaneous experience of the reality of Now will not appear paradoxical at all. It is only when we observers attempt to construct a history of our perceptions that reality seems paradoxical.

The first new physicists gather after Bohr announces the Principle of Complementarity (como, 1927).

Enrico
Fermi

Werner
Heisenberg

Wolfgang
Pauli

The reason for this paradoxical appearance of reality—at least, atomic reality as observed by physicists—is that no clear dividing line exists between ourselves and the reality we observe to exist outside of ourselves. Instead, reality depends upon our choices of what and how we choose to observe. These choices, in turn, depend upon our minds or, more specifically, the content of our thoughts. And our thoughts, in turn, depend upon our expectations, our desire for continuity.

Both the wave and particle descriptions of nature are remnants of our desire for continuity. They represent our best attempts to understand physical reality in terms of pictures, mechanical constructs of thought based upon continuity. When we observe anything on an atomic scale, we disrupt that continuity. This disruption has two consequences: (1) it creates a picture of atomic matter in our minds, and (2) it indicates, at the same time, the incompleteness of that picture. The incompleteness of that picture is the result of our thoughts, our failure in our attempts to maintain that picture throughout time.

These concerns regarding observation I call the *construction of reality by mental acts*. These are the acts of creation. Now, much of what we observe is *not* at all disturbed or affected by observation. The effects of observation upon elephants and baseballs appear quite negligible when these massive objects are seen with ordinary light. Here the uncertainty principle plays a very small role. Both position and momentum are simultaneously observable to all practical considerations. But we should not automatically assume that our observations have no role in the universe when we are examining electrons. Furthermore, since electrons are within us as well as outside of us, it is at least conceivable that our observations of ourselves play a significant role in our own human behavior.

All of the following examples and analogies concern a world of observation that is unfamiliar to most of us. Thus I have chosen to use ordinary, familiar objects in these examples. But the reader must remember that the thoughts and conclusions regarding the behavior of these objects are presented with the quantum mechanical perspective well in view. Ordinary objects fall within the safe boundaries of Bohr's correspondence principle; classical mechanical thinking is perfectly adequate in describing the motion of such objects.

Yet if we choose to regard everything we see and do within the framework of the new physics, then we can say that, to some extent, reality construction is what we do every instant of our conscious lives. We accomplish this construction by choosing

among the many alternatives incessantly offered to our minds. Thus, at the quantum level of reality, when we choose to "see" what we see, reality becomes both paradoxical and sensible at the same time. Our acts of observation are what we experience as the everyday world.

This way of thinking about the world is new to the Western mind. It arose when physicists discovered that their acts of observing the atomic world introduced a duality, a double or paradoxical way of seeing. We shall examine just how it is that the act of observing the world can, at the same time, introduce and resolve this paradox. And we will begin our examination by looking at an analogy that I call "The Paradoxical Cube." This well-known analogy was already familiar to the artists Victor Vaserely and Maurits Escher.

Next we will examine physicists' minds as I perform a "thought experiment" that sheds light on the duality of reality. The experiment, entitled "Complements of the Cosmic House," shows us that all matter behaves in two complementary, contradictory ways: it appears to be particulate and well localized in space, and it appears to be undulatory or wavelike and not well localized in space. How matter appears depends on our minds' choices; reality is a "matter" of choice.

Three acts of observation : A particle is born, reborn, and reborn again.

Having come to realize that the reality we experience is one that we choose from dualistic or complementary "sets," we shall next look at the way we are victimized by our choices. We will examine our victimization in the analogy of "The Magician's Choice." This analogy will show us another side of the paradox: that no matter what we choose, the choice will appear to have been already made. In other words, it will seem to us that we never really had a choice.

Then we will reexamine our physicists' minds as we take another look at a "thought experiment." We will see how it is that the atomic world appears to have been chosen ahead of us, even as we come to realize that we are its choosers. I call this "The Case of the Vanishing Observer."

We shall take another look at the seemingly magical process of reality construction by choice as we examine the analogy of "Newcomb's Paradox." We will offer, perhaps for the first time, a quantum resolution to this amusing paradox of an omnipotent "being" versus objective reality. That resolution, according to Bohr's complementarity principle, is that reality does not exist until it is chosen.

All of the above examples should help us to understand how the universe can appear to be both fundamentally paradoxical, chaotic, and indeterminate and, at the same time, logical, orderly, and quite determinate.

The Paradoxical Cube

Physicists have discovered that our universe follows the laws of quantum physics. According to these laws, the physical universe is fundamentally paradoxical. Our universe seems to be composed of facts and their opposites at the same time.

Yet we don't seem to observe these paradoxes. Why not? Because when we observe something, we see either the fact or its opposite, but not both at once. Without our acts of observation, the universe proceeds on its merry, magical, paradoxical way with facts and counterfacts intermingling. This intermingling is necessary; without it, no "real" world would ever be possible. The observer in his role behaves as Alexander did when confronted with the Gordian knot: he simply chooses to cut it, rather than remain stymied by its ever-present, challenging convolutions.

How does an "act of observation" take place? Examine the illustration of the paradoxical cube. Which side is facing you?

The Paradoxical Cube.

At first, you may see the upper-most square in front, as if you were looking up at the cube. But if you take a second glance, you may find that you are suddenly looking down at the cube, and the bottom-most square appears to pop out closest to you. As the observer, you have the choice of how you will view the cube. It is your act of observation that resolves the paradox. According to quantum physics, all paradoxes dealing with the physical universe are resolved in a similar manner by observation.

But there is yet another way to view reality. Look at the illustration again. That the illustration appears to be a cube is an illusion. In fact, it is eight points and twelve connecting lines forming an abstract pattern. When you see this abstraction as a cube, you are forced to make a choice: which face is in the front and which face is in the rear? When you view the illustration as an abstract form, however, no choice between these alternatives is even possible.

In its abstract form, both the upper and lower squares of the illustration are, so to speak, in front at the same time or in the rear at the same time. But in viewing the illustration as a cube, you the observer create the experience of this two-dimensional form having front and rear faces. Your act of observation creates the picture in your mind that "it" is a "cube." Seeing the "cube" as an abstract pattern of eight points connected by twelve lines is a complement to seeing "it" as a cube with a front face and a rear face. It is only a paradoxical cube when we, observers conditioned to think that everything we see must be solid, insist that "it" is a solid cube. Then the cube appears to "jump" from one perspective view to another, seemingly playing tricks on us.

Two artists, Maurits Escher and Victor Vaserely, use our preconditioning to confront us with similarly paradoxical views of reality. In the detail of the Escher print that follows, we notice a man seated on a bench. Lying on the checkered patterned floor in front of him is a somewhat crumpled drawing of our paradoxical cube. But look at the "cube" held by the man. Specifically, look at the struts the man holds in his hands. Their paradoxical positions in space are as confounding to his mind as material reality is to the mind of the quantum physicist.

Though the paradoxical cube is only an analogy of the abstract world of quantum physics, it demonstrates that there is a duplicity or duality to our acts of observation. Through quantum physics, physicists have discovered that the world, like the paradoxical cube, is also capable of being realized in complementary ways. This realization is known to physicists as the *Principle of Complementarity*. Complementarity refers to a duality, like red versus green. The complementarity principle reminds us that while we are observing the redness of something, its greenness is invisible, and vice versa. Anything that is red and green at the same time would be gray, for example.

Similarly, the physical universe has a complementary nature. It is known as the *wave-particle duality*. In the next section, we will watch the mind of a physicist as he performs a "thought experiment." Thought experiments are imagined experiences in

A detail from "Belvedere" by Maurits Escher.

which the outcome is already known. They are usually performed
ahead of any real experiment. In the following "experiment,"
the physicist will confront complementarity.

Wave-Particle Duality and the
Principle of Complementarity

Physicists have discovered that our physical universe, or
"cosmic house," appears like the paradoxical cube: there are two
different ways of observing it. We can view the universe in terms
of particles, or we can view it as made up of waves. These two
ways of seeing are complementary to each other; that is, we

"MEH" by V. Vaserely shows a blending of paradoxical and
complementary visual realities.

Courtesy Sidney Janis Gallery, New York.

cannot see the universe both ways at the same time. I call these ways, "Complements of the Cosmic House."

Faced with this wave-particle duality, some physicists tend to disbelieve the particlelike behavior of the physical world and opt for its wavelike aspect as a better description. Not all physicists think this way; the particlelike solidarity of our experiences paints a convincing picture. But adhering to this "solid" evidence that the world is composed of solid material "stuff" leads to a paradox much like that presented by our example of the "cube."

What do we mean when we speak of "the particle nature of physical reality"? Stop for a moment and pick up any nearby object. Hold it in your hand. For example, I have just reached for a pencil. My appreciation of its solidity comes when I hold it between my fingers. It gives me a secure feeling to know the pencil is there. This object is not elusive. It can be relied upon to be what it is: a pencil. After a while, I become bored with its solidity. So I play with it. Perhaps I break it into two pieces to see what it is made of. My gut feeling is that it is composed of more "stuff." I want to see its inner stuff. My desire is to seek greater security, greater solidarity, more reliability, and greater certainty. I seek the ultimate "stuff" of the universal pencil. So I go on destroying the pencil, but seeking greater security, looking for the fundamental building blocks that make up "pencilness." My fingers, however, are too clumsy to hold any of the small stuff I may find. I must also refine my measuring instrument; I must have pincers more delicate than my fingers. The problem is that my new pincers, when I find them, are made of stuff that is similar to the stuff I am examining.

Nevertheless, I continue my examination of the pencil. I put it into an oven, reducing it to atoms of pencil. By using heat, I free the pencil atoms from each other so I can get a better look at them. Then I allow these pencil atoms to come out of the oven "on their own steam," through a very small aperture in the oven. Instead of pincers, I decide to use a black screen with a very small hole in it. Atoms come boiling out of the oven, and most of them impinge on this screen. But every once in a while, one atom goes through the hole. And I am waiting with another collecting screen to catch it. My catching screen is covered with a thin layer of atomically sensitive emulsion, like the inside of a television picture screen. Whenever an atom strikes the screen, it leaves a small spot. The spot tells me that the atom is really there.

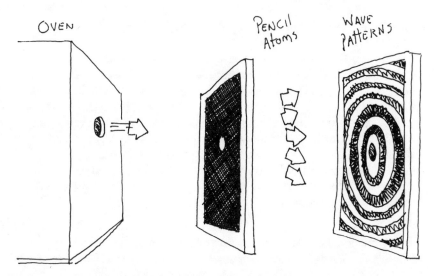

An oven producing individual pencil atoms, which pass through a black screen and form a ring interference pattern on the white screen.

But something odd is happening. Even though I have aligned the hole in the black screen with the aperture in the oven, I find that the atom doesn't continue to travel along that line after it passes through the black screen's hole. Naturally, I think that the hole is probably much too large. The atom is so much smaller in diameter that it can pass anywhere through the hole and thus end up anywhere on my catching screen. So I make the hole smaller. That way only those atoms that move along the straight line between the oven aperture and the black screen hole will pass through the hole and continue along that same straight line until they hit the second screen.

But instead of correcting the problem, I have made it worse. The deviations increase as I decrease the diameter of the black screen's hole. The atoms that pass through the hole are making marks on the second screen that are further off the straight-line path than before. The more I try to pinch the atom in the caliper-like hole of the black screen, the more slippery the atom becomes.

The universe is telling me something, I surmise. Absent-mindedly, I leave the oven on as I ponder the message of the universe. While I am pondering, atoms continue to boil out of the oven, passing through the oven's aperture, traveling on their way to the first screen, where they pass through the hole and are caught by the next screen. Millions of atoms are making the trip

from oven to the second screen after passing through the first screen's hole.

Suddenly I remember I left the oven on. I quickly return to my experiment and shut the oven off. Almost as an after-thought, I look at the second screen, the one that collected all those millions of atoms. I nearly fall off my chair when I see the pattern made by those atoms, all those independent particles of pencil stuff, on the second screen. Instead of a small, blurred spot, an image of the hole in the first screen, I find a beautiful set of concentric, circular halos. Rings of ever-increasing size, each centered about the line that joins the oven's aperture with the first screen's hole, greet my eye.

Two of the earliest electron wave interference pattern photographs (1927).

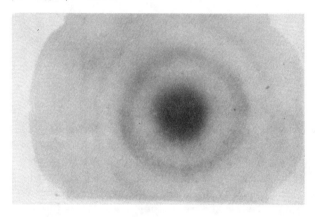

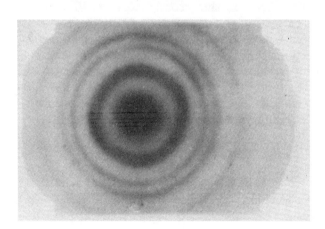

There is no way that such a pattern could have been produced by independent particles acting individually, I conclude. There must have been a conspiracy among the atoms. I test my hypothesis. I turn the oven back on and watch the pattern develop again. The individual atomic spots appear on the screen, one after the other. Each spot occurs at random. Yet somehow they seem to know just where to go to make the ring pattern. Why don't any of the atoms make spots in between the rings, blurring the ring pattern into indistinction? Somehow they don't do that.

My mind remembers that I have seen these patterns before, as a child. On hot summer days in Chicago, just after a sudden storm, I would sit and lazily drop small pebbles in the puddles left by the rain in the deep pock marks made by bulldozers resting in the empty lot behind my home. Each pebble dropped into the miniature pond would make ever-widening, circular patterns of ripples. Sometimes I would drop two pebbles at once and be surprised at the result. The two separate sets of ripples did not keep their separate identities. Instead, they interfered with each other and produced a new pattern unlike either one of them.

Somehow the pencil atoms must make waves, I decide. Each atom must be magically transformed, like the toad changed into a prince, from a solid little particle into a wave spread over space. That would explain the ring pattern on the second screen. It was produced by the interfering wave fronts.

At this point it is worth mentioning that these wave patterns are not observable unless one is looking for them. That is because each individual atom leaves just one small spot on the screen. It is the overall pattern of all the atomic spots that tells us something else is going on. These "wave" patterns are complementary pictures to the individual "particle" spots.

Look at the illustration of the paradoxical "cube" again. Each individual "hit" you get when you see the cube as a solid is like the observation of an individual atomic spot. After several "hits" of the cube, you see it as a pattern. In its abstract pattern form, what had appeared to be the sides of the cube are no longer distinguishable as "sides." Only the overall "wave" pattern is seen. In the same way, the "wave" ring pattern of atomic "hits" is seen.

Of course, there are many other examples in common usage that illustrate complementarity. Take the saying, "I can't see the forest for the trees." An individual's rights versus the rights of the state also illustrate complementarity. The important feature

Wave interference patterns.

for us is that the overall pattern is *not* random; it shows
organization—that is, an interference pattern impossible to
produce if the agent producing it is a random stream of separated
hot particles. Yet the particles *are* separate. Matter simply does
not behave in accordance with our ordinary ideas about it.

This wave-particle duality appears in all matter, including
light. There are no exceptions. Bohr, I am sure, would concur
that we, too, are part of the duality of nature. For nature is
dualistic; she behaves according to the Principle of Comple-
mentarity. Here's how a physicist might state it: The most
general physical properties of any system must be expressed in
terms of the complementary sets of that system. These sets are
joined as complements of each other, and the more we determine
or define a system in terms of the one of these complements,
the less we know about the other.[1]

The discovery of the Principle of Complementarity marked
a change in our thinking. It taught us that our everyday senses
were not to be trusted to give a total view of reality. There was
always a hidden, complementary side to everything we
experienced.

But this hidden side is not actually present. For example, in
the case of a coin that lands heads up, the hidden and comple-
mentary side is not real until it is revealed. Our actions in the
world are always a compromise between two such opposites.
The more we determine one side of reality, the less the other
side is shown to us. In everyday objects, this compromise is a
small price to pay. In atomic-sized objects, the compromise
exacts a dear toll. When we attempted to determine the exact
location of a pencil atom by using the hole in the screen,
we gave up all hope of determining the direction of that atom's
movement in the future. We could not determine its momentum
at the same time that we determined its position.

By reducing the size of the hole in our first screen,
we cause the interference pattern to spread out even more
across our second, receiving screen. The smaller we make the
hole, the more the pattern spreads. If we interpret this experience
in terms of atomic particles, we are faced with the indeterminate
measure of the momentum of each particle. If we interpret this
experience in terms of the wave, we are looking at "wave
bending" or diffraction produced by the narrow aperture offered
to the atom waves as they passed through it. Eventually, the
pattern becomes so spread out that we cannot be sure of what we
are observing.

As we widen the hole again, the location of each atom

passing through it becomes more uncertain. But the compromise pays off. We observe the interference pattern "tightening up." The pattern squeezes down; the concentric rings move closer and tighter together. The wider we make the aperture, the tighter the rings become. Now we are able to determine the wavelength of the atoms as they pass through. From de Broglie's formula, we know the momentum p and the wavelength L are related: $p = h/L$. Thus, as we determine the wavelength of the atoms as they pass through, we are also determining their momenta.

Further widening of the hole results in a complete loss of all information regarding the location of the atom as it passes through the hole. We simply can no longer determine where the atom passed within the hole. But our compromise is balanced by our observation of the pattern on the screen. The wave interference patterns have grown so tight that the separations between concentric rings have vanished. Instead, we have a sharp shadow line image of the wide hole appearing on the screen. Each atom passes through in a straight line. The momentum of each atom is well determined. By changing the size of the hole in the intermediate screen, we have altered the reality of the atom. The atom had no position going through until we measured its position. The atom had no momentum going through until we measured the momentum. What we determine depends on the size of the aperture.

Is the momentum hidden when we measure the atom's position? Is the atom's location hidden when we measure the momentum? Not in any ordinary sense of the meaning. Both of these attributes, momentum and position, are *potentially* present in nature, but not *actually* present, until an attempt is made to measure these attributes. How we choose to compromise will determine whether the wavelength (momentum) side of reality or the particle (location) side of reality is manifested. And with an intermediate-sized hole, we have a little of both sides.

In a sense, we never actually lose information. Rather, we shape it. That is, we alter potential reality, making it actual. What is hidden in our acts of observation is still potentially present. Thus, while the momentum seemed hidden, it had to be potentially present in order to make the interference pattern. For the pattern could only be produced by wave interference, not by particles colliding with each other. So even though wave knowledge was lost in the experiment, something of that knowledge was retained. It was retained in an entirely complementary picture, the picture of a wave through the de Broglie relation, $p = h/L$.

Heisenberg discussed this potential reality in connection with his Principle of Indeterminism. He called it a *third* or *intermediate reality*. He wrote:

> The concept that events are not determined in a peremptory manner, but that the possibility or "tendency" for an event to take place has a kind of reality—a certain intermediate layer of reality, halfway between the massive reality of matter and the intellectual reality of the idea or the image—this concept plays a decisive role in Aristotle's philosophy. In modern quantum theory this concept takes on a new form; it is formulated . . . as probability and subjected to . . . laws of nature.[2]

This potential reality is available for our choosing. The experiences we call "reality" depend upon how we go about making those choices. Every act we perform is a choice, even if we are unaware that we have made a choice. Our unawareness of choice at the level of electrons and atoms gives us the illusion of a mechanical reality. In this way, we appear to be mere victims subject to the whims of a "higher being." We appear as victims ruled by a destiny we did not determine.

The Magician's Choice

In a world where destiny rules, no choice is possible. A human being, like every other thing, living or dead, must follow along a well-trodden, predetermined path. There is no room for willful action. You may feel your past actions were freely chosen, but with a flash of hindsight, you probably see that you really wouldn't have made any other choices. On the other hand, perhaps you look back at your past and wish you had made other choices. Look again. You will undoubtedly find some little reason, some plausibility, that convinced you, at the time, that you were making the correct choice. In other words, you behaved reasonably and logically.

Many people believe in predeterminism or destiny. When an unforeseen situation arises, these people are likely to say, "See, I told you so," or "It's karma," or, as I heard one afternoon in a Parisian café, "Laugh too much at noon, cry too much at evening." On the other hand, there are probably just as many people who feel that they are in complete control of everything. To a child just beaten up by the neighborhood bully, they might say, "It was your own fault. What did you do to provoke it?"

Which view of the world is right? Fortunately, both views are wrong and right at the same time. We are, at once, the creators of our reality and the victims of our creation—as we shall see in the next example.

During the mid-sixties, in addition to my regular work as a theoretical physicist, I performed professionally as a close-up magician. And I was often struck by the fact that, like quantum physics, all good magic is paradoxical. For example, a girl is sawed in half and yet she is not. A man in the rear of the room instantly appears in front of the room. A card that is shown to be an ace is shown again to be a king.

One of the many secrets of magic I used regularly was called "The Magician's Choice."[3] A spectator was asked to choose from among several objects—cards, coins, etc. The spectator believed that he had a free choice, and so he was usually amazed when I was apparently able to see into the future, predicting his choice even before he had made it. His degree of amazement, I suppose, depended upon his underlying belief structure— whether he believed he had free will or whether he believed his choices in life were predestined. I'll tell you now, to break the suspense, I never really knew what object the spectator was going to choose. But I had prepared, in advance, a prediction for each possible choice I offered to the spectator. In other words, I had all possibilities covered. In much the same way, our universe is so prepared.

For a moment, think of God as a performing close-up magician. Like spectators willing to be fooled and yet seeking solutions to his or her prestidigitations, we are an ever-ready audience, eagerly awaiting the next trick. Sometimes we think we can catch the Great Magician in the act. But the magician called God has all possibilities covered and has hidden a special "catch-22" that prevents us from seeing the revealed secret. In the following scenario, you will be able to choose reality; at the same time, you will discover you really have no choice at all.

Imagine yourself sitting at a table in the living room of a famous close-up magician. The magician enters the room and adjusts his cape as he seats himself before you. He has a small bag with him. He reaches into his bag and places a placemat of green felt, stiffened by backing, on the table. He again reaches into his bag and brings out a large manila envelope, which he places on top of the placemat. He opens the envelope and pulls out three large cards labeled A, B, and C, respectively. He lays them in a horizontal row before you.

He says, "Here are three cards. You may choose one of them—card A, card B, or card C. Whatever choice you make has already been predicted by me and written down. I do not wish to influence you in any way—you are perfectly free to choose card A, card B, or card C. I already know your choice and I will demonstrate that fact by showing you written proof after you have made your choice. Now choose."

Suspiciously you try to anticipate what he thinks you will think. You might think that most people would choose card B because it's in the middle. Your thoughts might run as follows: "I'll outguess him and choose card A, which is lying to the left of card B. He could never know anyway—so really, what difference does it make? I'll choose A." You announce your choice: "I have chosen card A."

"Aha," the magician says, "I knew it! Open the envelope in front of you." He slides the envelope, the one from which he produced the first three cards, toward you. You look in the envelope and find a fourth card. One side of the card is blank. On the other side, written in the magician's big, bold hand-writing, are these words: "You have chosen card A." In disbelief, you examine the envelope again. It is empty.

Your mind races. "How did he do it?" you wonder. "Did he guess? Was it luck?" You look up at the magician's face. His cool, confident attitude tells you that it wasn't luck. He is very certain, and furthermore, you have heard from others who have witnessed the trick before that he never makes a mistake. Yet he seems human enough. It must be a trick.

At this point, a person's mind usually begins to sift through the memory of the past experience, attempting to eliminate superfluous thoughts from the essential ones in order to find a cause-effect relationship that resolves the paradox. For example, you might think, "Somehow I was *forced* to choose card A. It must have been a subtle force of choice. I did not have free will, although it appeared that I did."

Not satisfied with this, you might seek further explanation for the forced choice. "Maybe I was hypnotized. Of course, then I would not have had free will." Having resolved the paradox with this solution, you might next seek an alternative cause-effect relationship.

Your thoughts might be, "Maybe I don't have enough data. Let's see the trick again. Perhaps there are hidden variables that are beyond *my* control but are in the hands of this clever magician. If I see it again, the whole trick will reveal itself to

me." Once again, your mind seeks to resolve the paradox by establishing a cause-effect experience. The cause, in this case, would be hidden variables and the effect would be your choice of card A.

You look up at the magician and say, "Let's see that again. Do it once more, will you?" "Yes," he replies, "but there is a catch." "What's the catch?" you ask. "The catch is that you must forget that you ever saw this trick before!" "But that's no good," you plead, "for if I can't remember what you just showed me, how will I learn how the trick is done?" And there is the rub.

If, for the moment, you could rewitness the trick without the added catch, you would indeed see the answer, which is that the magician has hidden predictions for each choice. If you had chosen card B instead of card A, he would have asked you to look under the placemat on the table and there you would have found another card attached to the underside of the placemat upon which is written in the recognizable magician's hand-writing: "You have chosen card B." And a similar revelation would have been produced had you chosen card C. He may have simply asked you to read what he had written on the bottom of your chair or some other conspicuous place in the room: "You have chosen card C."

But the magician insists on his catch-22. So reluctantly you must go along with it. You somehow manage to forget that you have seen this trick before. He shows it again. This time you choose card B. He asks you to look under the placemat on the table. You are amazed to read the words you find written on the underside of the placemat: "You have chosen card B." However, even though you forgot that you saw this trick before, you feel a little uneasy about it. You would like to catch the magician at his game.

This trick shows us that although we spectators seemed to have no choice at all, we had free will. Yet whatever choice we made, we would have found that it had been predicted in advance. To quantum physicists investigating atomic phenomena, the universe appears much like this example of "The Magician's Choice," specifically including the trickster's catch-22 condition. When physicists make any set of observations, they find that they cannot predict the outcome of their choices and yet these choices appear to be related in a cause-effect or predetermined manner. For example, suppose they wish to determine the location of a moving atomic particle. From its past history, which they may have observed as a track on a film, they may suppose that its future is predetermined. But

if they set their detecting apparatus along the predetermined
path, they will inevitably be surprised. For their last observation
of the particle had so altered the particle's movement that its
next position along the track became only probable. Like the
spectator in "The Magician's Choice," physicists find that each
time they observe the particle and choose to base its future
position on its past position they are fooled.

In other words, we never discover God's hidden secret.
Our request to see the trick again is like the physicists' continual,
experimental study of nature. Each time the physicists ask, God
answers. But the physicists are not satisfied with the answer.
They are plainly disturbed with God's magic show. And they
have every right to be disturbed, because they insist on a reason
for such capricious behavior. After all, when they looked at the
past record of the atomic particle, its path appeared predictable.
Their minds, like your own, race with thoughts of hidden,
controlling factors. "What did we do wrong?" the physicists cry.
But in exasperation, they are forced to give up. Their feelings
border on despair. The more they search for the controlling
factors, the more the factors elude them. Finally, they resign
themselves—they cannot manipulate the universe; they cannot
control the universe; they are just victims of the universe.

The role of victims is one that we all can identify with.
Victims are not responsible for what happens to them. Those
"other guys" did it to them. Victims are not in control of what
happens to their lives. However, if we look closely enough at the
circumstances, a pattern of the victims' past events often
emerges. We see that the victims, perhaps unwittingly, carefully
"made their own beds," so they must lie on them.

Yet victims themselves usually appear to be unconscious
of their actions. With hindsight, they lament their past choices:
"If only we could have seen then what we see now." Perhaps that
lament is familiar to you. It certainly is familiar to me. But
that is just the point. We never could have seen then what we see
now. Our past actions, like the atomic particle's track or the
magician's trick, only seem predictable when we look back
upon them.

Why can't we see ahead? Why does the world appear
predictable when seen through hindsight? The answer to both
questions is: we never can see ourselves as we are now. How often
have you wondered why your best friends do such seemingly
stupid things? It is amazingly easy to see the other fellow's
plight. All of us are quite good at being "Dear Abby" and giving
advice to the lovelorn, our friends, even statesmen, umpires, and

presidents. We all know what's wrong with the country, why our favorite athlete is in a slump, and how to save the world. We all see the other fellow very well.

Yet when it comes to seeing ourselves, we are remarkably invisible. We haven't learned to see ourselves as others see us or as we see others. Whenever we observe, our part in that observation is seemingly minimized. Or, depending on our ego state, the opposite happens and our part in the process becomes blown out of proportion. While engaged in the act of observing, "we" separate from that which we observe. In that very act of observation, the objective, "real" world appears and the subjective observer vanishes. We know not how to observe ourselves. In the next example, "The Case of the Vanishing Observer," we shall look at how we observe the world, as we continue our inquiry into the nature of "reality."

The Case of the Vanishing Observer

Quantum physics has taught us that we, the observers of reality, are, at the same time, the participants of reality. In other words, "observation" is not a passive noun; "to observe" is not a passive verb. However, our classical, Western upbringing has preconditioned us to think objectively; to see the world as preexistent.

In a pre-existent world-game, there is no room for players. Like a computer machine, which goes on endlessly doing its thing and following preset rules, all the game can do is continue. And all we can do is watch, never touching the dials. We are simply passive, nearly nonexistent observers of that prechosen world-game.

Objectivity takes its toll; the cost is your awareness of your awareness. But objectivity is only an illusion. Consider the paradoxical cube. You chose sides and the cube appeared, but you lost your awareness of your choosing it. In other words, when the cube appeared, you vanished. At the instant the cube appeared, you projected the cube's appearance out of your mind. It was an act of sudden creation: "That is a cube!" That action of choice separated you from "it." Your picture of the cube in your mind became the real cube out there. All of this happened very, very quickly—the instant you "saw" the pattern as a cube. And probably just as quickly, you saw it as an abstract pattern again—or you thought of something else. Your mind was not

entirely fooled. But, if for only an instant, you created the cube "out there" as a solid, three-dimensional object.

Yet suppose you never could see the cube in its complementary guise as an abstract, two-dimensional array of points and lines. Suppose you were preconditioned to see it as a solid form, always and forever. I believe that our view of the world is analogous to such a preconditioned view of the cube. Seen through preconditioned eyes, the cube continues to jump from one "state" to another without continuously passing through any in-between positions. The more you see it as solid, the less you take any responsibility for its peregrinations. It jumps whenever it cares to jump, seemingly at random. After awhile, you might try to make sense of its jumpings, seek its hidden mechanism, and thereby continue to make the "matter" worse—for you are no longer there. You have become a passive point of observation.

To understand this phenomenon, carry it another step. Look at your hand. Feel your thumb. Each time you sense your thumb's presence, you objectify your experience. Your thumb is a thing, a part of your body. You feel your thumb "out there." Your thumb is not you, is it? Think about other parts of your body. Each thought brings a sensation to that part. And each sensation makes you vanish. You are not your sensation, are you? Each observation takes you away from the parts of your body and brings you into yourself more and more, until you vanish.

But you *are* there. All you see, hear, smell, touch and taste is subjected to your mind's pictures of all that you imagine you see, hear, smell, touch or taste. Reality is constructed from your thoughts of reality.

Let us look, once again, at the reality of the atomic physicists as they perform their thought experiment to catch pencil atoms. They see the pencil as atomic particles, tiny points of substance, like little ball bearings or itsy-bitsy baseballs. Reality is to them, and probably to most of us, solid. But the little baseballs do not behave like little baseballs—they diffract or bend and spread out like waves, producing wave patterns when collected together and individual marks when seen separately. If the physicists take the separated view as reality and the collected-together view as a "yet-to-be-explained part" of reality, they become victims of their own preconditioned thoughts: reality is particles of matter, and these particles behave in an unpredictable manner, seeming to jump around without regard to the path they apparently were following in the past, much like human beings.

Is there another view for the physicists—indeed, for us

all? I believe there is. We need to see the complementary side. We need to see our role in all of this. But this is not an easy task. It is difficult to give up our preconditioning. We are actively choosing the reality of the world each instant, and during that same instant, we are unaware that we are doing it. But our becoming aware of this simple truth can enable us to see the world's complementary side. And once we see this complementary side of reality, our old prejudices, like the sides of the "cube," will crumble. The barriers that separate mind and matter will dissolve. God and human will reconcile.

In the ancient Greek schools in Ionia and Elia, the essential essence of all things, called the "physis," from which our word "physics" is derived, led to the reconciliation of being with changing. The next example, "Newcomb's Paradox," will bring the ancient conflict of a divine being versus objective reality up to our present time. The new "physis" is, however, quantum "physics." We *are* necessary. We *are* needed. All we have to do is change our way of thinking.

Newcomb's Paradox

For those who have managed to accept the tenets of quantum physics, paradox is an old friend. Many theoretical physicists enjoy playing with and/or creating paradoxes that demonstrate how our prejudices get us into trouble. I don't really know if William Newcomb had that in mind when he created the following paradox. I do know that Dr. Newcomb is a good theoretical physicist.

I first met Bill Newcomb in 1961, when I chose to spend the summer of that year at the Lawrence Livermore Laboratory where he was working on the problem of Project Sherwood, the peaceful control of thermonuclear fusion. My doctoral thesis dealt with this subject; consequently, I spent many afternoons talking with Dr. Newcomb. Undoubtedly, during one of those afernoons, he must have presented me with this little problem.[4]

The solution to it, however, did not occur to me until 1977. It is this solution that I wish to share with you. It will provide perspective on how "quantum thinking" resolves the conflict between "free will" and "predeterminism." So let us return to the living room of our old friend, the magician. Only this time we will shrink him and ourselves down to atomic size.

Once again, he enters the room and seats himself before you. He speaks: "I am an enlightened Being able to witness the future, now. I have a gift for you. I shall make you very rich if you believe in my powers." He then places before you two small safe deposit boxes. The first is labeled "L" and the second is labeled "R." Again he speaks: "In box L, I have placed one thousand dollars; it is yours. In box R, I have placed either one million dollars (in large denominational bills, of course) or nothing. You have two choices. Either you choose box R alone or you choose both boxes." At first, you're surprised. You may have expected to have to choose between the boxes. But then you see that wouldn't really have made any sense. You wonder what the catch is. The magician says, "You must have faith in *me* to get the million bucks. Remember, I can see into the future. I already know what you are going to choose. If you choose box R, I will reward your choice, and you will find the one million dollars in the box. On the other hand, if you are greedy and choose both boxes, you will find box R empty. Your reward will be the contents of box L only."

He is very confident. Furthermore, as in the earlier trick, "The Magician's Choice," you have heard from others that he delivers only what he promises. Yet there he sits. He is not touching the boxes. Either the money is in there, or it's not, or . . . what?

Your thoughts may run, "This Being can really do what he says he can. He already knows what I'll do. If so, I have no free will. But how can he really know what I'll choose? Even I don't know my choice yet. If I have faith in him, I will choose box R and get the million. But since he isn't touching the boxes, whatever is done, is done. The money is already in that box or it isn't. So it doesn't matter—I'll choose both boxes and get one million *and* one thousand dollars. But he knows I'll think that, so he'll have seen ahead and not put the million in box R." On and on, your mind races with the paradox. Your only conclusion is that if you accept the Being at his word, you must choose R. Destiny rides again and you have no free will.

But you may think, "The Being is an ordinary being. Just folks like everyone else. He is playing a trick on me. Whether or not he has loaded box R, there is nothing more he can do. I'll choose both boxes. Then if I find box R full, I win one million and one thousand dollars. If box R is empty, it would have been so even if I had chosen R by itself, so I'll have lost nothing." Thus, if the Being is a being, we choose both. Free will is restored. What would you do?

The answer is choose box R if you want the million bucks. Your reward isn't caused by the Being's omnipotence or clairvoyance, however. It only appears that way to our Western, preconditioned minds. Since we are atomic size, the million dollars is in paradox-land, where it is in the box and not in the box at the same time. Your act of observation creates the choices—money there or money not there, according to whichever you choose. It is your act of observation that resolves the paradox. Choosing both boxes creates box R empty. Choosing box R creates it one million dollars fuller. Like the paradoxical cube's front and back sides, your choices create the alternative possibilities as realities.

"Belvedere" by Maurits Escher (see detail on page 132). Complements and paradox of the "Cosmic House."

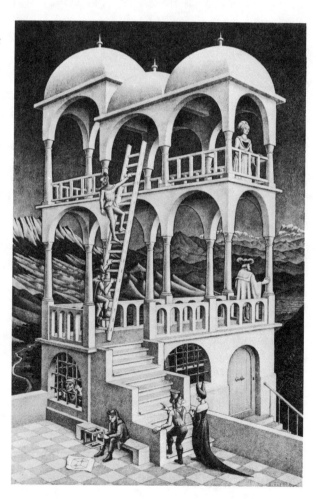

The Principle of Complementarity: A Recap

The quantum is tiny. The world we live in depends on the pictures of that world we paint in our minds. Because of the smallness of the quantum, these pictures seem quite consistent and continuous, logically connected to our pasts and a reasonable basis for our futures. From our classical heritage, two naturally occurring pictures of nature have emerged. These are the wave and particle descriptions of reality.

Physicists thus attempted to interpret all experience in terms of these pictures. Their attempts met with failure. This failure was due to the unforeseen and necessary disturbance created by the observer when he observed the atomic world. The world appeared paradoxical and discontinuous because we tried to use these pictures and ignored our own presences in the world.

Both of these schemes—our ignorance of our presence and the wave-particle picture—work successfully for mechanical everyday objects. The reason for their success with these objects is the smallness of the quantum. But it is finite and not zero. In other words, ultimately and fundamentally we affect the universe. Our presence can be felt drastically on the atomic level and hardly at all on the everyday, macroscopic level. In our attempts to leave ourselves outside of reality and our insistence on waves and particles as a description of reality, we are forced to regard the universe as paradoxical and dualistic, consisting of complementary attributes.

Although these ideas appear reasonable and were more or less accepted by most of the physical community, they contain a rather disturbing feature. Einstein was referring to this feature when he said, "God does not play dice with the universe." Somehow, in Einstein's mind, reality must be real. There must be an "out there" out there. The idea that whatever form reality takes is dependent upon the whim of the observer was repugnant to Einstein. Even more repugnant was the idea that the observer is powerless to control his fate.

In an effort to disprove the Bohr interpretation and reaffirm the continuity position, Albert Einstein and two of his associates presented a very careful and controversial paper in 1935. The subject of that paper was later to be called the *EPR paradox*. It said that quantum mechanics was not the last word on reality. However, it failed to suggest any solution for what might be added to or substituted for quantum mechanics. It also led to a new and unsuspected connection between all material objects.

The Case of the Missing Universe

Nothing is more important about quantum physics than this: it has destroyed the concept of the world as "sitting out there." The universe will never afterwards be the same.

JOHN A. WHEELER

The Devil's Advocate

Einstein had been defeated by Bohr's attempts to show that a continuous mechanical picture of physical reality could not be true because of the Heisenberg uncertainty principle. This principle simply refused to give equal status to the position and the momentum of any object in the universe. Yet Einstein never really gave up. During the years following Bohr's pronouncement of the complementarity principle, which explained that the universe had to be composed of complementary and contradictory pictures of reality, Einstein labored to show that the quantum mechanical story was not the last word.

He continued to hound Bohr with one thought experiment after another. These thought experiments put Bohr to the test. However, Bohr successfully defended quantum mechanics, ultimately by referring to his own Principle of Complementarity. Einstein, although defeated, was not convinced. He felt that the problem must lie in the theory itself. Somehow, quantum mechanics was not an adequate theory; it had to be incomplete. In 1935, Einstein tried to point out what he felt was missing. This became known as the *EPR Paradox*.

The EPR Paradox

On May 15th of that year, a gauntlet, presented in the form of a question, was hurled to the ground upon which physics stood. The question appeared in the pages of a prestigious journal of physics, *The Physical Review*, in an article entitled, "Can Quantum-mechanical Description of Physical Reality Be Considered Complete?"[1] The authors of this article were Albert Einstein, Boris Podolsky, and Nathan Rosen (or EPR, for short). They had been working together at the famous Institute for Advanced Study at Princeton University since Einstein's exit from Berlin in 1932 to escape Hitler.

Einstein was then fifty-six years old. He had the time to pursue this question, though many physicists would not consider

it the kind of question likely to lead to new discoveries. Whether or not it was a matter of their philosophy or even beliefs, physicists were more anxious to play with the new forms of mathematics and new relationships that quantum mechanics brought to bear on physical reality. They had little time for such questions as Einstein, Podolsky, and Rosen were to present. The EPR paper was nearly ignored.

The paper simply presented an argument—one that, to this day, has not been successfully resolved. It began with a simple test for the reality of any object. That test was given in the form of a condition. Physics is loaded with conditions. There are two kinds: *sufficient conditions* and *necessary conditions*.

A necessary condition is one that must be fulfilled in order for a second condition to be met. Children are notorious for giving necessary conditions to their mothers. "I won't go to bed unless you read me a story" is one example of a necessary condition. The child's mother may offer the child all sorts of goodies to get him to go to bed, and yet he refuses until he gets the story.

A sufficient condition is weaker in its demand. It is a minimal condition. For example, although it is not necessary to eat filet mignon to relieve one's hunger, it is sufficient to do so. The EPR Paradox began with this sufficient condition for the reality of any physical quantity: "*A sufficient condition for the reality of a physical quantity is the possibility of predicting it with certainty, without disturbing* [*it*]."[2] EPR were concerned with the probabilistic meaning given to real objects through quantum mechanics. Specifically, they were concerned with the position and the momentum of an object. Of course, predicting the value of a physical quantity with certainty is no problem when we are dealing with large objects. We can predict, with total certainty, that a coin lying face up on the table will continue to lie there, providing we don't disturb it. Our ability to predict this, therefore, is a *sufficient* condition for the reality of the coin showing heads up.

However, it may not be a *necessary* condition. If we toss the coin into the air, we are no longer able to predict with certainty that it has a face—even though we are no longer disturbing the coin after we have tossed it into the air. Nevertheless, the coin still has two sides. It is real, despite our inability to predict that it has a face as a real attribute of its being a coin.

Classical, everyday objects do not exhibit the bizarre elements of quantum mechanics because of the smallness of Planck's constant h. The sufficient condition of reality is clearly not a necessary one for classical things. But the same may not be true for the quantum world of objects.

The position and the momentum of any object appear to be real quantities. Both can be predicted with practical certainty for any classical-sized, macroscopic object. But in the case of atoms and electrons, the uncertainty principle denies reality to both of these quantities. It is impossible to determine the momentum of an object with absolute certainty if the position of that object is determined with absolute certainty. Thus we can conclude, from the EPR condition of sufficiency, that one of these two quantities must not be physically real. Which one is to be denied reality depends on our choice. When we measure one of the two quantities, the other is denied existence.

Even Bohr would agree with this. But Einstein was working toward a clever conclusion, one that would show that quantum mechanics, if accepted as the last word on reality, leads to a contradiction. Einstein and his friends would use quantum mechanics to prove that it is possible to predict either the position or the momentum of an object without disturbing the object. In other words, after the object leaves all physical influence that the observer is capable of exerting on that object, either of its two physical attributes can be predicted with certainty. But the choice depends on the observer, not the object. According to EPR, the object must have had *both* quantities before the prediction is made. All the observer does is choose which quantity to predict.

Yet EPR would agree that it is not possible to predict both position and momentum at the same time. To do so would violate the uncertainty principle. The EPR argument did not attempt to go that far.

The reason for this rather paradoxical situation has to do with the way in which the observer makes his prediction: he makes his prediction not by disturbing the object itself, but by disturbing another object that had a previous encounter with the first object. The observer learns about the first object by observing the second object because of something physicists call a *correlation* between the two objects that have interacted.

For example, take the game of billiards or pocket pool. When shooting one ball at another, it is possible to predict the behavior of the second ball by observing the first one only. Since these objects are large or "classical" size, it is possible to measure the position and momentum of a ball simultaneously with very good accuracy. By carefully measuring the position and the momentum of the first ball, both before and after its collision with the second ball, both the position and the momentum of the second ball can be determined. Once the two balls have collided, they are correlated. In other words, what happens to each of the balls depends on what happened in their past interaction. So if we observe one of the balls, we will find we can predict what we will observe for the other ball.

After the balls have clearly separated from each other, nothing we might care to do to one of them will affect or change the other. We take this as self-evident, for that's what we mean when we say the balls have separated from each other. The correlation that exists between the balls is solely a result of their past interaction and cannot be changed by anything we do in the present.

A classical picture of a correlation between two particles: The observer observes one particle to predict the position and momentum of the other particle.

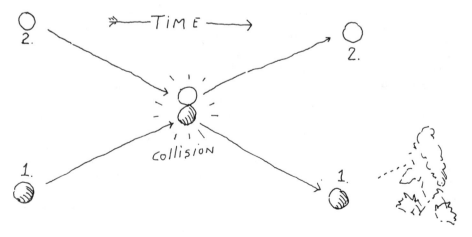

TIME →

2. 2.

COLLISION

1. 1.

The correlation I have described as existing between the two balls is a classical mechanical or Newtonian connection. It arises from Newton's laws of motion. Consequently, it is an indication of the completeness of those laws in dealing with the reality of the collision. If Newton's laws were incomplete in describing classical mechanics, we could not determine the reality of the ball we did not observe. Yet we know of this ball's presence because of Newton's second law. After moving with constant velocity, the first ball underwent an unexpected acceleration. According to the second law of motion, that means it had an additional force acting on it, a force produced by the second ball. Following Newton's third law—known as *the action and reaction law*—we can predict the movement of the second ball by our observation of the first ball. The second ball's reaction was equal to the first ball's action.

But quantum mechanics is another thing entirely. According

A quantum picture of a correlation between two particles: The observer observes the position of one particle to predict the position of a second particle - or he observes the wavelength of one particle to predict the wavelength of the second particle. He cannot do both.

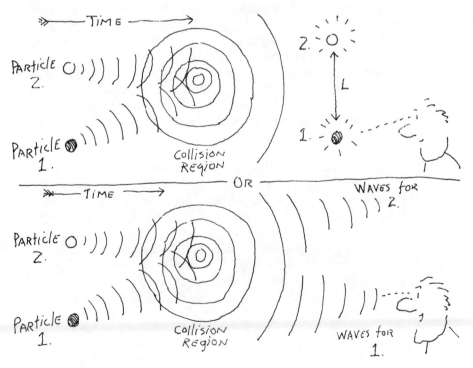

to its laws, we cannot know both the position and the momentum of either billiard ball with absolute certainty. Yet the theory is considered to be a complete description of that unfortunate situation. If it is a complete theory of reality, there should be no way to predict both of these quantities without disturbing the object that possessed them. In other words, there should be no way that the unobserved and therefore unaffected second ball could have both a position and a momentum unless we actually observe that second ball directly. No observation carried out upon the first ball can, by the condition of the two balls being separated from each other, disturb the "reality" of the second ball. Therefore, the second ball's physical attributes—position, momentum, or any compromise between these two—cannot and should not be determined by any observation performed on the first ball. Under no circumstances should the second ball have both position and momentum at the same time.

EPR found a way that the second ball would have both position and momentum at the same time and yet still be unpredictable. Thus they concluded that quantum mechanical theory must be incomplete because it gives these physical attributes to an object but cannot predict the behavior of the object.

To understand how quantum mechanics could produce such a paradoxical situation, EPR devised a clever way to correlate two objects: they constructed a wave function that determined a connection between the two objects. This wave function, although not in violation of the uncertainty principle, appeared somewhat mysterious. Within it, two types of information were contained. It enabled an observer to determine with certainty the relative distance between the objects and, at the same time, the sum of their momenta.

To understand this physical situation, imagine a beam of electrons interacting with a screen containing two parallel slits that are some distance apart. Imagine that the electron beam is being shined, like a flashlight beam, upon the screen. Picture the screen as having two long, narrow, horizontal slits, like the slits in a Venetian blind. Although these slits are extremely narrow, their separation is known. In other words, any two particles passing through the slits will have, at the moment of passing, a clear, relative separation. Now, keep in mind also that it is perfectly possible to measure the momentum of the screen, both before and after the two particles in the beam pass through it. The narrowness of the slits prevents us from predicting the momentum of either electron. However, by measuring the change

in the momentum of the screen, we can determine the total momentum given to the pair of electrons at the instant they passed through the screen.

To recap: EPR had constructed a wave function that contained two kinds of information, the total momenta of any pair of electrons that passed through the double-slitted screen and the relative separation between the pair as they passed. Thus, according to quantum physics, *both* of these physical quantities were real; they were capable of being measured simultaneously. But the location of either electron and the momentum of either electron were still undetermined. The location of a single particle passing through was undetermined because the exact location of the slit was unknown at the time of passing. The momentum of just a single particle was unknown because the recoil of the double-slitted screen was caused by the pair of particles acting simultaneously. According to quantum mechanics, this meant that neither the position nor momentum of a single partner within any pair of particles was physically real.

Reality had been denied to these physical attributes because of the special way that EPR constructed their wave function. Thus we know something about the particles as a pair, but nothing about them individually. It is like knowing a married couple very well, but never meeting with either partner individually to learn how each partner feels about the world.

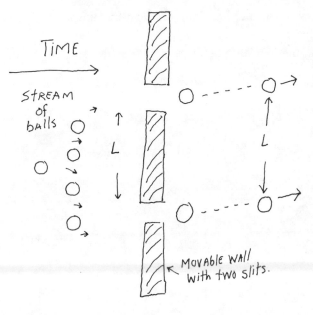

TIME

STREAM of balls

L

L

A classical picture of the EPR correlation between particles: Two balls pass through the wall, keeping the same distance between them, and each is given the same momentum by the wall.

MovAble WAll with two slits.

In this manner, the EPR argument found the two particles to be correlated. But this was no ordinary, classical mechanical correlation. For suppose that after the two electrons are well separated, an observer measures the location of one of them. From the observer's earlier knowledge of the relative distance between the two electrons, he can state with absolute certainty the physical location of the second, unobserved electron. Thus the second electron has the attribute of position because it is possible to predict the second particle's position without disturbing it.

But, hold on. The same argument works for the second electron's momentum. By measuring the first particle's momentum, the second particle's momentum is instantly known, because the earlier measurement of the screen's recoil determined the sum of the momenta of both electrons. If $a + b = 10$ and you know that $b = 3$, it is not hard for you to determine that $a = 7$. Thus, according to the EPR criterion of sufficiency, the second particle's momentum is also physically real because we can predict it without disturbing it.

To make an analogy, suppose that as you stand in line waiting to buy a theater ticket, two identical thieves race past you and grab ten dollars from your outstretched hand. You don't quite notice which of the two thieves takes the money or if perhaps both thieves together take it. You do note that they are identically dressed, but you don't remember what they are wearing.

Later the thieves are caught. They are held in separate

A quantum picture of the correlation between particles: The EPR paradox.

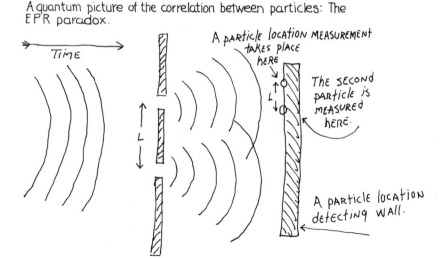

jails, however. Now comes the bizarre part. You go to one jail
and you ask the thief to return your money. He gives you $4.00.
You tell the jailer at the other jail to ask the second thief for
your money, and he retrieves the missing $6.00. You then ask
for a physical description of the unseen prisoner and discover
that the second prisoner is no longer dressed identically to the
first. When the prisoner is questioned further, it turns out that he
"lost" some clothes or exchanged them along the way.

So far, this is all plausible. But later a crime spree hits the
city. Every person who attended a social event where a $10.00
fee was charged was ripped off by a pair of identically dressed
thieves. Fortunately, the thieves were all apprehended. But the
results of the catch were a little unusual. Some people got their
money back. Others didn't. And some got more money returned
to them than they had lost. In every case where the money was
not returned in the exact amount of $10.00, the thieves were
discovered to be identically dressed. When the thieves were
questioned about what had happened to the money, their answers
were fuzzy.

On the other hand, in every case where the amount returned
was exactly $10.00, the thieves were never identically dressed. In
fact, it wasn't even clear the two were working as a team. Yet
they always "coughed up" exactly $10.00, even though one
thief might have only $1.00 while the other would have $9.00. In
other words, the sum of the amounts contained in both thieves'
pockets was exactly $10.00—providing they were not identically
dressed. The amount was never $10.00 in the other cases. But in

The particles are given the same momentum by the
wall, but are not the fixed distance L apart.

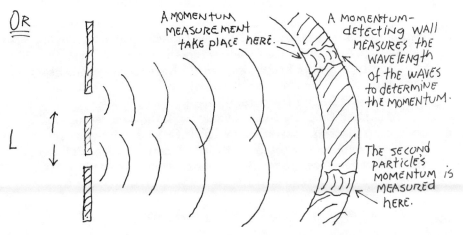

these other cases, each pair of thieves was easy to identify because the two thieves dressed identically. No two pairs looked exactly alike, however.

In this analogy, the identical clothing of the two thieves corresponds to the position measurement of the pair of electrons. The amount of money contained in the thieves' pockets corresponds to the total momentum given to the two electrons. The example shows a correlation between the thieves. If you caught them and observed their dress first and did not ask for their money, you would find that the thieves were always identically dressed. However, if you demanded money first, you would get exactly $10.00 from every pair of thieves you caught, but you would never find that those thieves who gave you the money first were identically dressed. Therefore, the correlation was either that every pair had $10.00 when money was demanded first or every pair was identically dressed if their clothing was observed first. What you observed about the thieves depended on the order in which you observed their attributes—whether money or dress.

What should we conclude from our analogy? Does the second electron really have both a position and a momentum at the same time? If the answer is yes, then it is obvious we cannot predict both attributes simultaneously using quantum mechanics as our theory.

Even more bizarre, suppose that quantum mechanics is a complete theory. Then the reality of the second electron, by which I mean its possession of the necessary attributes of position and momentum, would depend on our choice of measurement performed upon the first particle. This is extremely odd because the two particles need not be anywhere near one another to affect each other.

Thus EPR attempted to deny quantum mechanics its ruling authority over reality. The completeness of quantum theory would mean that objects that had previously interacted could still affect each other after they were well separated. This possibility was a fly in the ointment of Einstein's special theory of relativity. Indeed, this objection of EPR later became the condition of "Einstein separability."

To grasp the seriousness of accepting the completeness of quantum theory as described by EPR, we shall next consider how quantum theory could overthrow Einstein's theory of special relativity. However, in overthrowing special relativity, we are not just abandoning another theory. We are abandoning the necessary basis of any logical and causal understanding of physical reality. This is serious business, indeed.

The dots of uncertainty: These dots show schematically how in time and through space the two particles spread after experiencing the "Einstein connection." Both the momentum and positions of the particles are uncertain, yet they are connected.

Here the "momentum" dots are connected with arrows that show the potential momentum of each particle. The discovery of "A" with momentum towards the left, creates "B" with momentum towards the right.

Here the "position" dots are connected and numbered for each potential location. The discovery of "A" at any numbered position on the left creates "B" at a comparable position on the right.

Faster Than a Speeding Photon

It's all a dream.
Light passing by
on a screen.

Things That Go Bump in the Night

The speed of light plays a very special role in modern physics. It is the upper boundary, the highest speed in the universe known today. All of matter, light, and electromagnetic radiation can be said to be incarcerated at speeds never exceeding lightspeed.

If, for example, I increase a ball's energy by whacking it with my fist every time it flies by me (like a tether ball on a pole), the ball will show an increase in speed. It takes energy to speed up any object. In the case of ordinary tether balls, baseballs, and even rifle bullets, the energy goes into increased speed always, provided that the object is not moving at speeds near to lightspeed. For if it moves that fast, something strange begins to take place: the object no longer continues to increase its speed when given more energy. Instead, it increases its mass! As Einstein put it, "Velocities greater than that of light have . . . no possibility of existence,"[1] because it already takes an infinite amount of energy to accelerate any body to the speed of light.

But what if there were particles that had speeds greater than that of light?[2] Then these particles would not need to be accelerated from subluminal to superluminal speed; they would simply exist buzzing around at hyperlight velocity. Physicists have long been fascinated with these kinds of particles.[3] They are called *tachyons* from the Greek word *tachy*, which means fast. The words *tachometer* (an instrument used to determine speed) and *tachycardia* (excessively rapid heartbeat) are also derived from this Greek root word.

Tachyons, if they existed, would turn our world of cause and effect topsy-turvy. This fact has to do with the Einstein Theory of Relativity. Let's look at a simple example. Suppose that a rifle is fired at a target. It is obvious that the bullet had to leave the rifle and arrive at the target afterwards. But suppose you happened to be flying by on a supersonic jet at the instant the rifle is firing. Your speed would nearly match the speed of the bullet. In fact, you could almost fly side by side with the bullet and watch it from your jet cabin's window. From your vantage point, the bullet would seem almost to be standing still. Of course, the target is racing up to it helter-skelter. Is it possible

that you could fly by so fast that the bullet would not only stop outside your window, but would move backwards?

If you are a movie-goer, you have seen that effect many times. Just remember the old wagonwheel scenes in any "oldie but goodie" western. The wheels appear to move backwards, particularly if the wagon is going slowly. That's because the speed of the film's advance through the projector is greater than the speed of the rotating wheels. But still, the wagon is going forward. Thus it appears that no matter how fast we might fly by, the rifle bullet would continue to advance toward the target — even though, from our speeded vantage point, it might appear to be traveling backwards.

Relativity theory confirms this apparently obvious observation. But something weird would begin to take place if the bullet could be fired with a speed greater than the speed of light. Suppose the bullet happened to be moving at twice the speed of light, for example. We would notice nothing unusual about the firing if we were flying by with any speed less than half lightspeed. But the instant we reached half lightspeed, we would witness the rifle firing and the bullet hitting the target at the same time! Even weirder, as soon as we were flying by at speeds greater than half lightspeed, we would see the whole scene as if it were a film running backwards; the target would explode, sending the bullet and all of its gases back toward the rifle where they would neatly pack themselves into the narrow rifle barrel and travel up that small, bored cyclinder until all contents had repacked themselves into an undischarged round.

Since relativity successfully predicts the results of observations, we have come to trust it. Thus we would conclude that tachyons cannot exist because of the above example. This example illustrates what we would call a *causality violation*: the cause comes after the effect.[4]

Causality violations are serious crimes in an orderly and lawful universe. Speeding faster than light will always be observed by some observers as a violation of causality. They will see events along the trail of the speeding object happening in a reverse order. Of course, not every observer will be faced with this "monkey business." If we all were to observe the same violation of causality, we wouldn't think anything of it. We would simply say that the effect was the cause and the cause was the effect. Running movies backwards makes sense if we never run them forwards.

But not all of us will see the same thing. The world will seem bizarre when it is witnessed by observers who happen to be

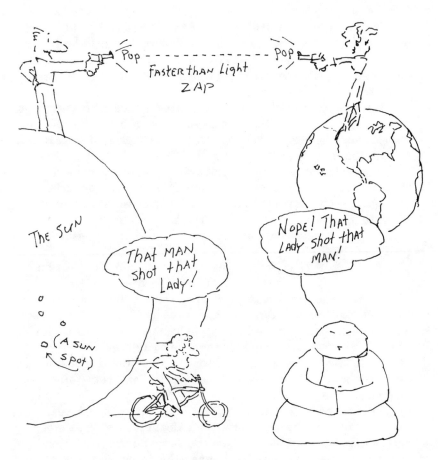

A causality violation: A contradiction of facts caused
by a tachyon.

moving at any fraction of lightspeed, even at 670 miles per hour, which is only one-millionth the speed of light. For example, if a westbound tachyon were to fly by with a speed of just over a million times lightspeed, leaving a trail behind it as it flew, observers on the earth would see it heading into the sun. But people in an airplane flying by at 670 m.p.h. would see the tachyon heading eastward away from the sun. Shades of flying saucers!

What would the truth be? Where did the tachyon originate? In the east or in the west? With causality violations, truth would dissolve into a hodge-podge of superstitions. Undoubtedly, Einstein must have felt this instinctively, although he never actually considered tachyons a reality.

He didn't have to. His theory of special relativity rid science of such bizarre objects. All is quite well with causality for objects that move at less than the speed of light. For in those cases, no one could ever observe a violation of causality. Things flying eastward always fly eastward.

But quantum mechanics, as exhibited by the EPR argument, would allow an observation of a physical quantity of one of a pair of previously correlated particles to "create" a similar appearance of that quantity in the other particle. This sudden appearance of a physical quantity in the second object would be caused by the measurement of the similar quantity in the first particle. Since the second particle could not already possess the value given to it by the measurement performed on the first particle, the reality of the second particle must depend on the measured reality of the first.

That means that "something" had to go from the location of the measurement of the first particle to the site of the second. And that "something" was no slowpoke either. There was nothing contained within quantum mechanics to slow it down, whatever it was. In fact, quantum mechanics would imply that this "something" was perfectly able to move at lightspeed or even faster. However, it was not light that was moving. Light could be explained and contained within the theory. This "something" was beyond such explanation.

The two objects previously correlated could be lightyears apart. They could be on separate galaxies. Yet as soon as an observation was performed on one of these objects, the second would immediately assume a similar value for whatever was observed for the first.

By attempting to dispute quantum mechanics, EPR had brought out into the open another of its bizarre features: the surprising connection between objects that had had a previous contact. Quantum mechanics indicated that this past contact allowed the objects to be correlated in this special way, even though they may have long since been out of any physical contact with each other. They were, so to speak, "causality time-bombs," liable to go off at any instant for no apparent reason. To set one off, furthermore, had to be an irresponsible act. There was no way to even know that you had done so if the objects were out of physical contact with each other. All you did was observe something. If that something was "quantum connected" to another object, the second object would "feel" the effect of your observation. It was like the fabled story of the "Corsican Brothers," who when separated from each other knew of each

other's love affairs because they had once been Siamese twins.

Although Einstein might have objected, I have called this "quantum connection" between any two past-correlated particles the "Einstein connection." Remember that Einstein was attempting in the EPR argument to disconnect such a connection by pointing to its unreasonableness. He gets the "honor" because he was the first to point out that quantum mechanics could even produce such an awkward connection. Yet the fact that an observation of A could produce a result at B when A and B were lightyears apart is not the main consideration.

The problem with the Einstein connection is that A and B could be simultaneous occurrences. Following our previous venture into the tachyonic world of relativity, that would mean that for some observers who were watching A and B from a different vantage point, A could be the cause of B. However, the order of the events could also be observed in reverse. Some observers would be able to see B as the cause of A. Simultaneous events happening in different locations can be observed by moving observers in opposite time orders. Thus such events could not be causally connected. At least not in any ordinary sense of causality.

But quantum mechanics must contain, if it is a complete theory of reality, an extraordinary connection between observers of events. It wasn't even necessary to have two objects to exhibit this connection. The connection I am referring to dealt with the relationship between all observations occurring simultaneously. This was called *synchronistic observations*.

According to quantum mechanics, it would be possible to see that a relationship extended out into space, covering a wide range of possible sites for the observation of an event. But in order to talk about this synchronistic connection, we will need a language, a picture of terms.

Qwiffs, Flows, and Pops

It is difficult to provide a language for this quantum synchronistic connection. We are still faced with the waves and particles of our classical experience. Nevertheless, I feel that the attempt will be useful. Let us begin with the idea of a quantum wave function, the kind first described by de Broglie and later refined by Schroedinger.

Though any picture is nearly impossible to imagine, let us try to imagine a quantum wave function. I shall call the quantum wave function a "qwiff." Think of a qwiff as spreading throughout space like ripples on the surface of a pond. I will also call the act of observation a qwiff "pop." Thus qwiffs "flow" and qwiffs "pop." Qwiffs flow like moving, undulating waves of water. Qwiffs pop like bubbles in a stream. But I want the reader to imagine that a qwiff pop is a destruction of a qwiff flow. In other words, when the qwiff pops, the qwiff itself vanishes. When a correlation exists between two particles, it is like a qwiff rubber band stretched between them. The observation of one of the particles pops the qwiff and instantly affects the other. Although the picture I have painted is a mechanical one, it is not a simple action-and-reaction picture. The qwiff is a quantum wave function that at best can only describe the probability of the observation and not the actual observation. It is not a real "thing," but it may be helpful to picture it as a real thing.

The next point that will be helpful in attempting to understand synchronistic connections is to realize that qwiff flows are determined by a mathematical continuous description. This description is provided by Schroedinger's equation. Since Schroedinger's equation describes how the qwiff flows, it describes how the qwiff changes in a continuous manner. We are in the curious situation of knowing with certainty how the probability of things changes.

But Schroedinger's equation cannot tell us what we actually observe. It cannot tell us where or when a qwiff pop will occur. There is no continuous mathematical way of describing a qwiff pop. Each pop is a sudden disruption, a break with the past, a violation of the law of cause and effect. Let us consider a simple example: the quantum mechanics of the nursery rhyme that begins, "Starlight, star bright/First star I see tonight. . . ."

The unseen qwiff, in an endless pattern of waves, flows in spacetime in a perfectly logical manner. For example, the qwiff describing a photon emitted by a star four lightyears from earth has a very simple pattern of movement. This pattern takes the form of a spherical wave, endless wave ripples pulsing outward from the center like the layers of an onion. A two-dimensional version of this is created whenever you drop a stone into a still pond.

An observer, A, on the earth could be, for example, thinking about the possibility of a star existing at some point in space. Imagine that the star is undiscovered and is crying for help,

seeking to be found. It sends out a single photon qwiff that spreads throughout all of space. Each point on its wave surface is a possible discovery point. But there is no intelligence in the universe to know that. So the wave surface grows, expanding further but getting weaker as it goes.Perhaps if it expands further, like a balloon blowing up, it will find intelligence.

Suddenly on earth, something pops in the "mind" of our thinking observer. In a flash, faster than light, the observer "sees" the light of the star. And at that instant, the qwiff is changed drastically like a pricked balloon. The photon is said to have arrived. Intelligence has occurred on the scene. Knowledge has occurred on the scene. Knowledge has been altered. The single

Qwiffs, flows, and pops: Imagining the unimaginable. We see a young person's mind and the universe is qwiff-filled.

photon qwiff, which had been spread over a four-lightyear radius
sphere, has collapsed to a single atomic event at the retina of the
observer. That event—the collapse of the wave function from an
eight-lightyear diameter sphere to a single point on the retina of
the beholder—is an alteration affecting the whole universe for
one single instant.

Meanwhile, another observer, B, may have also been seeking
that star's light. Suppose that observer B was waiting for the
flash on another planet that also happened to be four lightyears
from the star, but on the opposite side from observer A. B would
miss the show because A popped the qwiff. When A saw the
light, he altered the probability throughout all space.

But just before A's discovery, both A and B had equal
chances to discover the star. In that world inhabited by qwiffs,
the photon was potentially in both places—near A and near B at

He has just popped the qwiff.

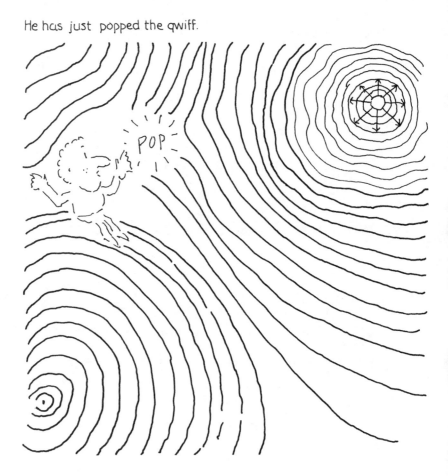

the same time. Indeed, it was potentially and simultaneously at every point on that qwiff sphere. Then A saw the light.

That not only changed A's reality, it also changed B's reality and just as quickly. It is tempting to say that A acted as the cause and B became the effect in this change. But we must not be hasty. We could just as logically say that B's nonobservance of the photon caused A's event to occur. Why? Because at the instant that B *knew* there was no photon, he also instantly altered the probability from a possibility to nothing. Thus B, as well as A, was responsible for collapsing the qwiff.

The instantaneous qwiff pop does not seem to obey the usual laws of cause and effect. Because of the instantaneousness of the A and B events, we cannot say who controls whom or what controls what. It's as if minds were eager, hungry children, all out there and waiting to gobble up the first qwiff that passes by.

We see the result: A star's photon has landed on his retina.

The problem is that the first gobbler leaves nothing for the rest—or else, by his act of not knowing, he creates a feast of knowledge for another.

In my wild imagination, I picture God in the center of the whole universe preparing quantum feasts of knowledge, all kinds of magical and tasteful future goodies in the form of magnificent qwiffs. The qwiffs spread throughout the universe faster than light, traveling both backwards and forwards in time. And God cries out, like a good Jewish mother, "Eat, eat, my children. These are wondrous gourmet things, real pearls." But, alas, we are an audience quite fearful of what could be. We watch the splendor and we moan. We are afraid to laugh at the Great One's jokes. We are afraid to feast on the new food, for fear of indigestion.

Even worse, God's qwiffs are popped by any intelligence, no matter how crude or primitive. Thus great pearls of wisdom are being gobbled up by deranged minds and turned into weird realities like bad Nazi war movies, starvation of countless sufferers, and insensitive, unfeeling people. God's timeless jokes are retold again and again as parables, Bible stories, and mystical insights. But, alas, they are all hopelessly distorted by inept minds.

Yet not all minds are inept. Science steps in. And then come Planck and Einstein and all of the rest throughout history past and history yet to be. An order is perceived. But who is creating that order?

Thus, from a certain and perhaps cosmic viewpoint, there is a connection between the two observers, A and B. They may never know it, however. Before the observations made by A and B, the qwiff was an unbroken whole spread over a vast range of space. Before the observation of that single photon by A, there was no objective separation between A and B. That separation arose when the photon was observed.

Of course, an instant later, another photon qwiff would reach the two observers. And again, A might see the light. But the qwiff favors neither A nor B. For it is equally likely that B will see this photon. And if he does see it, he will alter A's reality for just an instant. Then comes the third photon, and the fourth, and so on. Each photon qwiff is altered from nearly opposite sides of the vast spatial universe. In that continual series of observations, the vast distance of space is perceived by both A and B.

By observing the universe, each observer is disturbing the unbroken wholeness of that universe. By observing, each

observer is separating himself or herself from the rest of creation. By observing, the observer is gaining knowledge, but also paying a price. He is becoming more and more alone and isolated. Perhaps this is what is meant by the tree of knowledge in the Garden of Eden. The first bite of the apple is sweet, but costly. Our eyes are opened and we see we are alone.

God creates all qwiff flows, and you create all qwiff pops.

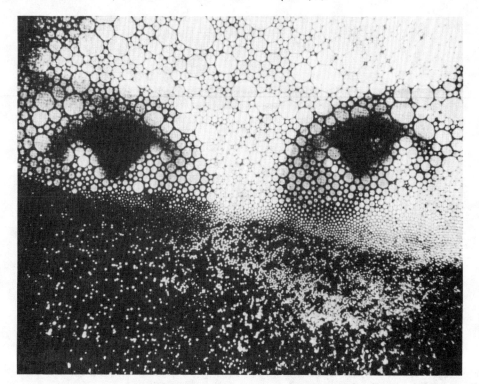

Breaking the Unbroken Whole

*"To be or not to be"
is not the question;
it is the answer.*

FRED ALAN WOLF

When Two Become One

My first real exposure to quantum mechanics came in 1958. I was then a graduate student at the University of California at Los Angeles, pursuing an advanced degree in physics. One of the textbooks required for our course in quantum mechanics was David Bohm's *Quantum Theory*.[1] It is an unusual college physics textbook. As you may have discovered, physics textbooks are normally quite dry and loaded with seemingly undecipherable formulae apparently created by machines rather than people.

Bohm's book was an exception. It had more words than formulae. It dealt with questions concerning topics that were apparently unrelated to physics. "The Indivisible Unity of the World," "The Need for a Nonmechanical Description" of nature, "The Uncertainty Principle and Certain Aspects of Our Thought Processes," and "The Paradox of Einstein, Rosen, and Podolsky" were some of the topics that Bohm considered and that were to have a great influence on my own thinking.

In 1973, I had the opportunity to spend two years as a visiting research fellow with the Department of Physics, Birkbeck College, University of London. During those years, 1973 through 1975, I had several discussions with Professor Bohm, who was head of the theoretical physics branch at Birkbeck.

Bohm referred to the synchronistic, causality violating quantum connection, as "nonlocality." In a paper developed later with Basil Hiley at Birkbeck, he wrote:

> The essential new quality implied by the quantum theory is non-locality; i.e. that a system cannot be analyzed into parts whose basic properties do not depend on the . . . whole system. . . . This leads to the radically new notion of unbroken wholeness of the entire universe.[2]

Quantum mechanics stimulates such thoughts. Physicists have come to realize that the mechanical picture of the universe cannot be the whole picture. But the problem still appears to be, "How can we understand the world?" If elements of reality, such as the location of an object or its path through space and time, are subject to disappearing according to one's choice of observation, we are not left with much. The basis of a reality upon the material world is fraught with such paradoxical behavior.

Even what we mean by "space" and "time" must be reconsidered. Unbroken wholeness means just what it meant to the ancient Greeks. You cannot analyze it. You cannot take it apart. For if you do, what you end up with is not contained within the original whole. It is created by the act of analysis. If the whole universe is this way, then the very experience of space and time must also be continuously created by observational acts.

If we could somehow reach out into the whole without breaking it, what would we find out there? Could we send and receive signals? Even the concept of a signal deeply involves one of our most sacred prejudices: the prejudice of space. Bohm and Hiley comment:

> First of all, we point out that in the theory of relativity, the concept of a signal plays a basic role in determining what is meant by separability of different regions of space. In general, if two such regions, A and B, are separate, it is supposed that they can be connected by signals. Vice-versa, if there is no clear separation of A and B, a signal connecting them could have little or no meaning. So the possibility of signal implies separation, and separation implies the possibility of connection by a signal.[3]

If the whole universe is one, nonseparable entity, signals would make little sense. To the extent that quantum mechanics provides instantaneous communication between all spatial points on a qwiffian surface, these points *cannot* be said to be separated. They are all only one point!

To the extent that they can be said to be separated points in space (and time), signals may be passed between them. Thus our two observers, A and B, from our previous example are both separated (they can signal each other by ordinary, slower-than-light means) and not separated (A's observation instantly affects B's reality as well as A's reality).

It is perhaps difficult to understand how two very different regions of space can be both separated and unseparated at the same time. To imagine this situation more clearly, let us return to the example of "The Paradoxical Cube." As you will remember, the illustration could be seen in two complementary ways: as a cube with jumping sides or as an abstract pattern of lines and points.

Suppose now that we have two such cubes in space. Suppose that they are completely independent of each other. Suppose that two observers come along and each observes his or her separate cube. There is no apparent connection between either the cubes or the observers, so the order of observations will appear completely random when they are compared. For example,

the first observer might initially see her cube with the lower side in front. A little later she will see the upper face in front. And perhaps later she will see it as a pattern of lines and points. Suppose her observations are coded so that U stands for a cube with the upper face in front, L for a cube with the lower face in front, and P for a pattern with no face at all. This individual's observational order over time might be: PPLLULUUUUPULULU.

The second observer would also observe his "cube" in a random order of P's, L's, and U's. For example, UPPULPULPPPLUUPU. By comparing the two orders of PUL's, we can determine if there is any correlation, any similarity between them. Of course in this case, since we cannot control the observers' choices or when a particular face of the cube will appear in front, there will be no "overlap" in the orders of observations by the two individuals. Of course there will be some coincidences, but there will be no obvious order to them.

UNCORRELATED quantum cubes

But now let us suppose that the two cubes had a past inter-
action and thus became correlated. We now have a situation
similar to the EPR paradox. In fact, Bohm used a similar
correlation between two spinning particles to explain the
correlation.[4] The observed directions of the spins of the particles
were found to be correlated. Now suppose that the two previously
interacted cubes are observed. Again, there is no way to control
the choices of the observers. Each observer is free to choose to
view his or her cube as a cube or as a pattern of points and lines.

Correlated quantum cubes.

Time ———→

The past
interaction of
two cubes

Correlated
quantum cubes

However, if both observers just happen to choose to view the cubes as cubes, a similarity in the order of their observations is apparent. For example, suppose that the first observer sees the order, ULLULLULLUPPLLUULLUULLUUP. The second observer will also observe, ULLULLULLUPPLLUU-LLUULLUUP. In other words, both will see the cube in exactly the same way. Yet neither will feel that the other controls his or her ability to choose among the U's, L's, and P's.

The order observed by each observer is random: it appears at the whim of the observer. Neither observer, for example, can "force" an L view of the cube. Yet when the observational orders are compared, the number of coincidences is overwhelming. It is as if each observer were seeing the same thing. The two observers exist as if they had only one mind and that one mind was observing only one cube.

Yet there are two cubes and two separated minds. Their "oneness" appeared only after they compared notes and observed each other's order of observations.

I Am This Whole Universe

This "quantum link" between all things could provide a better understanding of how humans come to understand anything at all. Any two points in space and time are both separate and not separate. Einstein's speed of light sets a clear upper boundary on the separability of places and times. When points are connected by signals traveling at speeds slower than the speed of light, the points are separate. When they reach the speed of light, signals begin to lose meaning. In fact, Einstein's theory predicts that neither space nor time "appears" for a particle of light. This counter-intuitive conclusion comes directly from Einstein's special theory of relativity. It is due to the observed fact that the speed of light is a constant. Any observer watching light as it moves from a source to a receiver would measure the light's speed to be the same. This is true even if the observer is moving relative to the source and/or receiver, and no matter how fast the observer travels.

If the speed of light is in fact fixed, the measures of space and time we normally think of as fixed are not. Space and time are relative. This means that any given interval of time, no matter how set and "frozen" it reasonably appears, can be observed to be longer or shorter in time by another observer.

Any length or distance suffers an equal embarrassment of nonrigidity.

Accordingly, moving clocks tick slower and moving rods shrink. The faster an object moves in relation to the observer, the slower its clock runs and the shorter it becomes. The limit to all this relativity is the speed of light. A photon's clock, if it had a clock, would be so slowed down that no time at all would pass. The distance it would observe traveling from one point to another would be zero distance. Both points would appear to be the same point "now" for the photon of light.

Beyond lightspeed, an object or a consciousness would be completely free of the shackles of space and time. It could "drop in" at any time, past or future. It could visit anywhere at an instant. All points in the universe would be its home. Quantum mechanics was indicating a meaning for this poetic thought. The universe is not just a collection of separate points. It is what it is according to the observer and what he or she does. By identifying with the "quantum wholeness" of the world, the observer "becomes" the observed. He is what he sees.

Shortly after the appearance of the EPR paper, Erwin Schroedinger became deeply concerned with the kind of reality being portrayed by quantum mechanics. He had already given much thought to such philosophical considerations.

Remember that Schroedinger was reported to have exclaimed to Niels Bohr: "If one has to stick to this damned quantum jumping, then I regret having ever been involved in this thing."[5] To which Bohr replied: "But we others are very grateful to you that you were, since your work did so much to promote this theory."[6] Later Schroedinger would write "What Is Life?" in an attempt to reconcile quantum physics and biology.[7] In his two long essays, "My View of the World,"[8] he revealed himself as a mystic much influenced by Eastern views. In his first essay, which he wrote in 1925 *before* he created his equation, he stated:

> This life of yours which you are living is not merely a piece of this entire existence, but is in a certain sense the "whole"; only this whole is not so constituted that it can be surveyed in one single glance. This, as we know, is what the Brahmins express in that sacred, mystic formula which is yet really so simple and so clear: TAT TVAM ASI, this is you. Or, again, in such words as "I am in the east and in the west. I am below and above, I AM THIS WHOLE WORLD."[9]

Schroedinger was indeed prophetic, though his prophecy may have been a self-fulfilling one, since he created the

"The Sower" by Vincent Van Gogh: The observer is becoming the observed. TAT TVAM ASI, this is you. I AM THIS WHOLE YOU-NIVERSE.

mathematical means by which quantum physicists have come to view the world in this way. I like to think of this statement, "I am this whole universe," as the initial postulate of quantum thinking. I think of it as the one mind seeing itself and accepting the paradoxes of its positions. That anything is at all is reconciled with quantum jumps.

The position of wholeness taken by Schroedinger I call *quantum solipsism.* According to solipsism, the self is the only thing that can be known and verified. Nothing else is for sure. According to quantum solipsism, everything depends on you. You create the whole universe; you are the "you-niverse." How do you manage this? The answer is: you use your mind. To understand the process, we will next look at your mind's architecture—the qwiff.

Imagination's Architecture: The Qwiff

The questions raised by such a self-centered view of the world do not have easily understandable answers. Far from it. For if the world exists and is not objectively solid and preexisting before I come on the scene, then what is it? The best answer seems to be that the world is only a potential and not present without me or you to observe it. It is, in essence, a ghost world that pops into solid existence each time one of us observes it. All of the world's many events are potentially present, able to be but not actually seen or felt until one of us sees or feels.

If we accept this picture (albeit, it is a strange picture), many events that were previously mysterious appear understandable. But before we consider some examples, let us examine some basic concepts. Starting from our present understanding of classical reality, there seem to be two fundamentally different kinds of reality.

The first reality I will call the "out there." It consists of all experiences, sensations, and events that you or I agree happen externally. The leaf fell from the tree. The car stopped at the red light. If you and I agree that any event or series of events happened, we usually mean that the event(s) was "out there." I realize that there is a certain "looseness" to my definition; it is intentional and approximate. For according to this definition, any mass hallucination would be an "out there" reality. Much of "out there" is repeatable and measurable. When a physicist talks about reality, he or she means the "out there."

But there is also a second reality, one we all know quite well. It is the world of our minds. In this world, much happens that simply doesn't fit our common experiences of "out there." I call this mind world the "in here," and it consists of thoughts, dreams, and pictures, which resemble or symbolize the "out there." Letters and numerals are symbols of the "out there." They were created in the "in here." In the "in here" world, magic takes place and we hardly give it a second thought. Often there is a direct link or correspondence between events (dreams, thoughts, and symbols) in the "in here" and events (that which is seen, felt, tasted, smelled, or heard) in the "out there." Again, I am somewhat loose in my definition. A person sleepwalking may only sense events as if they were a dream. In this case, sleepwalking would appear as an "in here" reality. When a psychologist talks about the mind's reality, he means the "in here."

And now, according to quantum physics, there is a third reality. It has attributes of both the "in here" and "out there"

"Don Quixote" by Dore: Quixote projected the "In Here" into the "Out There" and found the world of imagination closer to reality than he imagined.

realities. I think of this third reality as a bridge between the world of the mind and the world of matter. Having attributes, of both, it is a paradoxical and magical reality. In it, causality is strictly behaved. In other words, the laws of cause and effect manifest. The only problem is that it isn't objects that are following those laws (at least, not the ordinary kinds of objects we usually refer to), but ghosts! And these ghosts are downright paradoxical, able to appear in two or more places, even an infinite

number of places, at the same time. When these ghosts are used to describe matter, they closely resemble waves. And that is why they were first called "matter waves." In modern usage, they are called "quantum wave functions" or, as I have chosen to label them, qwiffs. They are called functions because they are functional, which means they depend on things for their operation. The things that the qwiffs depend on are space and time. Qwiffs change. They change in very orderly, causal ways whenever they are not observed. They are much like mischievous elves.

If we could somehow watch qwiffs without really watching at all—because our observations disturb these quantum elves— we would see some marvelous adventures. One qwiffian elf might, for example, divide into two, each elf replicating the other as they both do their pranks. Furthermore, they are addable or countable, but like ghosts that you can see through, adding them up sometimes produces nothing at all!

All or Nothing at All: How to Add Qwiffs

Let's imagine that we are able to "see" what goes on in the third reality. Remember that we aren't really seeing or observing, for if we were, we would only see what we normally see. This is just like "The Paradoxical Cube." Seeing the "cube" as a solid cube corresponds to our "normal" way of seeing matter; there are no ghosts—just weird, popping, quantum-jumping particles. But "seeing" the "cube" in the third reality would be seeing it as a pattern of points and lines. In a certain sense, "seeing" in the third reality is seeing a superimposition of the two usual ways of seeing the cube in the "out there" reality.

Physicists call this way of seeing the *Superposition Principle*. We have already come across this principle in our discussion of interfering wave ripples. This principle was also used by de Broglie in constructing his "snake swallowing its tail" wave form for the electron in the Bohr atom. Schroedinger's waves were another example of the idea of wave superposition— that is, the addition of one wave to another. And we came across the same idea in Bohr's concept of the wave-particle duality. The key feature of superposition is that one plus one can equal zero, two, or any number in-between!

Now here we will add or superimpose two qwiffs. In the next two illustrations, the Buddhalike figures wearing pointed

hats appear upside down and right side up. Think of the upside-down Buddhas as the opposite of the right-side-up ones. Whenever an upside-down Buddha and a right-side-up Buddha come together, they cancel each other out. We say that they destructively interfere with each other. But two right-side-up Buddhas or two upside-down Buddhas reinforce each other. We say they constructively interfere with each other.

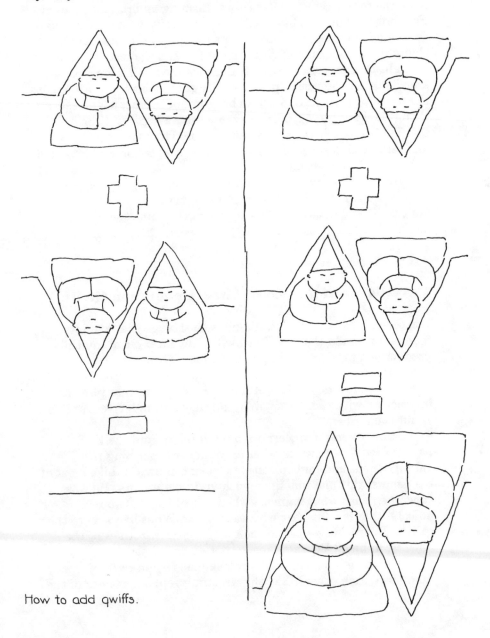

How to add qwiffs.

In the first illustration, the two qwiffs add together, or superimpose, to give nothing. In the second illustration, they superimpose to produce a qwiff with twice the magnitude of either one. If you think of the top qwiff in each drawing as a thought and the bottom qwiff as an opposite thought, then you might look at the first qwiff illustration as the canceling effect of a negative thought, while in the second qwiff illustration, we have the reinforcement effect of reaffirming an original thought. For thoughts behave like qwiffs. Since qwiffs exist in your mind as well as in space and time, we may begin to see how our thoughts actually manifest in the physical universe. It is the thought that creates the qwiff. Because the qwiff is our knowledge of the world, positive thoughts about the world create the world as a positive place to be. And, of course, negative thoughts work the opposite way, creating a negative world. Qwiffs obey the laws of cause and effect. They follow a mathematical description. Schroedinger's equation was invented to give us that description.

And qwiffs have a second magical property, not only can they be added together and vanish, but they can also be multiplied and in two or more places at the same time!

Two Places at the Same Time: Entangling Qwiffs

The second feature of qwiff magic is so strange that even its founders resisted the fact that qwiffs can entangle or multiply, producing a product that appears in more than one place at any instant. Each product may appear as an identical copy of its originator. How do qwiffs entangle? By entering into physical interaction with each other. Why do they entangle? To learn about each other.

Schroedinger's concern with qwiff magic and the EPR paradox led him to write an unusual paper describing the entanglement and multiplication element in qwiffs. Like most of his papers, this one was filled with vivid metaphors. He was concerned with what happens when two objects—two real objects, that is—interact with each other. What happens to their qwiffs? Schroedinger called the qwiffs *representatives of the objects*, in much the same sense that an ambassador is a representative of a country. What happens when two objects bump into each other? Like the wrestling representatives of the

United States and the Soviet Union in the film, *Dr. Strangelove*, the representatives of these two objects entangle. As Schroedinger put it:

> When two systems of which we know the states by their respective representatives, enter into temporary physical interaction due to known forces between them, and when after a time of mutual influence the systems separate again, then they can no longer be described in the same way as before, viz. by endowing each with a representative of its own. I would not call that the ONE but rather THE characteristic trait of quantum mechanics, the one that enforces its entire departure from classical ideas of thought. By the interaction the two representatives [or qwiffs] have become entangled. To disentangle them we must gather further information . . . although we know as much as anybody could possibly know about all that happened.[10]

What does Schroedinger mean when he says that although we know all that we can possibly know about the system, we must gather further information? How can we add further information to all that we can possibly know?

Schroedinger's Cat in a Cage

The only way we can add further information to all that we can possibly know is by observing the system. For our actions disturb the system. The system depends on what kind of question we ask it. Schroedinger made the analogy that a quantum system was like a tired but very bright student. The student would invariably give a correct answer to the first question you asked him, but he would become so tired after the effort that he would invariably give an incorrect answer to the second question. The order in which you presented the questions made no difference.

Schroedinger's questions to the student were like the questions of position and momentum put to nature by a physicist. The momentum of the system would correspond to your expectations, provided you measured momentum first. Similarly, the position of the system would correspond to your expectations, provided you measured position first. But in either case, the second quantity measured would never correspond to expectation. In the example that follows, the life of a cat in a cage will be at stake.

Imagine a closed steel cage containing one radioactive atom. This atom is said to have a *half-life* of one hour. That means in a sample of material containing a large number of such atoms, only one-half of them would remain after the passing of one hour. The other half would have "decayed" or transpired by emitting radiation into the environment. Thus after the passing of an hour, we have an equal chance of finding the atom intact.

Further imagine that the radiation emitted by the single atom strikes a sensitive photocell tripping a circuit that allows a poisonous gas to fill the cage. This gas will kill any living thing that has the misfortune to be in the cage at the instant the radiation hits the photocell. And now imagine that we place in the cage an unsuspecting cat. (All cat lovers, please forgive me—the example is Schroedinger's.) If we then wait one hour, what will we find in the cage? A living cat or a dead one?

What controls the fate of the cat? According to quantum mechanics, *you* do—if you are the one who is to open the cage and discover the cat. At first, you and the cat are quite independent of each other. But as time goes on, two possible qwiff editions of the cat appear in the cage; one dead and the other alive. The dead cat edition appears more and more probable as time wears on, while the live cat edition appears increasingly less probable. After one hour, there are two equally likely cat editions present in the cage.

Discovering a dead cat in a cage is not a pleasant prospect. Thus you are of "two minds" while waiting to open the cage. One mind is happy at seeing a live cat and the other is sad at finding a dead cat. Just a mild case of schizophrenia. In a certain sense, the universe has become two universes. In one, there is a living cat and a happy you, and in the other, there is a dead cat and a sad you. You at this time had nothing to do with this splitting of the universe. It came about because the cat interacted with the atom in the closed cage. The cat–atom interaction created the split. As far as you are concerned, there is only one universe, and you are in it!

But what happens when you open the cage? It is at this juncture that quantum mechanics appears to falter. While it is certain that you will know the fate of the cat instantly, it is not clear how you come to know it! Remarkably, it is not possible to explain the simple discovery of a fact using the new physics. There is no mathematical way to predict the cat's statis. To know, you must reach in and disturb the cage. That is what Schroedinger meant by gathering further information. Though the mathematical description told all that it could, it was incomplete.

But the question still rings in our ears: what does it take to complete quantum mechanics? Bohr and Heisenberg say nothing. It is as complete a theory as possible. We are responsible for its incompleteness. We play a vital role. Or do we?

Perhaps the role we play is overestimated. Perhaps there are, instead, hidden variables controlling the mysterious behavior of quantum objects. Perhaps there are other explanations. In the next chapter, we will examine a range of differing explanations. These explanations all arose from EPR's earlier considerations. The continuists have not yet given up.

The possible adventures of Schroedinger's cat and the observer.

Schroedinger's cat enters the cage. The observer waits.

The cat is in the cage. The dead cat qwiff is increasing with time.

Both the dead cat qwiff and the living cat qwiff are equal. The observer is also of "two minds."

The two minds and the cat qwiffs are separated for simplicity.

The qwiff has popped. There is a live cat.

The qwiff has popped. There is a dead cat.

Nothing Up My Sleeve

There may be no such thing as the "glittering central mechanism of the universe." Not machinery but magic may be the better description of the treasure that is waiting.

JOHN A. WHEELER

A scene from Luis Buñuel's brilliant film, *The Phantom of Liberty*, presents the French Revolution with a novel twist: the revolutionaries cry, "Down with freedom! Give us tyranny or give us death!" Indeed, the price of freedom is high. That old need for security invades our dreams of utopia. Don't we all want to know that there is something controlling us? Don't we all seek something bigger than we mere mortals, perhaps something hidden, something responsible for it all?

No surprise then that quantum physicists sought hidden variables that would return quantum physics from the world of magic to the objective universe of cheap tricks. Is there a hidden order? Were Einstein and his friends, Podolsky and Rosen, correct in assuming that quantum mechanics is incomplete? If they're wrong, what is this thing called "reality"? Is it—as the title of Robin Williams' record album, *Reality/What a Concept*, suggests—just a concept, just something we imagine?

Up until around 1965, the answer seemed to be: no one knows. In fact, no one even knew how to ask the question in a sensible way. Several debatable "hidden variable" theories[1] appeared, notably the theory of David Bohm and later co-workers.[2] Ingenious though they were, they only attracted mild interest from physicists who were already too busy applying quantum mechanics to everyday concerns like nuclear physics. But then came John Bell.

John S. Bell, a physicist working at the Stanford Linear Accelerator (SLAC) and the European Center for Nuclear Research (CERN) on leave from the University of Wisconsin, published a paper in the first issue of a new journal called *Physics*.[3] The paper was entitled "On the Einstein Podolsky Rosen Paradox." Thirty years had passed since the EPR paper had appeared. Bell presented his argument in the form of a theorem and showed that any attempt to produce a hidden variable understructure to quantum mechanics was doomed. In other words, there is no hidden message—this is it. We live in a Zen world and, like Pinocchio, there are no strings on us.

Our search for hidden, controlling strings, the hidden orders we all must obey, is part of our human nature. The first to realize its connection to quantum mechanics was Richard

Feynman. He found that a particle could still be a particle if it could follow two or more paths at the same time.

The Search for the Unseen Order

When I first saw *Man of La Mancha*, the musical based upon Cervantes' *Don Quixote*, I was deeply moved. I, too, had my impossible dream. I, too, felt I was destined to greatness. I dreamed of making my life count in the universe. Perhaps the Nobel Prize, a cure for cancer. The dream was to right the world's wrongs. My mind soared into fantasy.

It still does. I seek the hidden order of the universe; I want to know how God does it. I am not satisfied with my mortal limitations. Jonathan Livingston Seagull has nothing on me. "I want to know, I want to know, my God," laments the superstar Jesus Christ. And so must we all, as we evolve into super-conscious beings.

I have an "I." Even worse (or better, perhaps), I am a physicist. I have been taught to "see" the world in terms of its separate parts, cause and effect-wise, pushing and pulling on one another. Everything must have a reason, to my order-seeking mind. I am in the game of right and wrong, good and evil, and— most important, because I am a scientist—the world of order and chaos.

If only my dreams made sense! The concept of sense is based on our collective and individual need for the cause-effect world, the world of objective realism. Long live my fantasies, say us all! Objective reality is a dream. This dream (or perhaps, as some would say, this nightmare) has not lasted very long. We are just beginning to wake up collectively from it. But is the next experience the real reality? Or is it just another dream, just another world of our dreams?

Imagination is that drive, that dream, that search for the unseen order we all suspect lies beyond the reality we all have grown accustomed to, the facade of life.

The vision of an unseen order has been with us for a very long time. Hero of Alexandria, around A.D. 100, wondered about order.[4] Perhaps one day he wandered with a friend by a sunlit reflecting channel. Watching her reflection in the water may have also raised a question in his mind. Why does the light of my friend's image in the channel appear to come from under the water, at

"Enchanted Sleep" by Doré. Is life but a dream? If so, who is the dreamer?

exactly the same position as my friend? He traced the path of the
light rays in his mind and discovered an interesting and far-
reaching order: the universe is economical; the light rays always
took the shortest path upon reflection to reach his eye.

Fifteen hundred years later, Pierre de Fermat was amusing
himself by playing with bits of glass and our economical
medium—light.[5] Light is bent as it passes from air through glass
or from air into any other medium. Everyone has observed the
old bent-straw trick, whenever a drinking straw is placed in a
transparent glass of water.

Fermat wondered why the light took a bending path.
He soon found the answer. Not only was light economical, it
was also speedy. Light always took the shortest time path
between its source and the eye, even when passing through
different layers of differing media. Thus the straw's light reaches
our eyes appearing bent and distorted in order to be cheap and
efficient. How reassuring!

Around the same time period, A.D. 1650, Christiaan
Huygens, a Dutch physicist, pondered God's opening gesture. He
had devised an improved telescope with which he could see
Saturn's rings clearly.[6] Perhaps he, too, marveled at light's

economy. But if light was really economical, how did it know it was? In other words, how did light know, once it was on the path, that the next step it took was in the right direction?

Huygens saw light differently from his predecessors. He imagined light progressing outward in waves, each wave front carefully duplicating the one just before it, like ripples on a pond. But Huygens saw more. He imagined that each wave front consisted of thousands, even millions, of little transmitting stations, all lined up along the wave front like a rank of soldiers, each soldier in line emitting a pulse, a battle cry, and each minuscule cry, a tiny yelp hardly heard, but all together making a gigantic roar.

Each tiny yelp sends out a little circular wave ripple of tiny crests and troughs traveling through space and time. Together with a neighbor's yelp, that itsy-bitsy cry is reinforced only in the direction perpendicular to the line of the front. All other directions create confusion and the sounds come together randomly and disordered. The soldiers must go forward along the least time path, along the path that can be heard, the one just ahead.

Huygens used his imagination, and even today, in every optics class, his wave construction technique is taught. What a relief—it's just a mechanical trick. The light doesn't really have to know something in order to proceed. It follows the least time paths along the shortest routes by going along all possible paths from start to finish. It does this by sending out little wavelets that bob and weave along their paths in all possible directions. But it is only the least time path that reveals itself; all other paths cancel out in confusion and noise, as the troughs and crests of the light waves slosh together.

The idea is a powerful one. Good thing that light is a wave. For if it wasn't—if light was particles after all—how could we explain its behavior? Such were the thoughts of Richard Feynman, an American physicist in the 1940s, working on his doctoral thesis nearly three hundred years later. Feynman had noticed something magical.

Feynman noticed that classical particles, like baseballs and billiard balls, also follow a least-something path. That something turned out to be *action*, the same quantity that makes up Planck's quantum constant. In every interaction, a whole amount of action units must be passed from one thing to the other. Feynman noticed that classical particles follow a least-action path through the universe. No matter how an object moved, it balanced out energies so as to use as little action as possible.

All physical things move economically, disturbing and disrupting the balance between kinetic energy and potential energy as little as possible.

Hero's least or shortest path for light rays, Fermat's least time paths for bending light, and even Huygen's wavelets all must follow the path of hidden orders. Light follows orders. Feynman found that everything follows the same orders, be it light or be it baseballs.

To create a physical reality is simple. Learn to move by staying as close as possible to a balance of energies. Yet if things were in perfect balance, nothing would or could move at all, or else the universe would be totally bananas (very crazy).

Have we found the hidden orders? Is the search over? The world is a giant machine run by an economical, albeit somewhat cheap, God. In other words, a lawful universe is an economical universe, a balanced universe.

It was turning out that this principle of least action was even more powerful than Newton's laws, for later discoveries revealed that even the laws of electricity and magnetism as well as light followed it. But then, as Feynman puts it:

> How does the particle find the right path? . . . all your instincts on cause and effect go haywire when you say that the particle decides to take the path that is going to give the minimum action. Does it "smell" the neighboring paths to find out whether or not they have more action?[7]

Feynman: How does the particle find the right path?

What happens if we fool light into taking the wrong paths? Can we do this? The answer is yes. When we fool light, we observe the phenomenon called *diffraction*, the bending and interfering of light with itself. The way we accomplish this is by blocking the natural light paths. Feynman states:

> When we put blocks in the way so that the photons could not test all the paths, we found out that they couldn't figure out which way to go. . . .[8]

It may seem strange to think of light particles losing their way. But what about ordinary particles like baseballs? Feynman continues:

> Is it true that the particle doesn't just "take the right path" but that it looks at all the other possible trajectories? And if by having things in the way, we don't let it look, that [it will do something like light does?] . . . The miracle of it all is, of course, that it does just that. That's what the laws of quantum mechanics say.[9]

In other words, we can make matter behave like light. We can block some of the natural paths that matter takes in getting from here to there and cause it to interfere with itself, canceling itself out as light waves would. The world follows all possible paths open to it.

Feynman hoped to find how God gave orders to matter. He found that all possible paths, including the least action paths, contribute to the history of an atomic particle. The particle magically follows as many paths from its present to its future as it finds open to it. This discovery would later stimulate Hugh Everett to formulate a bizarre, parallel universe theory of quantum mechanics. By blocking out the natural or least action path, the quantum interference effects could be observed. By using the idea of a "sum over the paths" available to a particle, Feynman could rid us of any picture regarding quantum wave functions.

But somehow this wasn't enough. Interfering paths or waves still were a mystery.

Bell's Theorem: Separate Houses with a Common Basement

Physicists are human. They, too, have fears and likes, just like everyone else. Their needs for warmth, security, and the pursuit

All possible futures.

All possible pasts.

of happiness are no different than those of anyone else. But quantum mechanics seems to pull the carpet out from under all our traditional beliefs regarding security and predictability. Quantum physics is not "nice." It is not simple and straight-forward. Thus physicists traditionally brought up with the nice formalities of classical Newtonian physics are often outraged or at least disturbed that quantum physics offers no solace to seekers of a deterministic universe.

Classical physics concepts, like all physics concepts, are unfortunately not immune to the slings and arrows of experience. A theory may be beautiful and elegant, but if it doesn't fit the facts, it's just plain wrong. A photon emitted many years ago from a distant star makes its way to my eye. Does it exist if my eye is not there to see it? The question is reminiscent of the age-old puzzle, "If a tree falls in the forest and no one is there to hear it, does it make any noise?" The answer appears so obvious: of course it exists. The photon must be there, like the sound waves from the falling tree, whether or not anyone experiences it. At least, that's the answer if you believe in classical physics.

But alas, quantum mechanics does not seem to agree. Accordingly, the photon comes into existence as a spot on my retina only when I see it. Physicists have been more or less "forced" to accept this mystical position because of the uncertainty principle, which denies existence to objects having both spatial locations and well-defined paths of motion simultaneously. But suppose that the uncertainty principle is simply a sign of our ineptness. Suppose there is a real physical world out there, but we haplessly mess things up as we go about the world discovering it. To our insensitive methods, a whole world remains hidden. Quantum physics does not deny that we play a role in every measurement procedure. Could there be an underlying, unrevealed order to quantum mechanics?

Such may have been the thoughts of David Bohm in the early fifties.[10] Bohm led the chorus of those who followed Einstein's dream of a nongambling God in a revival of the search for hidden variables. By rewriting Schroedinger's equation in a form more familiar to the workers in the field of statistical mechanics, Bohm was able to point to the key difference between classical and quantum mechanics. This difference appeared as a single term in the equations and was given the name *the quantum potential.*

This quantum potential acted upon the real classical particle in much the same way that any field of force would act. Thus the

potential was capable of accelerating and slowing the motion of the particle. In this, it was like the gravitational potential that acts upon an automobile coasting along a hilly highway. But the quantum potential was also different, for it depended on the distribution of an infinite number of possible locations of the particle. No matter—the particle had only one position and one unique path. However, it was practically impossible for us to determine that uniqueness because we did not quite know which of its infinitely possible positions the single particle had.

Though the Russian physicist Vladimir Fock felt that Bohm's position was "philosophically incorrect,"[11] no one really argued with Bohm and his followers in a convincing manner. Yet the followers of Bohr would soon rise to the occasion. The Bohr-Einstein debate would live again.

The date was April of 1957. It was the Ninth Symposium of the Colston Research Society, held at the University of Bristol, England.[12] Bohm presented his Einstein-inspired uncertainty principle position, while Leon Rosenfeld, a contemporary of Bohr, argued for Bohr's complementarity.

Bohm's position was that the underlying assumptions of the uncertainty principle (there cannot be a more deterministic theory than quantum theory) are contradicted by the possible existence of a hidden level of reality. Moreover, Bohm stated, it may be totally impossible to detect this level of reality. Rosenfeld, on the other hand, argued that the world is as we experience it. All hidden variables, if they exist, must be connected to our experiences. They must show themselves. It is the peculiar wholeness of the quantum process, the indivisibility of the quantum of action that must be transferred in any observable process, that denies existence to a hidden, more orderly level of reality. We simply cannot help but disturb the universe whenever we observe it.

It might seem that if we cannot observe anything without changing what we observe, we should perhaps drop the idea that anything exists without our observing it. But then along came John S. Bell and his strange theorem. Bell offered a proof that the hidden variable interpretation sought after by those physicists desiring a deeper, more mechanical, cause-effect basis of reality could reveal an even worse kind of order. Real particles may exist according to Bell, but they follow very strange orders. These orders border on what we now call psychic phenomena.

How did we get to such a strange world view? The heart of the problem for John Stewart Bell was the arbitrary division of

the world into things and observers of things. Quantum mechanics did not really tell us where this dividing line was to be drawn and who was observing what? Bell felt that a study of the problem of hidden variables would shed some light. He had become fascinated with the chapter on indeterministic physics in Max Born's book, *Natural Philosophy of Cause and Chance*,[13] and he had read Bohm's 1952 papers on hidden variables. He decided then to present his thoughts in the *Reviews of Modern Physics*,[14] but due to an editorial error, Bell's paper, written in 1964, was not published until 1966.

In this review paper, Bell expressed his view that earlier mathematical proofs by the eminent mathematician John von Neumann (who decided that hidden variables were not possible because they were inconsistent with quantum mechanics) were too stringent. He successfully constructed a hidden variable theory describing particles that were spinning like tops.

Paradoxically, while he was writing his review, he was also working on a second paper that contradicted the conclusions of the first paper. He had become obsessed with the Einstein-Podolsky-Rosen argument, and it was the content of this second paper that became known as "Bell's Theorem."[15] There, Bell proved that any "local" hidden variable theory cannot reproduce all of the statistical predictions of quantum mechanics.

The key word in his paper is *local*, and it means "on the spot," happening at a precise location. A local hidden variable is something that only affects things at a particular location. For example, a bottle of champagne awaits me. I open it and it explodes, popping the cork to the ceiling. That explosion depended on the state of the bubbly in the bottle, locally there in front of me. While it is true that the bottler prepared the shipment of wine bottles, all containing champagne from the same barrel, the condition of the champagne upon arrival depended strictly on the environment within each bottle. Those clods who left their bottles in the sun before they opened them have no excuse for the spoilage that resulted. Certainly, their carelessness cannot affect my bottle, which has been carefully preserved in my cool cellar. Thus local variables are quite reasonable.

Nonlocal variables are not at all reasonable. Change any one of them here and something happens elsewhere instantly. In other words, nonlocal variables are our old friend, the Einstein Connection. Bell's proof showed that hidden variables only affecting the immediate environment would produce observable

results that contradict the predictions of quantum mechanics. In other words, if there were hidden variables that behaved reasonably, there would be observable consequences that were entirely unreasonable. How could they be unreasonable? They would alter the "crap" tables of reality.

And now we come to the second part of Bell's theorem: that local hidden variables cannot reproduce all of the statistical predictions of quantum mechanics. The key word here is *statistical*. All of us are conditioned by statistics. We literally live in a statistical world. Statistics tell us that people only live seventy years, dogs less than twenty. They also tell us how fast we can drive safely, how much we can eat, and what we should pay for life and medical insurance. They even govern what we will be able to watch on television or in cinemas.

Statistics enable us to discern the underlying laws that govern behavior. Whether the subject is baseballs, rocket ships, atoms, or people, statistics describe normal behavior, what we should expect to observe. Consequently, whenever we observe and label something an *abnormality* or a *deviation* we mean that what we observed is not statistically predicted to occur.

Take the famous Nielsen rating system for determining what Americans are watching on television, for example. From just over one thousand television sets, the raters can determine what the whole nation is watching. Why? Because the people watching those Nielsen sets are typical Americans in homes around the United States. They are a sample. If seven hundred sets are tuned to "Happy Days" on a given night, the raters expect that 70 percent of all television sets in the country are tuned to that program. But suppose that the people in the sample system decided to have a conspiracy? In other words, suppose they all decided to watch "I, Claudius" on PBS instead of "Happy Days." Since it is highly unlikely that 70 percent of the nation as a whole would be watching the PBS program, we would have quite a deviation from the statistic norm.

And indeed, Bell's theorem showed that local hidden variables, like the hypothetical hidden conspiracy of the Nielsen sample system, would create results that would deviate from those predicted by quantum physics. So far, no one has ever observed any phenomenon that deviated from that predicted by quantum mechanics. Thus, if there are hidden variables, the rules they follow are not local.

Nonlocal hidden variables or parameters are, therefore, the only kinds admitted to provide the substructure for a

deterministic world. To have an orderly house, you need a collective network basement, one that is common to all of the houses on the block. For nonlocal means just the opposite of local. Whenever a nonlocal parameter varies, it instantly affects objects that are not in its immediate environment. If there were, for example, nonlocal hidden variables governing the opening of my champagne bottle, they would affect the conditions of all champagne bottles processed at the same time as mine. Thus when I pop my cork, the other bottles would also lose some carbonation. And that disagreeable flattening of all those other bottles would occur instantly, at the moment I opened my bottle. While such a deterministic world would give us a kind of cause-effect basis for reality, we would all be victimized by the instantaneous whims of those we happened to have interacted with in the past. Bell concluded:

> In a theory in which parameters are added to quantum mechanics to determine the results of individual measurements, without changing the statistical predictions, there must be a mechanism whereby the setting of one measuring device can influence the reading of another instrument, however remote. Moreover, the signal involved must propagate instantaneously, so that such a theory could not . . . [satisfy Einstein's objections in the EPR Paradox].[16]

Clearly, the price of determinism is too high. We sought hidden variables in the first place to rid us of those tachyonic (faster than light) ghosts. But if we insist on a well-ordered world of observation, the underworld is indeed magical.

The rules followed by hidden variables are far more unruly than the laws of observed variables. The deeper we go in our search for law and order, the more we find ghosts and goblins, monsters and boogeymen. "Is there any hope?" cry the classical realists. Yes, provided that someone can prove that quantum mechanics yields the wrong predictions about the world. So far, however, quantum physics has given excellent results.[17]

Probing the depths of reality is much like probing our own depths in a psychological study. I am reminded of Carl Jung's *archetypes*, forms of what now is called the "collective unconscious mind." These forms are, in some sense, buried in a deep pool called "the unconscious." They are said to exist in all of us. But do they? I think not. Furthermore, I don't believe there is any collective unconsciousness at all. We create it when we seek it, in much the same way that physicists create "hidden variables" when they seek an underlying order to reality.

Thus, there are no "hidden variables." Why not? Because, simply, we don't need them to explain anything. The world is already paradoxical and fundamentally uncertain. Further digs lead not to anthropological discoveries, but to human's creative ability to form from that which is not, that which *is*. Since there is nothing out there until we find it, we are discovering nothing more than ourselves. No wonder we find paradox wherever we look.

We are that nothing we seek. Just as zero is both plus 10 and minus 10 at the same time, we are composed of complementary properties. If we seek ultimate order or ultimate chaos, we create a monster. What we seek already preexists as imagination or can exist because of imagination. Our imaginations are constantly changing. Nothing is forbidden to them. If quantum physics continues to give a correct picture of reality, then perhaps little is impossible. As one physicist put it: that which is not forbidden is compulsory.

We Has Found the Hidden Variables: They Is Us!

A few years ago I visited physicist John Clauser in his laboratory at the University of California, Berkeley. We had been attending a series of discussions concerning Bell's theorem. Clauser was one of the first physicists to attempt an experiment measuring the limits set by Bell's mathematical theorem. His results confirmed quantum mechanics; the hidden variables, if they existed, were nonlocal. As I entered Clauser's lab, I was amused to see, attached to his door, the words that introduce this part of the chapter. They are adapted from these immortal words of Pogo, Walt Kelley's comic character: "We has found the enemy, and they is us!"

Clauser's experiment tested what we meant by physical reality—specifically, objectivity and locality, which he abbreviated as $O + L$ or simply OL. Objectivity is what we have been talking about up to now in this book. It means the existence of a physical universe independent of the actions of my thoughts. The opposite of objectivity is subjectivity—the world as it appears through my eyes. Colors for a color-blind individual are subjectively influenced. So are likes and dislikes of people's personalities.

A world without objectivity and locality would be a very subjective world. It would consist of one element: me. This is the world of the quantum solipsist.

The world of the quantum solipsist bears some resemblance to Descartes' "I think, therefore I am." A quantum solipsist says: I am the only reality. Everything out there is in my mind. To change reality—that is, to change objects into different objects—I need to change my mind. To the extent that I am able to do this, so appears the world as I see it. My failures to achieve dramatic results, such as floating off the ground or traveling backwards and forwards in time as easily as I do so in space, are perhaps due to my lack of imagination.

Similar to solipsism, we have a way of thinking called *positivism*. Positivism denies everything except sense perceptions as the only admissible basis for human knowledge. What we know is simply what we sense. In contrast, let us add the two ingredients, objectivity and locality. Objectivity means material reality, and locality means that whatever happens here and now can only be caused or affected by past events that were materially connected to the here and now.

And now let us look at a letter written by philosopher Karl Popper to physicist John Clauser, whose experiments confirmed that both objectivity and locality were impossible. Clauser's experiments showed that a world that is both objective and local—attributes we normally take for granted as the basis for our own world—is not our world. Our world conforms to the rules of quantum mechanics, and quantum mechanics (QM) denies material reality and locality. Clauser and Horne describe their results in the conclusion of their 1974 paper in the *Physical Review D:*

> Physicists have consistently attempted to model microscopic phenomena in terms of objective entities, preferably with some definable structure. The present paper has addressed the question of whether or not the existing formalism of quantum mechanics can be recast or perhaps reinterpreted in a manner which restores the objectivity of nature, and thus allows such models (deterministic or not) to be made. We have found that it is not possible to do so in a natural way, consistent with locality, without an observable change of the experimental predictions.[18]

Popper's letter to Clauser is dated August, 1974. He wrote:

> Many thanks for your immensely interesting paper. I still cannot believe that Objectivity + Locality is untenable. In fact, I do not

think that Bohr would have expected it, in spite of the fact that
he rejected Einstein's pleading for OL. It is only now, due to Bell
and to your group, that the implications of QM become clear;
though it is also clear that Bohr discerned them, if somewhat
dimly. (Still, should Wigner too be right in discerning that QM
implies solipsism, then QM *must* be false, in spite of your and
Freedman's shattering results. Do not forget that positivism
(Mach) rejected atomism.)

I am more than puzzled. If positivism is objectively right, why
should I accept objectivity "thus far, *and no father*"?[19]

Clauser's experiments went against objectivity and locality (OL).
But in supporting quantum mechanics (QM), they tended to
indicate that positivism and solipsism are closer to truth.
And that is a very strange situation, indeed. Suddenly everyone
out there is you. Popper's last remarks are a play on the
paradox of objectively knowing that there is no objectivity
or fathers.

Let's look at an example of quantum solipsism in action. Life
is a great teacher. But too often we confuse its messages. Have
you ever noticed how stubborn some people are? Perhaps one
day not too long ago, you may have said to someone, "You are
very fixed in your attitude about that." Or you may have
observed that your spouse kept belaboring a point that you
would gladly have given up. Why do others behave that way?
In a world of objectivity and locality, what you see about the
world outside of yourself is what is. The other person is stupid
and pig-headed. You have merely been the observer of that fact
and been kind enough to point it out to the stupid person you
are dealing with. Perhaps the person benefits from your
observation. He might say, "Thank you for pointing that out
to me. It's just that lately I have been worried about the prices
of Japanese kumquats."

Your observation of that person's quality of obstinacy is an
example of objectivity. His admitted worry about kumquat prices
is an example of locality. The problem that occurred between you
and him, then, was not influenced by you. He was at fault. Does
this little scenario seem familiar to you? Does its explanation
in terms of objectivity and locality make sense?

But let's look again, this time through the eyes of a quantum
solipsist. That other person is you. His pig-headedness is not
his quality but a projection of *your* thoughts. If he appears
stupid, you are looking at what you see as stupid. In other words,
you are looking at your own stupidity, your own pig-headedness.

That other fellow is nothing more than a mirror of you. He does what he does as you see it for you to learn about yourself. Your experience of his feelings and attitudes are your own feelings and attitudes.

The quantum solipsist is a powerful individual, for after all he or she is the whole universe. He uses his power in magical, beneficial ways. He uses his mind. Perhaps the hidden variable is the mind?

Losing Our Minds

Consciousness and Parallel Universes

There are no strings on me.

PINOCCHIO

What Kind of Machine Am I?

If there are no strings attached to us, why do we experience the world as if there were? Eugene Wigner, Nobel Prize winner in physics, believes that our consciousness alters the world itself because it alters how we appraise the future. That is, we experience the world the way we do because we choose to experience it that way. In an amusing example, now called "Wigner's Friend," we see how it is that a friend's consciousness alters reality and leads to a disagreement.

But what is this thing called consciousness? What is its place in quantum mechanics? Hugh Everett III completed his graduate studies in mathematical physics at Princeton University in 1957. He offered in his doctoral thesis an outrageous solution to this question: no consciousness is necessary in quantum physics. The future is not altered by consciousness. Rather, *all* possible futures really happen! Instead of a single universe proceeding in a haphazard, conscious-ness-altering "drunkard's walk," there are an infinite number of "parallel universes," all proceeding on well-ordered qwiffian flows into the future. And we are on all of those universe layers!

By their nature, all these universes are parallel and none overlap. Therefore, we are only aware of the universe layer we happen to be on and not the others. Every action taken is an interaction that acts like a fork in the road for a wayfaring traveler. Only the traveler need not make up his mind; he is on both forks simultaneously but aware of only one of them.

Every observer, in Everett's view, is nothing more than a machine with a memory. The apparent freshness of experience on any single universe layer is due to the uncertainty principle. Consciousness is the quantum connection between the numerous layers making up the quantum machine. In other words, we are quantum mechanical "golems."

The Golem: A Machine with Consciousness?

The roots of the story of "The Golem" can be traced to the Jewish ghettos of medieval Germany.[1] A pious spiritual leader, Rabbi

Loew, known to be a master of the deeply mystical, magical Cabala (or Kabbala), created a "practical" use for his magic. He created the golem, an attendant who would serve his people in their sufferings and struggles, bringing aid to the oppressed community. "He shaped it from clay, endowed it with spiritual breath, and made it a doer of wonders." Can we repeat the Rabbi's miracle today?

My first encounter with golems came in the fall of 1973. I had been given a small grant from the University of London, Birkbeck College, Department of Physics, to make a computer-generated motion picture of the interaction between ions and molecules. As a result, I decided to submit the film to a computer arts festival being held in Edinburgh, Scotland. There I met Professor Ed Ihnatowitz from the Department of Mechanical Engineering at the University of London. Professor Ihnatowitz has a remarkably inventive mind. Even more remarkable, he is also a renowned artist and sculptor. But before I tell you about his work, let me tell you about the festival.

Every year, in the fall, the city of Edinburgh hosts an arts festival. It is a week-long gala event that celebrates much that is new in European art, including the performing arts. Recently computers have come into their own as an art medium. One ingenious creator even composed a computer ballet with the performers wearing the most unusual costumes.

Professor Ihnatowitz was exhibiting, among several of his works, a film of one of his "sculptures." At the time, the actual "sculpture" was on exhibition at the Eindhoven Museum in Holland. It consisted of a large, tinker-toylike construction in the form of a prehistoric beast. It was bigger than an elephant, perhaps shaped more like a giraffe. Furthermore, it moved. The professor included in its mechanical design a sensitive sound receptor, one that would respond differently to sounds of varying pitch and loudness. The receptors were attached to the creature's head, much like ears.

To the delight of children, who were ceaselessly enthralled with its antics, the "beast" would respond to their squeals by lowering its head from its lofty height to the level of the children's mouths. It was listening to them and wanted to bring its "ear" closer. That is, it would listen until the child happened to make an unpleasant noise. Then it would jolt its head upward, away from the unpleasantness and return to its haughty position.

I was quite impressed with the film and the inventiveness of the beast's creator. But the way the creature entertained children wasn't the amazing part of this invention, although that is what it had been designed to do. It seems that each

morning, when they opened the museum, the attendants were perplexed to find that the beast had laid its head on the ground as if it were asleep. As soon as it "heard" them, it would, as if awakening from its sleep, turn its head toward the pleasant sounds of the attendants' low, morning voices. Since this behavior had not been programed into the device, it was at first difficult to see just why it was "going to sleep at night." Could it have gotten bored? For many days, this uncanny "lifelike" behavior created quite a stir.

But soon enough the reason for its behavior became apparent. Can you guess what it was? It turns out that, in a sense, it was getting bored. Once the museum had closed, shutting out voices, only the sounds generated by other machines within the well-insulated building broke the silence. One of those machines was the air conditioner housed on the floor below the beast. The beast, like a child listening to its mother's heart-beat, was listening to the pleasant hum of the air conditioner. With no other voices to keep it company, the creature sought out the only "living" companion around it—another machine.

For some reason, I was quite moved by the behavior of the beast. Later I asked the professor how the unexpected behavior of his creation affected him. He responded by telling me that this was quite a usual case among his inventions: the things did the unexpected. Is it possible we may build a sophisticated, thinking device that will surprise us by exhibiting self-generated, intelligent behavior? What then constitutes the difference between living things and machines?

The possibility of creating an intelligent mechanical device, a golem, is greater today than ever. This is undoubtedly due to the great advances in microminiaturization of electronic circuits called "chips."[2] According to a recent article in *Future Life*, what formerly required 400 cubic feet of hardware to store one million characters in computer "memory" now takes only .03 cubic feet, about the size of an American baseball.[3] As our hardware technology becomes smaller and smaller, we shall ultimately be faced with quantum physics. Perhaps we are quantum machines.

The Mind of Professor Wigner

Einstein once remarked that the only incomprehensible thing about the universe was that it was comprehensible. We are

able to understand and find meaning in our lives and in the world we all expect to see each morning when we rise from our slumbers. But how does that happen? How is it that you and I can agree and find meaning in the world? From a quantum point of view, this is a real question. The evolving future "seems" to be attached to the past. We "seem" to be governed by our past conditioning. We are much like puppets with someone else holding the strings. Why?

Eugene Wigner offers us an answer. This Nobel Prize winner in physics suggests that our consciousness alters the world by altering us. It affects how we appraise the future. And it does this by altering our own quantum wave functions, our qwiffs. Since our qwiffs contain all possible futures, it is our wills that change those probable futures into an actual present. This happens as a result of the impressions we gain whenever we interact with anything. Wigner describes the process:

> The impression which one gains at an interaction may, and in general does, modify the probabilities with which one gains the various possible impressions at later interactions. In other words, the impression . . . called also the result of an observation, modifies the wave function of the system. The modified wave function is . . . unpredictable before the impression . . . has entered our consciousness: It is the entering of an impression into our consciousness which . . . modifies our appraisal . . . for different impressions which we expect to receive in the future. It is at this point that the consciousness enters the theory unavoidably and unalterably.[4]

So we experience the world as if it were on strings and tied to the past or to a "heavenly manipulator" because we cannot precisely control the results of our choices. Ultimately, each of us is the source of our own joys and sorrows, through such choices, our own wealth and poverty, and all that we experience. But the impressions we gain are unpredictable. They modify our wave functions just as the fiddler's fingers on a violin change the waves on the strings. You are the fiddler. It's time to leave the security of the inside "past" of your "time" house and climb onto the "future" roof. It is because these impressions are undetermined that you have this power. You are the "fiddler on the roof." But the tune may not come out exactly as you wish.

What I am pointing to is our power, as individuals, to influence events in our everyday lives. Quantum mechanics clearly shows that nothing can be predetermined, no matter how events may appear. Not only is ours a small world, it is a Zen world after all. You may object and claim that you can't change because people remember how you are, that you are powerless to change

anything. But the indivisible quantum of shapable action proves you wrong.

Even our concept of memory needs revision. The unrelentless quantum shows that the past as well as the future, is created. There is no past. There is no future. We create both, continuously and in unpredictable ways. *This* is it. There are no hidden messages. If, for only an instant, you sense this overwhelming fact of your existence, it will alter your future now as you hold this book in your hands. You can't help but sense a feeling of power. No one knows you. You know no one.

"But hold on," you say. "Of course, I know my daughter. Why, she is right here before me. What do you mean?" You want to know how we can experience the same things and know by our communication that we are doing so. Surprisingly, quantum physics can provide a solution to this puzzle.

How is it that we share a common reality? We shall answer this question in two ways. First, we will look at an amusing example provided by Professor Wigner. It has been given the name, "The Paradox of Wigner's Friend." We shall then extend this example into the following section, which concerns what I think is the most outrageous idea of reality ever to hit the fans of consciousness. Whereas Wigner's friend creates reality through acts of consciousness, the parallel universes theory rids us of consciousness altogether! However, be prepared for a shock. What replaces consciousness is a far more mystical and magical enterprise, for we live in an infinite number of continually interacting universes.

The Paradox of Wigner's Friend

Consciousness is the creative element in the universe. Without it, nothing would appear. There is no sound without ears, and there is no Schroedinger cat, living or dead, without you to open the cage. Quantum mechanics does not explain this; Eugene Wigner simply postulates that it is true. Although some readers will undoubtedly object that I should use the word *consciousness* in this manner, I feel justified in defining consciousness as "that element outside of the physical universe that collapses the qwiff, producing the observed result from its range of possible situations."

Professor Wigner appears to agree with me.[5] Here is how he

approaches the problem. Just before you open the cage, there are two cat editions superimposed in the cage. But the instant you open the cage *one* of those editions becomes the real cat and the other edition vanishes. That is, the buck stops in your mind the moment you know the cat is alive (or dead). To emphasize the point, Wigner has us consider the amusing paradox of his friend.[6] It goes like this:

Wigner's friend is carrying out an experiment. He has placed a particle in a box and closed the box. According to quantum physics, the bound-in particle no longer has a well-defined position, but now assumes the form of a standing wave pattern inside the box. This wave pattern tells where the particle is likely to be found but not where it actually is. Furthermore, because the particle is contained, its momentum is also indeterminant. It could be moving toward either the left side or the right side of the box.

To find out what is happening inside the box, Wigner's friend decides to open two sides opposite each other at the same time. The removal of the two opposing walls causes the standing wave pattern to split into two opposite, moving wave pulses. After awhile, both pulses will pass through their respective

The parable of Wigner's friend.

Wigner's friend has captured a qwiff in a box.

The qwiff describes a particle. If the friend opens the box, the particle can escape from either end.

The qwiffs are running from the box; the particle has not been detected yet.

openings. The friend then sees the particle on the left (right) side of the box and records his observation.

At this point the professor appears. He explains to his friend that he was carrying out an unusual experiment that involved both the friend and the particle. The professor had placed both in a very large box. Thus, according to quantum laws, even the friend's observation of the particle was split into two possible editions. In one edition, the friend sees the particle on the right of the box, and in the other edition, he sees it on the left side of the opened box. The professor points out that it was his kind observation of the friend and the particle that "created" the friend observing the particle when he (the professor) had opened his bigger box! In other words, the friend and the particle owe their very existence to the professor's kind observation.

Wigner answers the paradox by stopping the observational

Aha! The particle has been seen; the qwiff has collapsed and popped.

But hold on, there is a professor who is observing the observer and the particle qwiff.

The professor claims the right for popping the qwiff and making up the observer's mind.

buck with the friend in the first place. Accordingly, his friend's mind created the particle's position, so when the professor opened the larger box, he only saw what was already there. But is this really a solution to the problem? Wigner felt it was the only acceptable solution. We know that consciousness or mind is affected by physicochemical conditions, so why shouldn't the mind, in turn, affect those very same conditions? Thus Wigner is forced to go beyond quantum mechanics to find the means by which consciousness collapses the qwiff and produces reality as observed from the unobserved, potential quantum world. So far no one knows how to do this in a completely testable mathematical model.[7] But do we need to go beyond the already outrageous postulates of quantum physics to create the world? Hugh Everett III doesn't think so.[8] However, the alternative he offers is perhaps even stranger. He asks us to accept quantum mechanics at its word. The world is not just in our minds until we create it—it is really out there and in all of its editions at the same time.

An Infinite Number of Parallel Universes

Everett added an amusing aside to the paradox of Wigner's friend.[9] When the professor reveals that he "created" the friend and the particle, the friend does not respond with gratitude. Instead, he points out that yet another observer may have placed all three of them—the professor, his friend, and the particle— in an even larger box. Thus, they may not have any independent, objective existence until this third observer opens his box.

Do we exist in a nest of Chinese boxes, wherein each box owes its existence to a larger box in which it happens to be nested? Who opens the last box? Is there a last box, or does the series of boxes go on forever to infinity, all of them waiting for God to observe his or her own dream? If reality is just a dream, who is the dreamer? If there is only one dreamer and I am that dreamer, then nothing exists but me. This is the solipsist's position, and it is not a very popular philosophy. It is, however, logically consistent. To get out of the nested boxes, Everett posed another solution: all possible editions of reality really exist.

Jorge Luis Borges, in *The Garden of the Forking Paths*, described such an outrageous world as

an infinite series of times, in a dizzily growing, ever spreading network of diverging, converging and parallel times. This web of time—the strands of which approach one another, bifurcate, intersect or ignore each other through the centuries—embrace every possibility. We do not exist in most of them. In some you exist and not I, while in others I do, and you do not, and in yet others both of us exist. In this one, in which chance has favored me, you have come to my gate. In another, you, crossing the garden, have found me dead. In yet another, I say these very same words, but am an error, a phantom.[10]

To grasp the idea of parallel universes, we need to review the possible alternative explanations of reality provided by the interpretations of quantum physics.[11] *The* problem is how to explain the universe with more than one observer in it. Furthermore, we need to understand how it is that we—all of us observers—can come to any agreement at all about what we observe.

Why is there a problem? The most common interpretation postulates that the world changes in two fundamentally different ways: it pops and it flows. A pop is a sudden, discontinuous change brought on by any observer's act of observation. This change is sudden and noncausal. It cannot be predicted even by quantum mechanics. Therefore it is outside the ability of quantum physics to predict the capricious behavior of nature. Whenever the world "pops," someone has observed something. Until the "pop," the world remains unobserved.

The world also changes in a continuous, flowing manner. But it is not the objects of the world that change in this way. Rather, it is the qwiffs, which represent those objects, that change in a continuous, flowing, and causal manner. The qwiffs, however, only represent reality; they are not reality any more than the oil-tongued ambassador who represents a country is the country he represents. His country may be undergoing revolution while the ambassador appears quite calm and smoothly tells us that all is well back home.

Qwiffs represent what *could* take place in reality. Quantum mechanics predicts with certainty the behavior of qwiffs. Qwiffs predict with uncertainty the behavior of matter. If the world was somehow totally represented by the qwiff (or, in the case of the ambassador, if a representative could be found for

each person in the country), the world would then flow and not pop. The world would then be totally predictable.

But the world is not predictable in principle. The problem is the magical ingredient that pops the qwiff. Who decides when the world is to flow (remain unobserved) and when it is to pop (be observed by someone)? Einstein expressed the dilemma more colorfully when he said that he could not believe a mouse could bring about drastic changes in the universe simply by looking at it.[12] If the mouse doesn't pop qwiffs, who does? Can only human beings pop qwiffs? Does the mouse live in a qwiffian ghost world of all possibilities happening at once? Perhaps it is better to be a mouse than a human being!

From this perspective, the paradox of Wigner's friend seems more realistic. For instead of there being a series of nested observers, each observing another observer, you yourself are that nested series. Your electrons are observed by your atoms, who are, in turn, observed by your molecules, which are watched by your cells, which are seen by your organs, which are monitored by your nervous system, which is willed into action by your brain, which is observed by you, and you, in turn, are watched by . . . where does the buck stop? At what point does reality finally and totally exist? Quantum mechanics does not tell us where consciousness enters to record the event. Instead, it tells us in principle how all of the above interact. It predicts that, at each level of interaction, a bifurcation or sometimes even a multifurcation takes place. It says that, at each level, equally likely possible paths come into existence as a result of interaction, just as in the example of "Schroedinger's Cat." Quantum mechanics never says when a single cat appears. As far as quantum mechanics is concerned, all possible paths are represented by the qwiff.

But if one postulates that consciousness exists outside of the physical world, where does it enter? There does not appear to be any convenient entering port for the mind to reach in and pop the qwiff. We may never discover a way that is consistent with the world as we observe it. So far all attempts to modify quantum mechanics to include consciousness have fallen short of explanation.[13]

Everett listed five alternatives by which the paradox of the observer may be resolved.[14] The first alternative we have already mentioned. There is only one observer in the entire universe, and each reader may rejoice because—you are it! All other people follow the laws of quantum flow. They remain in a state of suspended animation, or however you wish to think

of them, until you come along. Only you pop the qwiff. Congratulations! I thank you for creating this book and the writer who is writing these words. But then you knew these words all along.

The second, third, and fourth alternatives limit the validity of quantum physics.[15] Each of them, in a sense, states that something must be added to quantum mechanics. Yet, as we have seen in this book, it is not easy to do this in a consistent manner without making quantum mechanics weirder than it already is. At this point, what you add to the recipe ruins the cake.

Thus we come to the fifth and final alternative. It simply states that the world does not pop. All observations by all observers are interactions and therefore governed by the causal laws of the quantum universe. All is flow. The world is continually changing in a smooth fashion. However, it is a bizarre world consisting of all possible worlds. There is only one qwiff — the master qwiff, with all of its branches spread out in space-time like a network of the grandest design. There is no consciousness. None is needed.

The mouse does not change the universe; it is changed by the universe. Multiple copies of itself are formed with its every observation, and each copy follows along like an automaton. However, each copy remembers what it saw in the previous interaction, and each copy is sensitive to changes that take place in its environment. In one mouse universe, white cheese is remembered; in another, parallel universe, the cheese is red. Each time there is an interaction of the mouse and the cheese the mouse-cheese branch of the one qwiff splits into as many branches as there are varieties of the taste sensitivity of the mouse and tastability of the cheese. If the mouse has a highly sensitive tasting apparatus, it notices what kind of cheese it is eating. Thus each copy of the mouse tastes a different cheese. On the other hand, if the mouse is insensitive to the difference between cheddar and swiss, no split takes place. But in either case, the mouse is only aware of its one experience — its individual existence as a single mouse.

"All well and good for mice," you may say, "but what about people? Surely you're not saying that we, too, are automatons?" Yes, indeed, I am. For we are nothing more than the qwiff's branches. Everything that is possible is actually occurring on some universal layer parallel to this one. "But I am conscious!" you cry. "I am more than a machine!" And yes, you are. You are a qwiff branch. You are in every branch of the universal wave

function. And in every branch of the Big Qwiff you are only aware of that single branch. Why? Because that is what a branch is: an offshoot from an interaction between the various possible things that could interact. And since all things can interact, they do.

"But why can't I get what I want when I want it?" you may ask. The answer is that some things can occur in more ways than others—in other words, there are more branches. The world branch you happen to be on, and where you are reading this book, is one of many branches that happen to occur more often than other branches where you are not reading this book.

Let's look at an example. In it we shall explain how it is that each of us is only conscious of the layer we happen to be on and how it is that we all are aware of each other. We shall also see how it is that we can come to any kind of agreement about what we each observe. Furthermore, this example will help us to understand how it is that we can have disagreements about what takes place in our lives. Thus, from this point of view, we shall learn how it is that several people can witness an accident and come up with entirely different stories about what took place.

People are sensitive creatures. They are able to respond to various kinds of stimuli in remarkably sensitive ways. Consider the sense of smell. Just a few molecules whiffed tells us that the potatoes are burning! Indeed, sensitivity is an important ingredient for living things. And we can use human sensitivity to help us understand how we can exist on several layers or universal branches of the Big Qwiff and yet only be aware of the edition we are on.

We have all heard the expression, "Boy, is she sharp!" We know that the speaker means the lady is quite intelligent. Sharpness can be defined as "the ability to discern differences or make differences where none were perceived before," as when one uses a sharp instrument to cut something. In fact, the root word *skeri*, meaning "to cut," is the Indo-European root for the word *certain*. Thus a sharp mind "cuts" or separates one observation from another.

Now let us imagine that we have found such an individual, a person who is able to tell the differences between cheddar and swiss cheese. The cheese has been ground up, so no obvious visual clues as to the identity of the cheese are available. To tell what variety of cheese we have, the cheese must be sniffed or tasted. According to the many-worlds version of quantum mechanics, once the discerning lady tastes the cheese, she

immediately splits into a large number of duplicate copies of herself, one edition for each possible variety of cheese imaginable in the untasted batch. In each universal layer, she knows just what she tasted. The layers are quite distinct, as distinct as the ability of her taste buds and intelligence to perceive the remarkable differences in the taste of cheese. Then along comes a friend.

Now there are two possible kinds of friends. One kind includes equally observant cheese-tasters and the other kind includes clods who cannot tell the difference between "liederkranz" and "mozzarella." But let us suppose that this friend is the discerning kind of friend. The lady offers her friend a sample of the cheese. Of course, he does not know what is in store for him—namely, that as soon as he tastes the cheese, he will split into a billion replicas of himself, each replica blessedly unaware of the split. But our unknowing but game friend tastes the cheese. If he is as sensitive to the taste of cheese as the lady, he will share his worlds with her. So on each layer that the lady tastes cheddar, we will find her friend as well, also tasting cheddar.

However, our story is not over yet. Does the friend know that what he tasted is the same as what our discerning lady tasted? Can the two of them find happiness together in their branch of the Big Qwiff? Well, yes, if they agree that they have tasted the same thing. And for that to happen, the friend has to observe the lady as well as the cheese. Did she taste the same thing he did?

To be certain she tasted the same thing that he tasted, it is not enough to just ask. Cheese tasting is quite an art. It requires discernment beyond words. And that is where he can run into trouble. If he is too sensitive to her, he will find that not only is he on a different branch corresponding to the different possible cheeses of the Big Qwiff, but each of these branches also has a billion or more fine branches corresponding to all of her taste bud differences. For example, the cheese may indeed by Mozzarella #324, Batch #867. Yet although he knows this, his extreme sensitivity to her tastes will cause him to be on a different fine branch corresponding to her description. Thus she may say that the cheese is bittersweet and tacky, with a slight aroma of Kentucky bluegrass. As a result, her friend's experience of the cheese and of her will be different than if she said the cheese has "a slight aroma of morning bluegrass."

This could lead to confusion because, while he is not equipped to sense those differences in the cheese, he is equipped

to sense those differences in her. And, therefore, for the two of them to have complete agreement, he must be insensitive to her whims of tasting, her fine structure. Let's suppose that he has the required insensitivity to her and the required sensitivity to cheese. Then they will be in agreement about what they each taste no matter which layer of the splitting-cheese part of Big Qwiff they are on. In other words, they are on all of the layers and not aware of any but the one they are on. She tastes Cheddar #1 on Layer #1; he tastes Cheddar #1 on Layer #1; and he sees that she tastes Cheddar #1. Now repeat the preceding sentence, substituting 2, 3, . . . on to infinity. Then go back and repeat it for Mozzarella #1, #2, #3, and so forth.

Disagreements are due to different sensitivities. Learning to get along sometimes means not getting too specific. At other times, it means getting specific and enjoying life's many universal branches. You are enjoying them even if you don't know that you are. So you might as well start to enjoy life; you will anyway.

Of course, there is more that we could say about the parallel universes interpretation of quantum mechanics. I must admit that I find it reassuring that reality as a whole is completely deterministic, all of it flowing while my little piece of the Big Qwiff appears to suffer from indeterminism and the uncertainty principle. What is remarkable about this interpretation is that it shows that the mathematical formalism is capable of determining its own interpretation. In short, it is what it says it is.

It was this observation that led Everett to write his thesis in the first place. Bryce S. Dewitt and Neill Graham have put together Everett's original papers and the comments of other physicists in a remarkable little volume entitled *The Many-Worlds Interpretation of Quantum Mechanics*.[16] Dewitt also included his own exposition on the subject, which I found particularly clear.[17] One of the most important ideas in Everett's work is that the normal worlds occur in greater abundances than the maverick worlds where everything goes crazy. This is because the relative frequencies of occurrences of events taking place on any one branch are matched almost exactly by the number of branches in which a single occurrence takes place. Thus, an experiment in which 50,000 coins are flipped in the air gives the same probability of a single head occurring as an experiment in which just one coin is flipped.

Finally, can we jump from one branch to another? The

answer depends on your interpretation. Since you are on all branches in which you exist, there is no need to jump, for where would you jump to when you are already there? But if you don't like parallel universes, then you can't help but jump because you are popping the qwiff every time you choose to do anything. The only reason you can't do what appears to be impossible, like flying or floating in the air, is that the worlds in which you can do such things may be maverick worlds in which you don't exist as you.

So what can you do? Anything you want to. You are doing it. To get to any branch of the multiple-branching, universal qwiff is simple. Just become aware of what you want to do. From any branch there is a pathway leading to any other branch. Time is all you need, and time is really all you have to work with. So it becomes clear. Time is the necessary medium for change. Consciousness is the awareness of any particular branch you happen to be aware of. If you were aware of all of the branches at one time, you would know all there is to know, sense all there is to sense. You would also see the whole universal qwiff, for you would be able to see with certainty how all of the branches began and how they must end.

When this moment occurs, you are free. Until it occurs, keep making the impossible possible. Keep choosing which branch you wish to sample life on. Remember that you are on all branches that you can exist on. It's up to you which branch you happen to be sampling now. And since joy for all people is desired, eventually all will be joyful if that is the branch we all wish to be aware on.

Think of the branches as branches of a tree and of the sense of self you now feel as the sap or lifeblood of the tree. Feed the good branches.

Human Will and Human Consciousness

The universe begins to look more like a great thought than a machine.

SIR JAMES JEANS

Queerer Than We Can Imagine

What an imagination! No doubt you have said that about someone or have had it said about you. Usually, when we think of someone with a vivid imagination, we think of a person who is able to put together things or concepts that were previously unthinkable. Paper milk bottles. Air-sailing. Skydiving. Mini-card computers. The list is endless. Who thinks up such things? How do people do it? Well, if Professor Richard Feynman is correct, imagination is as natural for man and nature as breathing. He describes it as wonder. He wrote:

> For instance, I stand at the seashore, alone, and start to think . . . There are the rushing waves . . . Mountains of molecules, each stupidly minding its own business . . . Trillions apart . . . Yet forming white surf in unison . . . Ages on ages . . . Before any eyes could see . . . Year after year . . . Thunderously pounding the shore as now. For whom, for what? . . . On a dead planet, with no life to entertain . . . Never at rest . . . Tortured by energy . . . Wasted prodigiously by the sun . . . Poured into space . . . A mite makes the sea roar . . . Deep in the sea, all molecules repeat the patterns of one another till complex new ones are formed. They make others like themselves . . . and a new dance starts . . . Growing in size and complexity . . . Living things, masses of atoms, DNA, protein . . . Dancing a pattern ever more intricate . . . Out of the cradle onto the dry land . . . Here it is standing . . . Atoms with consciousness . . . Matter with curiosity . . . Stands at the sea . . . Wonders at wondering . . . I . . . A universe of atoms . . . An atom in the universe.[1]

Atoms with consciousness, matter with curiosity? Are these peculiar statements for a physicist? I don't think so. They are simply recognitions of undeniable facts. That particular recognition, the perspective that allows mind to imagine that it, mind itself, exists as mind, I call consciousness. Consciousness without imagination is a contradiction. Mind that lacks wonder is mindless.

But what is "mind"? Perhaps the best definition I can give is that mind is "the metaphor of all possible metaphors." For example, we see ourselves in our "mind's eye." Mind is stuffed with metaphors, is itself a metaphor. Mind looks at itself in order to know that it exists. As you read this, perhaps

it becomes evident that anything we say about anything is a metaphor, the substitution of one experience for another. Every definition is always "in other words." In other words, "in other words" is a substitute. Writing or talking about the process is like holding up a mirror to a mirror to see what a mirror looks like.

Mind looking at mind is a similar process. Since atoms with consciousness are looking at atoms with consciousness, we have the same experience of wonder and mystery whenever we look at the universe. We are looking at ourselves. It is this process that we call the universe. Professor Feynman goes on to say:

> So what is this mind, what are these atoms with consciousness? Last week's potatoes! That is what now can remember what was going on in my mind a year ago—a mind which has long ago been replaced.
>
> That is what it means when one discovers how long it takes for the atoms of the brain to be replaced by other atoms, to note that the thing which I call my individuality is only a pattern or dance. The atoms come into my brain, dance a dance, then go out; always new atoms but always doing the same dance, remembering what the dance was yesterday.[2]

If it is true that the universe is nothing more than mind looking at itself, then what is self?

The Quantum Mechanics of Human Consciousness

What am I? I'm sure the question has crossed your mind as often as it has crossed mine. Am I simply a machine? Is my mind an illusion, a simple construction that arises out of my mechanical brain? Am I, as John Lilly put it, "a human liquid bio-computer"? Somehow, deep inside of me, I feel that I am more than that. At least, I think I must be. If I am more than a mechanical device, then what distinguishes me from a can opener or a washing machine?

The answer appears to be my consciousness, my mind. But this is not an easy answer to understand, for what do I mean by my consciousness, my mind? In this chapter, I hope to define consciousness by showing what it *does* rather than what it *is*. As a physicist, I learned a long time ago that you never can really say what anything is, only what it does. When I say that an electron is a particle carrying a negative charge of

electricity and a magnetic moment, I am only describing how an electron behaves.

Similarly, consciousness is what consciousness does. And what does it do? It performs a dual role in the universe. In the world of the quantum, it is both the awareness and the creation of experience. It is the *being* and the *knowing* of experience. With the stroke of the twentieth-century quantum eraser, the dividing line between ontology (theory of being) and epistemology (theory of knowing) is rubbed out.

In short, knowing is mind and being is matter. Just how the two separate is the magical process we call consciousness. Professor L. Bass of the Department of Mathematics at the University of Queensland, Australia, has studied their connection, and he sees them in continual interaction. This interaction between mind and matter, or knowing and being, has perplexed philosophers for centuries and is called the "mind–body problem." Bass's paper, "A Quantum Mechanical Mind–Body Interaction," published in *Foundations of Physics*,[3] offers us a solution, one based upon quantum physics, to this ancient perplexity.

The problem has to do with *will*. Just getting the job done is not sufficient. Any old machine will do that. It's *knowing* that the job is *being* done that is the grabber. In other words, when I choose to do something, how does it get done and how do I know that I am doing it? Surprisingly, it is quantum indeterminacy that leads to deterministic choices on the normal level of perceived experience. If this indeterminacy was to vanish somehow, my will would not be done. I would have no choice, none at all.

All of this choosing takes place inside of me because special channels open in the walls of my neurons.[4] Neurons are highly adapted, electrochemical, excitable, elongated cells that make up my central nervous system (CNS).[5] Bass suggests that we have created, through the process of evolution, a device within our CNS. I like to compare this device to an agency, such as the Central Intelligence Agency (CIA). This device, much like the CIA, gathers information.

This device exists as an independently operating agent in each and every neuron, perhaps in each and every molecule, or even in each and every atom. Each agent is free to choose what he or she wants, where he or she wants, and when he or she wants. But the choice is somewhat limited: it is to note or not to note reality. And at these levels of reality, reality noticed is reality created. In a single act of noticing by one of my CNS agents, a pure qwiff pops and a dream becomes a reality.

Bass's model directly connects will with qwiff reality. This reality takes place inside of single neuron. As a result of an encounter of the cell's membrane (substrate) with an active group of atoms on an enzyme molecule inside the cell, the neuron is left in an indeterminate state. The qwiff describes the cell as being in a state in which it cannot be said to have fired a definite number of times. This indeterminate reality may persist over several time cycles (milliseconds).

But then an unusual event happens. This event *cannot* be predicted. It is the conscious noting of the positional configuration of the active atomic group on the enzyme molecule. It is this sudden and unpredicted event that I call the "act of consciousness." When this event occurs, the neuron is no longer in an indeterminate state. Suddenly it has fired a definite number of times. Furthermore, I am aware of it.

In the next part of this chapter, we shall look at a very short period of time—short, that is, in comparison to our normal time perception. The period of time is five thousandths of one second. It corresponds to the period between pulses or firings of a single neuron. As we shall see, much goes on in the human nervous system during this time.

A Quantum Mechanical Mind-Body Interaction: Bass's Model

How do you will something to happen? For example, when you choose to bend down and pick up a pencil, what is going on? Why is it that we sometimes do things with much apparent willful thought, while at other times, after much practice, we just do the same things without thinking at all? An initially directed and conscious action becomes a habit, an unconscious act. Our ability to learn is dependent on our acquiring of habits— for example, the habit of listening. Learning, it appears, is the ability to turn initially conscious acts into unconscious habits, good or bad.

According to Bass, this ability we have is due to the development of the above-mentioned magical device, one that pops the qwiff in our nervous systems. Bass has us place the device right smack in the central nervous system itself. The device was not present in early humans. Conscious direction

of muscular movements confers an advantage in natural selection that might have taken ten million or perhaps one hundred million years to evolve. This device is capable of choice, depending on whether the qwiff has just been popped. Bass argues: "Only the long evolutionary process could justify the introduction of such a device, the construction of which is at present entirely beyond the practical capabilities of science."[6] In other words, the device would produce different results, depending on the behavior of the qwiff, not the matter.

Let us look more closely at the CNS. It is made up of nerve cells. These cells are excitable, capable of undergoing a transformation that involves their ability to transmit electrical impulses along their elongated bodies. These impulses can cause, by minute chemical reactions, contractions of small muscle fibers connected to the nerve cells. It would appear that if this device is anywhere within us, it must be in our nerve cells. Nerve cells control us. But what determines whether a nerve cell fires — that is, undergoes electrical transformation?

Now Bass points out that it is the act of noticing, the event in the consciousness of a suitably located observer, that causes the cell to fire. I call such an event a qwiff popping. When a qwiff pops, the wave function has been changed or modified. From the instant the event is noted, the moment it becomes an event of consciousness, the world is a different place. This is because the appraisal of possibilities now available to the observer has also changed. Thus I notice a pencil on the floor and I reach to pick it up.

This whole process is not simply mechanical. I have a choice. However, the choice is very subtle. It is to note or not note the event. I can make the event part of my consciousness or not. For a pencil lying on the floor, this appears clear enough. But we are now dealing with events at the level of individual nerve cells. The taking note of the event is, in fact, the event we are talking about. The situation is analogous to an observer watching himself in a mirror. The instant the observer notices that he is observing himself, a new awareness occurs. At that moment, he is no longer observing himself in the mirror. Instead, he is observing himself in the process of observing himself. As soon as he stops observing himself engaged in observing himself, he can once again simply observe himself in the mirror.

The concept is elusive because it is self-referring. To notice, you have to notice that you notice. It is a mirror facing another mirror and asking, "Who is the fairer, you or me?" But what is

the event we are talking about? Is it the nerve cell firing itself? No. It is even further down the scale of events: We need to look at a smaller part of the nerve cell. This smaller subsystem consists of one complex molecule. It is part of an active group of atoms on an enzyme molecule inside the nerve cell and lying very close to the wall of the cell.

Several kinds of enzymes actively operate within human cells. For example, proteolytic enzymes introduced into a nerve cell can modify the ability of that cell to fire. Apparently, the enzyme attacks the protein gates to specific channels connecting the cell to other nerve cells. Depending on the configuration of the enzyme, the gate opens or closes, and the cell fires or it doesn't.

We might think of the enzyme as a kind of gatekeeper. How does the enzyme do it? It appears that it has tails, and that it lies attached to the cell wall (membrane) so close to the channel that a mere encounter of one of its tails with the channel gate occurs whenever the cell fires.

The small subsystem we are interested in lies at the end of one of these tails. Bass cites a specific example. It is called *methylamine* and it is a molecule that terminates the side chain that composes the tail. It is a part of this tiny molecule, which

Molecules with tails surrounding a protein gate.

consists of two hydrogen atoms and one nitrogen atom forming a triangle configuration, that determines the activity of some important enzymes, such as the aldolases. To this little molecular triangle we shall pay a great deal of attention in what follows, for the device we are seeking operates on its atomic level of behavior.

The scenario goes something like this:

The nerve cell fires. The protein gate undergoes a change in conformation appropriate for a channel gate. The tail enters the gate. The two hydrogen atoms form a baseline on the tiny tail's tip, with the nitrogen atom above or below that line. If the nitrogen (N) atom is above the baseline, the tail fits into the gate much like a key fits a lock, and the gate stays open to fire again after the tail leaves the gate.

If, on the other hand, the N-atom is below the baseline, the tail again fits the gate, but like a good boy, it closes the gate after its encounter with it. These are the only two fits of the tail's "key" tip into the gate "lock." So far, so good. An "up" triangle keeps the gate open. A "down" triangle closes the gate. So, what happens? Well, it depends on whether or not you notice. You see we are in quantum land. Thy will is about to be done.

Enzyme molecular "consciousness"?

Quantum semaphores: The two possible positional configurations of the NH2 molecule after it encounters the protein gate.

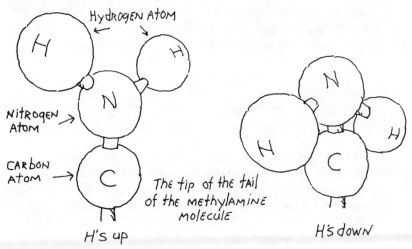

Hydrogen Atom

H

Nitrogen Atom

Carbon Atom

C

The tip of the tail of the methylamine molecule

H's up

H's down

The Impossible Mission:
The Exercise of Human Will

In chapter 11, we looked at the example of Schroedinger's cat. Perhaps you wondered how the cat could be existing in two contradictory realities at the same time. Certainly real cats do not exhibit such bizarre features. But if we descend to the molecular level of reality, we shall find our own examples of Schroedinger's cat. They are the molecules and atoms that make up our nervous systems.

For the cat in the cage, it was the interaction of a radioactive atom with the cat that caused the double reality of a live cat and dead cat existing side by side within the cage. If the atom radiated, the cat was dead. If, on the other hand, the atom did not radiate, the cat was still alive. The atom was an analogy to the actual behavior of the triangular NH_2 molecule. This molecule looks just like an isosceles triangle with two equal sides. But because of its tiny size, the triangular molecule participates in quantum reality in order to remain stable.

Molecules are curious things. Each is made up of atoms that stick together by electrical forces. But it seems these forces are not enough to keep the molecule stable. If the forces become too attractive or too repulsive, the molecule shakes and sometimes flies apart. Quantum magic glue comes to the rescue and keeps all molecular families of atoms together. However, the price is high: the family members must give up their individual selves. They must live in a qwiff world occupying two or more places at the same time. The moment any of the atoms that make up the molecule become located in one spot, the molecule begins to shake and dance. It radiates away excess energy in its attempt to stabilize itself. The little triangle is no exception to the rule.

In other words, the H-atoms do not exist separately whenever they are part of a molecule. All we have are their remnants, their qwiffian ghosts to remind us that they are potentially present. Their actual presence comes into being only when they are noticed. At that instant, the molecule shakes. The radioactive atom in the Schroedinger cat cage is analogous to the dual positions of the H-atoms in the molecular triangle. To find a single position, the little triangle encounters the gate. In the case of Schroedinger's cat, the cat plays the role of the protein gate.

After the interaction of the triangle with the gate, we have two gate positions—open and closed at the same time. Again,

this is completely analogous to what happened to the cat after it interacted with the radioactive atom. The gate's qwiff is double positioned. Now, if the gate is open, the cell continues to fire. A neighboring neuron responds to that signal. If it receives two or more blips, telling it that the gate is still open, it transmits a high-frequency signal, alerting the neural network of which it is a small piece.

On the other hand, if the gate is closed, the neighbor only transmits a low-frequency signal to the rest of the CNS net of which it is a piece. Which does it do? That depends on you or, more specifically, on your agency. The agent must pay attention to that frequency, listen to its melody. Since the triangle was in two places (like the radioactive atom that may or may not have radiated) at the time of interaction with the gate, the gate (like the cat that is, at once, alive and dead) is both open and closed, potentially, at the same time. Thus it is simultaneously firing to its neighbor and not firing. Following along the logical chain of possible events, that means the agent is sensing both a high-frequency and a low-frequency signal at the same time, and yet the agent is not really sensing anything at all (like the cat's observer who has not yet opened the box). Why? Because these signals are only potentially present in your nervous system; they are in the qwiff world.

The stable but uncertain quantum world of a molecule: The hydrogen atoms (H's) do not exist as atoms, but as qwiffian ghosts.

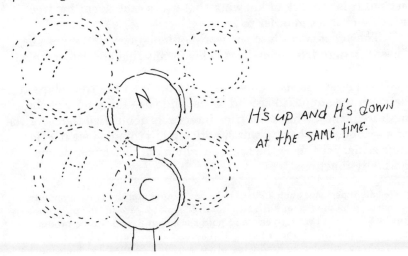

H's up and H's down at the same time.

The agent must choose to notice that there is a low-frequency or a high-frequency signal on his line. All it takes is for him to choose it. Once he has, it becomes part of your agency's agenda. Suppose he notices the high frequency. And down at the molecular level, the gate is open and the little triangular tail points upward. Of course, if he noticed a low frequency, then following the chain of logic back to the little triangle, it would be pointing downward.

In either case, something has been noticed. A choice was made. The original cell itself now undergoes another kind of transformation: it transmits, at the instant notice is taken, a train of microwave frequency pulses to a nearby muscle fiber, which then contracts mechanically. The agent was completely free to notice the signal at any time. There was nothing causing him to take note at that particular time. He was also free not to note it.

What happens if he simply does not pay attention to the potential reality sharing reality with your nervous system? Suppose he ignores those ghosts from your qwiffian world? Then, nothing happens. The original cell relaxes in its own random thermal bath and does not alert the muscle fiber. The little triangular tail maintains its previous uncertain configuration and remains stable.

Taking note of its position shakes the tail. It then dances inside the cell emitting the microwave frequency that, in turn, induces the cell to signal the muscle. This is the essential feature of the model: it uses quantum uncertainty as a basis for willful action. It is the lack of knowing that gives each agent his free will. He chooses in order to know.

The agent tunes into the world of imagination. Suppose he "hears" a high-frequency buzz. This means that the cell signaled a second time, but hold on—did it really signal twice? This question arises as soon as we begin to consider the time elapsed between the supposed second signal and the taking note of the high frequency. That brief time interval is about five thousandths of a second. It is hardly worth noticing anything on such a tiny time scale, yet this is the scale on which our nervous systems normally functions.*

* We can experience such a small time scale quite simply. It corresponds to something moving to and fro two hundred times a second. If you pronounce the letter *e* as in the word *eat*, and hold the *e* sound, you will be producing a sound vibration of about two to three hundred vibrations a second. Of course, you will also be producing other sounds as well. Five thousandths of a second is the time between two successive vibrations of your letter *e*.

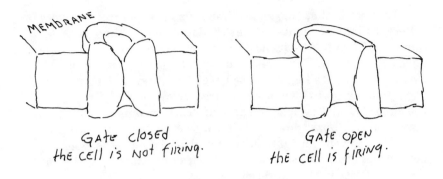

Gate closed
the cell is not firing.

Gate open
the cell is firing.

A cutaway view of two positions for a protein gate within the membrane or neural wall.

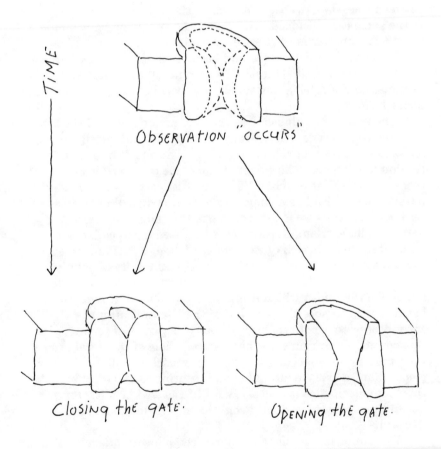

TIME

OBSERVATION "OCCURS"

Closing the gate.

Opening the gate.

The uncertain gate is open and closed after encountering the NH2 molecule.

The fact is that this small time interval separates two very different kinds of events. About the latter event, there is little question. The high frequency was definitely noticed by a single agent of the CNS. But what actually took place at the first event, when the tail entered the gate? Did it leave the gate open, thus producing the ultimate high-frequency buzz noticed by the agent? Or did it close the gate after its encounter, causing a low-frequency buzz to be felt? The answer is, paradoxically, neither and both. The gate is open and closed and it is also neither open nor closed. Like the observer of Schroedinger's cat, the gate exists in the third reality.

Now perhaps an objection arises in your thinking. Why is it necessary for the cell's gate to behave in this paradoxical manner? Why is it necessary that there be a time interval between these two events? Why can't the two events happen at the same time? Indeed, why aren't the two events one single event? The answer is: if these events did not occur as they do, free will would vanish. We would become total machines. Without this tiny, precious time interval, we would all be simple stimulus-response engines, behaving much like thermostat-controlled house heaters.

The initial stimulus causes the interaction between the tail and the gate to take place. From nothing, two potentially realizable events occur. You might say that a kind of dynamic tension takes place. The closest I can come to describing this "sense" is to call it psychic. Your agent is alert to what can possibly occur. He has a choice now. That choice did not exist until the stimulus was "sensed," until the tail encountered the gate. The little triangular molecule has been changed by the encounter, but it is still quite stable. Although it is now in an excited state, its atomic constituents are still quite blissfully uncertain as to their locations. Consequently, the molecule does not shake the tail to which it is connected. The alert agent still has a choice: to note the position of the H-atoms after the encounter or to ignore them. Without this period of respite, this contemplation time on the neuronal scale of temporal events, we would become nervous wrecks. Our muscles would be responding to every neuronal signal, continuously twitching. Quantum mechanics is necessary for life as we know it. Out of uncertainty comes freedom. From the uncertain atom comes free will.

But suppose that the agency noticed a low-frequency buzz. The tail's tip points downward, thus closing the gate after the encounter. Again, the H-atoms' positions are noticed and the

tail shakes. Up or down, so long as it is noticed, the enzyme will be alerted by its tail. The neuron, in turn, becomes alerted by the enzyme and signals the muscle fiber to contract. The choice is to note or to ignore. In either case, thy will be done.

But, we have left something out of the discussion. What device pops the qwiff in the first place? Where does the device exist? The answer seems to be nowhere. The device may be what we mean when we say the magical word, "I." The device is our awareness of our own existence. "I" exist because I choose to exist.

The Atom and "I": Are Atoms Conscious?

Bass's model offers us an answer. Consciousness is choice. This choice, however, is not among the already chosen and preexistent forms known to us as matter. This choice comes to us from qwiffland, the land of our imaginations. Before we choose (which is the same thing as saying, before we are aware of anything), the universe is paradoxical and not "out there." Something called "mind" is present. Mind is in the world of quantum reality.

The exciting feature of Bass's model is that it ties together or correlates a single quantum event (the localization of the single tiny molecule's position) with a macroscopic event (the excitation of the whole neuron). Bass cautions us, however:

> While examples of neuronal excitation triggered by single quantum events are well established and explained . . . it would not suffice for the present purpose to trigger the macroscopic event by any one of many possible quantum events (such as a one-photon interaction with any one of many pigment molecules). It is apparent that here the impression entering the consciousness of the observer must pertain to a single unique quantum system described by a wave function [qwiff].[7]

Do human beings possess this unique ability? Can a person correlate macroscopic events with single quantum systems describable by a qwiff (such as the methylamine molecule)? For this ability to be present, a close coupling between the whole neuron and its individual ionic channels would be necessary. This coupling would appear as a "kind of enhanced sensitivity" or heightened awareness. Bass suggests that

> a detailed model of the requisite close coupling between a unique ionic channel and the excitation of the neuron would be too

speculative. In order to see how such a coupling might have been evolved for some special neurons, it should be noted that groups of some 100 normal ionic channels . . . are known to suffice for excitation by electrodes, but a lesser number is likely to suffice on the known specialized parts of any neuron (the so-called axon hillock), where firing is initiated in normal functioning of the neuron because of the locally high membrane excitability. The extension of these existing local features of neuronal membranes to the limit required in the present model in a set of specialized neurons would seem to be within the scope of natural selection.[8]

Bass's device changes the qwiff; it pops the wave function. But where is it located? It has no location. It is the living neuron itself. It is the enzyme operating within the neuron. It is the molecule operating at the end of the tail of the enzyme within the neuron. It is the atom operating within the molecule that lies at the end of the tail of the enzyme that is attached to the wall of the neuron. It is the conscious atom noticing itself and thus creating itself. Consciousness is the process wherein potential reality becomes actual reality. It is the qwiff popping. It is the wave function collapsing.

At the atomic level, consciousness is primitive, but necessarily so. Neurons contain possibly several billion atomic "consciousnesses." We might call each such consciousness a mind. All together they are the agents that make up your intelligence agency. At the molecular level, each agent performs a single task: that of noticing itself. It is like one potential reality noticing another potential reality within the same pure qwiff. In that sudden mysterious event, one of those potential realities just "appears." That act of consciousness is the creation of reality at the atomic and molecular level. Now the neuron is alerted to signal the muscle. Now the neuron is signaling the muscle.

Perhaps several billion minds are acting in that neuron or in other neurons. Some minds notice the high buzz and others choose the low buzz. Together these minds, these countless minds, functioning in quasi independence, often unaware of each other's presence, and sometimes even making choices detrimental to your life, act on your behalf. In fact, they act *as* your behalf, by choosing what you experience as reality. Together these minds "make up" your mind. They are your own CIA. And when an outside event stimulates a quantum encounter between your neuron's gates and enzymes, these simple minds join in random fashion, some seeing H-atoms up and the others seeing H-atoms

down. They are your normal mind, your normal waking (or possibly sleeping) mind.

Taken randomly, they form a kind of net of unknowing, a pool of unconsciousness. In this way, your individual minds know what's going on, while your collective consciousness hasn't the foggiest idea of why you bent over to scratch the cat. Your action becomes an unconscious, habitual act, like riding a bicycle. When you were first learning to ride, you had to mind your minds; you had to listen to them as they all screamed their pitiful, tiny discoveries of up H's or down H's to no one, as the whole ensemble that is called "you" tipped and fell out of balance and hit the street.

But you got up again. "You" took over. You rode the bike. Imagine climbing on that bike for a moment. Remember how you felt as your parent or sibling pushed you out solo? You were in a pure state, your qwiffs unpopped. You did not know how to ride. Then you began to tip. You became alert. Your neurons had fired alerting NH_2's to encounter the gates, to find out what was going on. The NH_2 molecules tasted the gates and snapped back. They were excited, but stable. The gates had doubled; they were in qwiffland. Your qwiff was still pure and unpopped after the encounter, and you were falling over.

Each agent looked at himself, inspecting for possible damage. And each agent saw the two possible positions. So each agent chose. The qwiff popped. The gates were then open or closed—nothing in-between. Each mind knew, and all of them together presented a sum of their knowledge. They were "you." You knew. You acted. You chose to do something. You stopped or you leaned the other way or you pedaled faster.

This integrated consciousness is your consciousness of consciousnesses. It is a kind of overseer. It observes the observers. For it, all of the other acts of consciousness form a mixed state of popped qwiffs. That mixture of states is thus physiologically identical to billions of molecules, each of which is in one of the two possible states, up or down H's. Your first conscious acts while learning to ride a bike where conscious to your collective consciousness, which was observing all the way down to your atoms. In this manner, you correlated your falling off the bike with your atomic feelings. You were of "one mind." But after all those qwiffs popped, you became "many-minded." And that made a big difference. The individual "minds" were then trained; they were noticing. Together they formed the unconscious random pool of atomic minds acting independently.

An imaginary view of how we learn to "make up" our minds. Having observed the scrambled data of the world, one mind becomes many atomic minds, they observe each other, and then they become one mind

ONE MIND NOT KNOWING.

Atomic minds unknowing, qwiffs unpopped, nothing observed.

Atomic minds knowing, qwiffs popped, things observed.

again. This sequence can also be observed proceeding from the "one mind knowing" back towards the "one mind unknowing." This may be the way we forget.

Atomic minds interacting and correlating.

Atomic minds knowing and becoming one mind again.

One mind knowing.

All for One and One for All: Where Is My Mind?

Wilder Penfield, the well-known neurosurgeon and mind researcher, discovered through many exhaustive case studies that the mind has no unique location within the body. As he stated in his book, *The Mystery of the Mind*: "To suppose that consciousness or the mind has location is a failure to understand neurophysiology."[9] But if the mind does not have a location, then where is it?

The mind appears to be everywhere. It is observing on the scale of atoms and molecules, neurons, cells, tissues, muscles, bones, organs—in other words, it is observing on all scales of physical existence. It sees all, from your NH_2's to your socks. It is one mind that is capable of acting as several atomic minds.

There is an intentional, subtle difference between the one mind and the individual atomic minds. The atomic minds pop qwiffs. They operate at the level of quantum mechanics. They deal in the bizarre world of choice among qwiff possibilities. And their choices have not been decided upon until they choose. Each action of an atomic mind is a popping of a qwiff. When an atomic mind operates, the gate is observed to be open.

The one mind does not normally deal with atomic realities. In fact, it deals only with atomic minds, and it deals with what has been created by the choices made by the atomic minds. It acts as a data-saver. In the example of the paradoxical cube, the atomic mind "sees" the cube with one face in front. The one mind adds up all of the pictures of the cube gathered together by all of the atomic minds that are acting.

By summing up the experiences of the atomic minds, the one mind makes up its mind. It literally creates a one-mindedness. In doing this automatically, it transforms new experiences into old experiences and creates habits. In the case of the firing of the neuron, it didn't make any difference which position of the molecule of NH_2 was noted by any individual atomic mind. So long as a position was noted—up or down for the molecular triangle—the neuron fired. Thus, even though the atomic mind could not predict nor determine what it would observe, the behavior of the whole person became determined. Bass reminds us that "an initially consciously directed action gradually becomes automatic through frequent repetitions; yet the process of fading from consciousness leaves the actual muscular movements entirely unchanged."[10]

The unique freedom of the one mind is that it is all of the atomic minds and any one of them at the same time. There are no clear dividing lines between the one mind and any other

consciousness within the body. This freedom arises because the mind has no location in space. It operates psychically in just the same manner as the two observers observing the two previously correlated paradoxical cubes (p. 181). Each mind saw a cube with a particular face forward. No mind could predict which face was forward. Yet both saw the same face forward. It was as if each saw the same cube or each was part of one mind only.

If this idea is correct, then consciousness is able to sense things on an atomic scale. The possibility is mind-boggling. It means that new or novel events can be accepted at the atomic level, the level where potential reality becomes real reality.

Julian Jaynes, in his book, *The Origin of Consciousness in the Breakdown of the Bicameral Mind*.[11] postulated that introspected volition—the ability to know that one is controlling one's own destiny—has been a recent addition on the evolutionary scale. Jaynes also points out that today's schizophrenic is a "throwback," a return to the time before humans acquired their "willing" minds. Was it the "one mind" communicating with the many minds? Was the event of the bicameral breakdown that of a human being acquiring Bass's device? Did that event, three thousand years ago, occur because that person's neurons had at last evolved the necessary close coupling with their unique firing channels?

I suggest that this was the case. Humans had found out who they were when they became atomically conscious. Or perhaps, better said, they had learned how to live in quantum reality.

The first documented case of quantum consciousness may have been Moses. When he asked, "Who are You?" of the Presence felt at the burning bush, the answer came: "I AM THAT I AM." Moses then recognized that, within him, the God Voice now spoke as Moses. And from that moment onward, humans began to control their destiny. When I picture the "one mind" piercing the individual atomic minds, I am reminded of the words of my teacher of the Cabala, Carlo Suares. When asked whether one must seek for one's soul, he replied, "No, don't worry, it will find you."[12] My higher self is seeking me. My "one mind" seeks to find my many scattered minds.

Is there evidence for this many-minded theory? Split-brain research indicates that we do indeed have many minds, each acting in a complementary fashion with all the others.[13] William James, in *Principles of Psychology*, noted that

> in certain persons the total possible consciousness may be split into parts which coexist but mutually ignore each other, and share the objects of knowledge between them. More remarkable still, they are complementary.[14]

If these split minds function atomically, perhaps the complementarity spoken of by James is the same complementarity referred to and identified by Neils Bohr on the level of atomic phenomena. Following this line of thinking, all metaphors become nonmetaphorical; they are simply describing reality on several levels of perception at the same time. For example, your feeling of excitement is your atoms in excited states. Since we are clearly of the world, that complementarity of atomic phenomena should also exist within ourselves. The sum total of all the complementary consciousnesses make up our normally perceived world, that world of classical cause-effect reality.

But what about the quantum world? Do the various atomic minds that make up a person's one mind communicate with each other? Can you align your atomic minds in some coherent fashion? If so, the effect would be fantastic and quite magical.[15]

Imagine your one mind as the chief of your CNS. Picture your individual atomic minds as agents acting independently. Remember that it makes no difference whether or not the molecule is "observed" pointing upward (\uparrow) or downward (\downarrow). In either case, as long as it is "observed," action is taken and a muscle fiber is contracted. Suppose that an atomic agent, acting alone, observes the following pattern over time:

time ⟶

$\uparrow\uparrow\uparrow\downarrow\downarrow\uparrow\uparrow\downarrow\downarrow\downarrow\downarrow\uparrow\uparrow\downarrow\uparrow\uparrow\downarrow\downarrow\downarrow\downarrow\uparrow\uparrow\uparrow\downarrow\uparrow\uparrow\downarrow\uparrow\downarrow\downarrow\downarrow\downarrow\uparrow\uparrow\uparrow\downarrow\uparrow\downarrow\downarrow\uparrow\downarrow$

Such a random mixture of up and down H's, although sufficient for producing the necessary muscle contraction, hardly causes the "chief," the "one mind" to stir. It is free to explore other things, other ideas, or other neuronal realities. As a result, that once-directed choice fades from consciousness; yet the muscle, now trained, contracts. Things happen more or less mechanically. That random chain of arrows, corresponding to a random mixture of high- and low-frequency buzzes on the line of the CNS, produces a quantum washout, a series of classical, objective experiences.

The integrated effect is sometimes my "H" is up, sometimes it's not. In other words, nothing unusual is happening. But that's just one agent acting alone. Suppose that now there are several atomic minds acting and observing. Let's look at three typical minds, each observing a particular chain of signals as before.

Let's label them minds 1, 2, and 3. Since we have three minds
acting, they are acting in different places. Their pattern of
observations might appear as:

time
———→

↑↑↑↓↓↑↑↓↓↓↓↓↑↑↓↑↑↓↓↓↓↓↑↑↑↓↓↑↓↑↓↑↓↓↓↓↑↑↑↓↑↓↓↑↓ (mind 1)
↓↓↓↑↑↓↓↑↓↑↑↓↓↓↓↓↑↓↑↓↓↓↓↑↑↑↓↑↓↑↓↑↑↓↓↑↓↓↓↓↑↓↑↓ (mind 2)
↓↑↑↓↑↓↑↓↓↑↓↑↑↓↑↓↓↑↓↓↑↑↑↓↑↓↑↓↓↓↓↑↑↑↓↑↓↑↓↓↑↑ (mind 3)

(space is the vertical label at left)

Such a random sequence of sequences would appear to wash out
all quantum experiences. These signals are also distributed
spatially as well as temporally. Again, nothing to excite the chief.

But now, the will participates. The atomic minds must notice
each other. Not just a breakdown of bicamerality, but of atomic
separability is taking place. The atomic minds are
communicating with each other. The effect would be startling,
perhaps appear cosmic, to the mind filled with voices.
And perhaps Moses saw the burning bush. The pattern of the
individual minds would be partially coherent; they would be
repeating each other's patterns. It might appear something like:

time
———→

↑↑↑↓↓↑↑↓↓↓↓↑↑↓↑↑↓↓↓↓↑↑↑↓↓↑↓↑↓↑↓↓↓↓↑↑↑↓↑↓↓↑↓ (mind 1)
↑↑↑↓↓↑↑↓↓↓↓↑↑↓↑↑↓↓↓↓↑↑↑↓↓↑↓↑↓↑↓↓↓↓↑↑↑↓↑↓↓↑↓ (mind 2)
↑↑↑↓↓↑↑↓↓↓↓↑↑↓↑↑↓↓↓↓↑↑↑↓↓↑↓↑↓↑↓↓↓↓↑↑↑↓↑↓↓↑↓ (mind 3)

(space is the vertical label at left)

Each mind senses the same pattern of arrows, each "hears"
the same "drummer." Such a spatial correlation would be
noticeable to "the boss," and a new awareness would be "felt."
Suddenly, "I think, therefore I am."

Today we are already familiar with such a spatial correlation
existing in several minds at once. Only the minds are in different
bodies. The rock concert experience is, I believe, such an
example. Group meditation produces a similar result, but so does
"team spirit." Perhaps this is what we mean when we say there
are "good vibes" between people—their consciousness patterns
are matching. Spatial correlation makes us of "one mind."

But how do we do it? How is an individual mind able to
resonate its pattern to another mind? The answer is through
the qwiff, that psychic conduit that ties us all together as one.
And what happens if there is temporal as well as spatial

correlation? For example, suppose we had our three atomic minds observing this pattern:

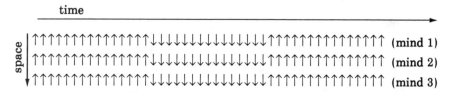

Again, such a combination could not or would not be ignored by the chief. It would be of extreme significance, a kind of "seeing" with an atomic magnifying glass. One would certainly feel a new awareness. Is this cosmic consciousness?

Is this what happened to a few individuals in the past, such as Buddha, Jesus, and others? Is this what is happening now to so many? I believe that the answer is yes. We are beginning a new age of awareness, the age of quantum consciousness, the age of the conscious atom. By looking within ourselves, we may be able to solve the problems facing us on the final frontier—the frontier of the human spirit.

God's Will and Human Will

Some very old questions are still around. These questions concern human behavior, thoughts, and will. Can quantum mechanics shed some light on such questions as: Am I just a machine? How does my will act? What is God's will? Is there a God?

Most of these questions and others, I'm sure, regarding mind and matter have never been satisfactorily answered. These questions all relate to human power to control and determine destiny. Just how far do our human powers extend? Quantum mechanics seems to point to the limits of human power. These limits refer to our knowledge and our ability to gain knowledge. The qwiff or quantum wave function is unobservable. Yet we feel that it is an adequate model for determining the probabilities of events. Qwiffs flow in a perfectly orderly fashion. But then an observation takes place. The orderly flow becomes a disorderly pop. A probability becomes an actuality. We humans seem to have some control over our lives and yet we also seem to be powerless victims to another will, another order.

In this chapter, I have offered mostly speculative thoughts, models, and ideas about how quantum mechanics, God, human thought, and will are related. I view quantum mechanics as very necessary in human development and psychology. I feel that the underlying order of the qwiff, the quantum mechanics of the universe, is God's will being done. Yet to us, this order appears random and often without any meaning. In an earlier chapter, we saw how the paradoxical cube appeared to have no special order to its appearance. Sometimes the upper face of the cube seemed to pop out in front and sometimes the lower face. By letting two cubes have a past interaction, two separated observers observing separated cubes later discovered that the order of their observations were identical. Yet each observer had in fact seen only a random pattern without any meaning.

This example gives us a small glimpse of the unity of the universe. The observers' wills could not control the cubes. Yet the two observers found an order in their observations. This order could not be used for communication or manipulation. Each observer was free to choose what he or she wished. And yet each saw in the other's order of observation his or her own order. Perhaps this is the unique form of human communication. We are one to the extent that we stop manipulating each other. We are many to the extent that our individual wills be done.

The cubes were analogies for quantum particles such as electrons and atoms. But can the analogy go any farther? Can quantum mechanics help us to understand our own limits of power? If it can, perhaps the world could become a safer and more enjoyable place to live in. Perhaps if people saw that there was no way to break the uncertainty principle, wars would stop. Certainly, if people became aware that a power over another human being was impossible because of quantum physics, the world would be a different place for all of us.

Quantum mechanics, perhaps more clearly than any religion, points to the unity of the world. It also points to something beyond the physical world. It matters little which interpretation you choose—parallel universes, Feynman paths of action, qwiffs that flow and pop, or consciousness as the creator. All of these interpretations point to the mystery of the physical world from a nonphysical perspective.

We might say that God's will is exercised in the world of the qwiff, the quantum wave function. It is a causal world of exact mathematical accuracy, but there is no matter present. It is a world of paradox and utter confusion for human, limited

intelligence. For it is a world where a thing both occupies a single place at a single time and occupies an infinite number of places at the same time. Yet there is an explicit order to the paradox. There is a pattern to the many positions, a symmetry.

But we, who exist in the world of matter, can only disrupt that perfection of paradox by attempting to observe the pattern. We pay a large price for a material world. The price involves our sanity. We cannot make total order of our observations. There always appears to be something missing. This disruption of God's order appears to us as the Principle of Uncertainty. Thus we become helpless, feel inadequate, and long for the order we are helpless to create in the universe. All we can do is go along with it.

On the other hand, we are free to choose. Our very helplessness to create a perfect order allows us to create. You might say that the uncertainty principle is a two-edged sword. It frees us from the past because nothing can be predetermined. It gives us the freedom to choose how we go about in the universe. But we cannot predict the results of our choices. We can choose, but we cannot know if our choices will be successful.

The alternative to this uncertain world is a certain world. In such a world, particles would follow well-determined paths with exact locations at each and every point. But this alternative is known to be unworkable. The tiny electron inside of every atom would have to radiate each and every instant in such a determined world. It would lose all of its energy and quickly fall into the nucleus. All atoms would disappear. All electromagnetic energy would vanish. All nervous systems would cease their activity. All life would stop. For life as we know it can only exist through the blessing of uncertainty, and security is a myth.

Yet security is there. We feel its presence. It is the longing for the perfection of universal order that we all feel. It is felt as the desire to crawl back into the universal womb. But, alas, we cannot do so and still remain in human bodies. We must accept the uncertainty of our positions. Without that uncertainty, there is no world.

Perhaps if we come to understand how modern physics, particularly quantum mechanics, can make us aware of the limits of human will, we will learn to get along with each other. Even better, we may realize our cosmic heritage as part of the greater will. I hope so.

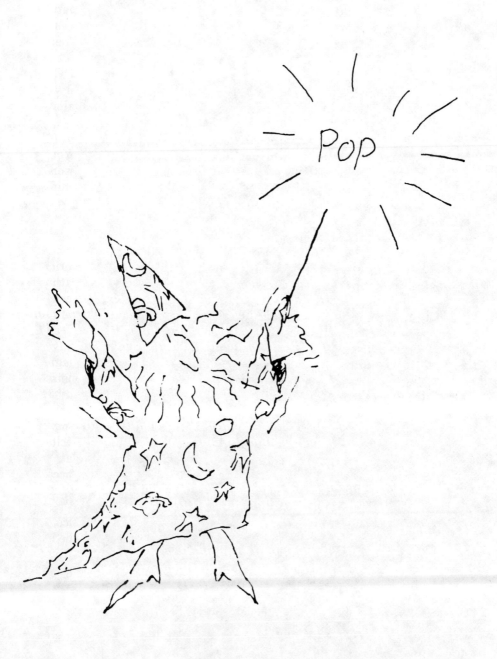

New Ideas in Quantum Physics

Wigner's friend:	*You know, Eugene, I do not think this Schrödinger was very practical about cats.*
Wigner:	*Why?*
Wigner's friend:	*Do you have any idea what the smell is like in here?*
Wigner:	*First verify that the radioactive source is in position in the enclosure and then put the cat inside.*
Wigner's friend:	*There seems to be some kind of a label on the radioactive source. It says "Free sample from the Atomic Industrial Forum." Things from the Atomic Industrial Forum are sometimes not what they seem.*
Wigner:	*Never mind. Get the cat in there.*
Wigner's friend:	*Eugene, it seems to me that you have underestimated grossly the subtleties of superpositions of macroscopic quantum states.*
Wigner:	*Why?*
Wigner's friend:	*It is not so easy to get this cat and myself into a superposition state. OUCH!*
Wigner:	*What is going on?*
Wigner's friend:	*To think that I should have gotten tetanus shots to participate in a philosophic experiment.*

A. S. WIGHTMAN

Since the writing of the first edition of this book, a number of new and exciting developments in quantum physics have occurred. In this added chapter I want to explore and explain two of what I believe to be the most provocative of these ideas. Each concept appears to have been created more from science fiction than hard-nosed physics. In any case, since quantum physics is a weird business, as by now I am sure you all know, some of you may be wondering just what more could be added to this "new physics."

The first idea concerns a new twist to the interpretation of quantum physics called the *Everett Parallel Worlds Interpretation.*[1] If some physicists are correct, the detection of a parallel universe is just around the corner, so to speak. While the whole idea of other universes existing side by side with our own may at first seem to be a fantasy, a novel development has surfaced that could make this science fiction science-fact. This development comes from the world of technology: the modern computer. It appears that through the design of a new type of computer—one that brings the laws of quantum mechanics under the fingertips of the user—it will be possible to actually detect the presence of a parallel world.

As it may have dawned on the reader, the computer industry is continuing to develop smaller and smaller computers with ever-decreasing computer elements known as *chips*. These chips are shrinking so fast that it won't be too long before we are looking at the first molecular chip. Consequently, since the operation of these chips will occur on a very tiny space-time scale, the laws governing those operations will be based on the principles of quantum physics.

Not that today's computer chips don't already operate using these principles. They do! However, the level of quantum operations governing present computer microchips is well hidden below the control of the user. As far as the user is concerned, the computer chip is an assemblage of simple on-off devices—classical physical machines—and memory storage. The laws of quantum physics do apply here, no doubt, but no one using today's computer would ever know it. What I am referring to, as far as a future computer is concerned, is the actual use of quantum laws and all of their paradoxical features right at the fingertips of the user. In other words, a user of a quantum

computer will be able to carry out genuine operations that use the language and principles of quantum physics instead of the present simple Boolean logic of on-off digital arithmetic.

The second idea concerns a new interpretation of quantum physics. In this explication, called the *transactional interpretation*, the future communicates with the present. Here the problem of interpretation, which has been the brunt of much disagreement among physicists, is resolved by assuming that a quantum wave of probability[2] moves backward through time from the future. In this interpretation, a physical system can only actually appear to an observer if the quantum wave representing it propagates both from the present into the future and backward through time from the future to the present. If the quantum wave is allowed this seemingly science-fictional privilege, a number of paradoxical results can be explained.

While the originator of this new interpretation doesn't believe that it could lead to any new experimental result, it may turn out that there is a surprise in store. It appears, however, that experimental evidence for it won't come from anything as seemingly cold and remote as modern technology, but from something quite close, warm, and fuzzy—human physiology.

Some recent experimental data[3] indicate that a subject is actually aware of a physical sensation a full half second before his brain has been able to tell him that he is aware. This has led the neurophysiologists who made the measurements to what they call a "delay-and-antedating" hypothesis.

This hypothesis refers to the delay in time of cerebral production—the actual appearance of relevant brain activity needed for a conscious sensory experience of an earlier physical sensation—combined with the subject's antedating, or earlier dating, of that experience. The subject's brain showed that neuronal adequacy wasn't achieved until after a full half second following the sensation. Yet the subject stated that he was aware of the sensation within a few thousandths of a second following the stimulation. Put briefly, how can a subject be aware of a sensation, that is, be conscious of it, if the subject's brain has not registered that "awareness"?

The answer may turn out to be a surprising new discovery. The future actually communicates with the present in the human nervous system.[4] If this turns out to be experimentally further verified, it would be the first time that evidence from the field of biology was used to support a theory of physics.

Both of these developments arose after the publication of the first edition of *Taking the Quantum Leap*. Consequently I have

taken some time to explain them in the form of a tutorial. The ideas are weird, no doubt. However, as I was told by one of my readers of the earlier edition, "When I first read your book, I couldn't understand it. But after a year, I read it again, and it all seemed understandable." Perhaps this chapter will at first seem strange, but a re-reading may offer some new insight. I believe that these concepts are the most important conceptual developments in quantum theory that have arisen since the first writing of *Taking the Quantum Leap*.

Idea One: Taking a Photograph of Another Everett Parallel World

The imagined dialogue at the top of the chapter, occurring between Professor Wigner and his hypothetical friend, describes an amusing confrontation known as the *paradox of Wigner's friend*.[5] It describes a well-known problem in quantum physics known as the *measurement problem*. The problem is, what takes place when some observer measures a property of a quantum system? Assuming that every object in the universe—people, cats, machines of all kinds, brains and minds, airplanes, mountains, etc.—all obey the laws of quantum physics, how can anything be actually observed?

This is a problem, as you may now realize, because the quantum laws allow, and in fact require, that any physical system exists in a superposition of possible states. For example, an electron in an atom may occupy several, indeed, an infinite number of positions simultaneously. Each position would be called a position state for the electron. In order that the atom possess a unique and stable state of energy, the electron must exist in a superposition of position states. This superposition appears as a cloud called the *electronic wave cloud*. Without this cloud, the atom would not be stable and would disintegrate spontaneously.

This disintegration occurs if someone actually takes a look at the electron. The cloud suddenly collapses into a single location at a single point of space and time, and the electron no longer remains bound to the atom. On the other hand, if the measurement of the position of the electron in the atom is not attempted and the atom's energy is observed, the cloud persists, and the atom remains in a stable energy state.

This trade-off between possible observations is known as the *principle of complementarity*[6] and has been a problem for physicists ever since quantum mechanics was invented. The problem is that since quantum physics requires an electron to be a cloud, just where is it when it is occupying space in an atom? Since any subatomic object, such as the electron, is supposed to be a pointlike[7] particle, it cannot occupy the whole atomic space and nothing but the whole space, so help it. If it is a point, then where does it exist as such? Moreover, how does such an innocuous event as looking at an electron cause it to suddenly appear as a point?

The answer, as I previously discussed,[8] is that it exists as a pointlike particle in each of a dizzying infinite number of parallel universes. The superposition of all of these electrons, each in an other-worldly parallel universe, is the appearance of a single electronic cloud in this universe. This interpretation of quantum physics was first put forward by physicist Hugh Everett and is called the *Many Worlds Interpretation.*

The examples of Wigner's friend[9] and Schrödinger's cat[10] are no exceptions to this interpretation. As you may recall in the cat paradox, the cat, after spending some time in a box containing a device that may or may not emit cyanide gas, must exist in a superposition of two states—as a dead cat and a live one. In the Wigner's friend paradox, the friend, observing a physical system such as a cat, is also in a superposition of mental states. In one state the friend sees and believes the cat alive and in the other he sees and believes the cat to be dead. Then Professor Wigner comes along and apparently resolves the dichotomy by observing the friend and the cat in one or the other of these states.

At the 1986 New York meeting[11,12] I attended, physicist David Albert presented a "new move"[13] to the above already-confounding paradox. As he put it, the old stories end with the cat and the friend in a superposition of mutually exclusive states and beliefs about those states. Albert gave a new ending to an old script.

First of all, he assumed that the laws of quantum physics are obeyed by everything and that if these laws say that a system including a friend and his mental state of belief exist as a superposition, then so be it. That the friend doesn't know his own mind is not a problem, provided that the friend exists in two parallel universes. In each world or universe the friend (and the cat) are in one unique state of mind and body.

Suppose that the friend in world 1 sees that the cat is alive and believes that what he sees is a live cat. In world 2 the friend

sees that the cat is dead and believes that he sees a dead cat. In fact, he uses a measuring instrument (perhaps a stethoscope or some other life-monitoring device) to carry out and record the measurement.

At the end of this story (the place where the old paradoxes usually end), the friend, the cat, and the measuring instrument are consistently connected together. However, there are two possible worlds for them to inhabit—the dead world and the live world. In each world a consistent story has unfolded. In each world the belief and the reality are compatible.

What makes this a strange story is the fact that the superposition of both worlds also exists. This superposition of cats, friends, and stethoscopes, as bizarre a mixture as one may imagine, is itself a unique state and is observable as such by the professor who comes along a little later in the story. As far as the professor is concerned, this state is quite normal and is measurable. I can't imagine what this state could mean in this illustrative example, but we can suppose that some academic measuring device, perhaps a new kind of camera, that monitors cat-friend-stethoscope hook-ups exists and that the professor has one. The camera photographs and obtains a picture of the cat-friend-scope.

Now the professor only inhabits a single world—the world expressed to him through his camera. Even though the photo-apparatus measures a superposition of cat-friend-scope states, it and the professor are not in any superposition of states themselves. In fact, following the quantum rules, a graduate student could come along and photograph the professor who is observing the cat-friend-scope with his camera. The graduate student would say that the system composed of the professor, the camera, and the cat-friend-scope exists in a state, too. This could continue ad infinitum, ad nauseam.

Now since the photograph contains a superposition of cat-friend-scope states (live and dead), one could say that the professor, in his single world, has in his possession a photograph of the superposition of the two worlds, 1 and 2, that the friend and his cat occupy. This photo is nothing more than a double exposure showing the friend with his stethoscope hooked to his ears listening to his cat.

On the friend's face are two superimposed expressions—joy and disgust. If you look carefully enough at the photo you can see that the cat's eyes are open and closed in double exposure also.[14]

This is not anything new as far as the parallel worlds story is concerned. The cat-friend-scope is after all a physical system and

is therefore subject to the same laws as any other physical system, including the quantum law of superposition of states. In this regard the cat-friend-scope is no different than the atom I mentioned above. It is here that Albert embellishes the story with a new move.

Suppose that the professor shows the photograph to the friend. In other words, the friend gains access to the camera. Remember that the photograph is a double exposure showing the friend in two worlds even though the friend, as far as he knows, inhabits a single world containing either a dead cat or a live one. Thus the friend can see himself existing in a parallel world. This rather extraordinary state of affairs is a new move, but it is nevertheless perfectly allowed in the game called quantum mechanics. The friend in world 1, for example, will see himself and his alter-ego in world 2 together in one photo. And likewise for the friend in world 2. In other words, the friend will have knowledge of the existence of the other parallel world.

As strange as this sounds, this move is perfectly acceptable according to the Everett interpretation of quantum mechanics. This move, the possession of a record of oneself in another world, is a strange new idea, and as yet most physicists are still trying to figure out just what it can mean.

One physicist, however, has discovered how this new move can actually be experimentally realized. David Deutsch of Oxford University has used this move[15] to design a quantum mechanical computer that can solve a variety of problems in fewer calculational steps than any classical mechanical counterpart. The idea is to break up any problem into a series of separate parts, then to have the quantum computer carry out the calculations of those parts simultaneously, in tandem so to speak, in separate, parallel worlds.

The physical state of the machine at any time consists of the superposition of those separate calculations in one area of memory. Normally two separate memory locations are required to carry out the calculations. Not so in the parallel universes computer. When the calculations are complete, the quantum computer then looks at one of the parallel worlds and obtains a *picture* of itself. However, in obtaining this picture, it is also possible to obtain a result not desired.

Using a Quantum Computer to Predict the Stock Market

Deutsch imagines a very practical use of his machine: predicting the stock market. Suppose that a two-part investment program is written for an ordinary classical computer to estimate tomorrow's stock exchange movements based on today's. Suppose that an investment strategy can be computed based on the results from the program, and a running time of one day for each part of the program is required. Since there are two parts of the program, both parts must be calculated. Since each part takes a full day to compute a strategy, the computer would need two full days to be able to make its prediction. This makes the classical computer quite useless, since by the time the computer had finished its calculation, the day for the investment would have passed. Today's stock predictions would serve no real predictable power for yesterday's market.

The quantum computer runs quite differently. It carries out both parts of the calculation in one memory location that exists in parallel worlds on the same day. So the program is completed in time for the next day's market. However, there is a trade-off. Even though both parts of the program are completed on the same day, they exist in parallel worlds. All we can do is enter one of the worlds, as in the Albert example above. Because the answer exists as a superposition, there is a probability that the calculation will not be correct.

Consequently, you may not always enter a world where the strategy is successfully computed. To make this simple, suppose that when the strategy is correctly computed, a memory bit shows the value *zero*, while if it is not successfully computed, it shows the value *one*. Suppose that in any world you enter, the strategy is successfully completed fifty percent of the time and not successfully completed the other fifty percent. The quantum computer computes an answer each day, but we can't be sure that a successful strategy is arrived at on any given day. We can't be sure that the memory bit discovered for that day will be a *zero* and not a *one*.

Thus we have a trade-off. The quantum computer completes the program with a fifty-percent chance of being accurate in time for the next day's market. The classical computer completes the program with one hundred percent accuracy one day after the market closes. The classical computer is always accurate, but it is always too late to do anything with the answer.

The quantum computer is successful in computing a strategy only one day out of two on average (when the memory bit shows a *zero*) and on that day a successful investment can be made. When the quantum computer is not successful in computing an answer (the memory bit shows a *one*), no investment is made for that day. Thus the practical investor has a distinct advantage of weighting his bets to invest when and only when a successful calculation of the strategy is made.

Deutsch believes that quantum computers will be possible in the near future. He believes that they will use magnetic flux quanta as the fundamental units instead of today's on-off fixed Boolean logic elements. Professor Deutsch also believes that the Everett Parallel Universe model is not just an interpretational choice, but a testable reality. He points out, as I have stated in *Star Wave*,[16] that a true artificially intelligent computing machine cannot be realized until quantum interference effects, such as the parallel universe theory predicts, can be performed.

Deutsch concludes one part of his paper[17] with the following interesting observation:

> In explaining the operation of quantum computers I have, where necessary, assumed Everett's ontology. Of course the explanations could always be "translated" into the conventional interpretation, but not without entirely losing their explanatory power. Suppose, for example, a quantum computer were programmed as in the Stock Exchange problem described. Each day it is given different data. The Everett interpretation explains well how the computer's behavior follows from its having delegated subtasks to copies of itself in other universes. On the days when the computer succeeds in performing two processor-days of computation, how would the conventional interpretations explain the presence of the correct answer? *Where was it computed?*

Idea Two:
The Future Influencing the Present

Where indeed was the answer computed? Remember that in the parallel worlds computer, the computer, its memory, and its program operate in two worlds simultaneously. We also may ask when was it computed? For it appears that Deutsch's machine is achieving something of the impossible by gaining a successful strategy in one day that would require two days of computing. Is the quantum computer able to reach into the future to gain the answer? Deutsch doesn't bring this subject up, but physicist John G. Cramer from the University of Washington makes us face this possibility.

In two papers,[18] Cramer brings into play another interpretation of quantum physics. In Cramer's view, the usual or Copenhagen interpretation[19] of quantum mechanics suffers a serious fault because it fails to account for the act of observation that collapses the quantum wave. Before any measurement takes place upon a quantum physical system, the system is believed to be in a quantum state represented by a mathematical expression called the quantum wave function, or as I have called it here, a qwiff. When the observation occurs, the qwiff is said to collapse from a "wave of all possibilities" to a single undeniable fact. Not only is this true, but in order to compute the probability of this collapse taking place—the probability of the event associated with the collapse—the wave must be multiplied by a mathematically-related wave called the *complex-conjugate*. In other words, both the wave and its conjugate (what mathematicians call *complex numbers*[20]) must form a product of multiplication in order to determine the actual probability of an event occurring.

Multiplying two mathematical entities together to obtain a single entity is quite common in science. For example, in the branch of physics called *classical mechanics*, to obtain the force on an object its mass is multiplied by the acceleration the object

undergoes when the force is applied. This multiplication follows from the second law of Isaac Newton.

However, nowhere in any of the previous interpretations of quantum mechanics, including the Copenhagen interpretation, is there any law explaining what is physically occurring when a quantum wave is multiplied by its complex-conjugate. Nowhere is the complex-conjugate wave given any physical significance.

Cramer noticed that if we take it for granted that the quantum wave is a real physical wave—one that exists and propagates through space and in time—the conjugate wave turns out not to be a mystery, provided we are willing to borrow an idea from science fiction to explain it. The conjugate wave is also a real physical wave, but with a time twist.

Since the quantum wave moves from one place to another, then it also takes time for that movement. For example, we imagine the wave starting at some place and propagating outward through space much as a wave would move from a stone dropped in a still pond. We picture the wave as an expanding circle. The circle enlarges more and more as time goes by.

In this example, the conjugate wave is pictured as if it is generated at the pond's boundary. It looks like the original wave with one important exception—the conjugate wave runs backward through time. It starts out at the edge of the pond just when the original wave strikes the pond's border, and like the original wave in a movie running backward, appears as an ever-shrinking circle that collapses back toward the source—the original stone dropping in the pond, moments earlier.

The conjugate wave, as it goes back through time, moves through the same space as the original wave, but travels in the opposite direction. Consequently, it interacts with the original wave. Whenever two waves interact this way, their wave forms must be multiplied together. From a normal time perspective, the conjugate wave behaves in a manner well known to all electronic engineers: it modulates the original wave.

Indeed, the evening news you hear or watch could not be a possibility without the process of radio and/or television wave modulation. The original, or *carrier* wave (as it is called by electronic engineers), produced by the station carries the evening news as a modulation—a variation in the strength and/or frequency—of the broadcast wave to which your receiver is tuned. Similarly, the conjugate wave modulates the original wave and mathematically this is nothing more than the multiplication of the two waves together.

Thus, Cramer, through this new exposition that he calls the

transactional interpretation, explains why probabilities are computed the way they are, by the multiplication of the original wave by its complex-conjugate wave. In order that anything gain physical currency, both quantum waves must be simultaneously present, one modulating the other. Here also is the explanation of the wave function collapse—it arises when the future-generated conjugated wave propagates back through time to the origin of the quantum wave itself.

Cramer calls the original wave an *offer* wave and the conjugate wave an *echo* wave. Thus a transaction occurs involving an offer and an echo—much like the transaction between a computer with one of its peripheral devices, say, a printer or another computer over a telephone line. An offer is made. A receiver accepts the offer and confirms it by sending back to the offerer an echo of the offer that indicates to the offerer that the message was received. The exchange then cyclically repeats until the net exchange of energy, and other physical quantities that will manifest, satisfies certain requirements. These could include the conservation laws of physics and any other restrictions imposed on the quantum wave, known as boundary conditions. When this is all taken into account, the transaction is complete and all's well that ends well.

An Example:
Wheeler's Choice

To see how this interpretation might work in an example, ponder the paradox[21] first presented by physicist John A. Wheeler. Wheeler asks us to consider a simple experiment. It consists of a light source and a screen containing two slits,[22] similar to the so-called double slit experiment. The only difference here is that instead of a permanent, light-sensitive film-emulsion screen mounted in back of the slits, the screen is held on pivots so that it can be rotated in an up position to capture a photon or rotated down so that the photon continues on its journey.

The distance between the emulsion-screen and the slits is significantly long so that the experimenter has plenty of time after the photon has passed through the double slits to decide whether or not to rotate it into position or to leave it down.

If left down, the photon continues on its path and finally ends up reaching one of two telescopes. Each telescope is

mounted directly along a line-of-sight in back of each slit. Thus if a photon hits telescope 1, the photon must have traveled through slit 1; and similarly for telescope 2.

Indeed, the time for the passage of the photon once past the slits could be so long that they could be on the moon and the screen-telescopes set-up could be on earth. This would allow a light-travel time of about one and three-quarters of a second between the photon's passing the slits and reaching the re-mainder of the apparatus. The reader can imagine the distance between the slits and the rest of the experiment to be as large as one pleases.

The experimenter, in deciding at the last moment to rotate or not to rotate the screen into position, is in a quandary. Suppose that the experimenter places the screen in position. Then, according to quantum mechanics, the single photon must pass through both slits simultaneously in order to make an inter-ference record on the screen-film. In other words, the film emulsion acts as a device for determining the wavelike properties of the photon.

On the other hand, if the experimenter decides to leave the screen down, the photon reaches one telescope or the other, indicating that it passed through one slit or the other. Thus, with the screen down, the telescopes measure the particlelike property of the photon. Screen up: the photon passes as a wave through both slits. Screen down: the photon passes through either slit as a particle.

Now this isn't anything new as far as the double slit paradox is concerned. It is still a mystery. What is new is that the screen isn't rotated into position until well after the photon has passed through the slits! In other words, the experimenter delays the choice until the very last minute, and then that choice determines by which path the photon, which has already gone by, has journeyed. The effect, in a sense, has come before the cause. The cause—the experimenter's choice in the present moment—determines the effect—the path—already taken by the photon in the past.

There is no way to really understand this using any of the conventional interpretations. However, using the transactional interpretation, the paradox is seemingly removed. The photon's quantum offer wave leaves the source and passes through both slits toward the remainder of the apparatus. If the screen is up, the photon is absorbed, and the film emulsion sends back through time a conjugate echo wave that also passes through both slits and is received by the light source. The offer and the echo waves

pass through both slits and the transaction is complete. If the screen is down, the offer wave again passes through both slits toward the telescopes; however, only one telescope sends back an echo wave through its corresponding slit. Only one wave is returned because of the boundary condition that a wave represent a single photon. If both telescopes sent back echo waves, there would have been two photons present.

Back to the Future: Awareness Before Awareness

If one takes Cramer's interpretation seriously, then we have a whole new picture of time in regard to quantum events. Every observation is both the start of a wave propagating toward the future in search of a receiver-event and is itself the receiver of a wave that propagated toward the observation from some past observation-event. In other words, every observation sends out both a wave toward the future and a wave toward the past. Two events in normal or serial time are then said to be significantly connected, or meaningfully associated, one with respect to the other, provided that the transaction between them conserves the necessary physical constants and satisfies the necessary boundary conditions.

Cramer emphasizes that the transactional picture is just an interpretation, and as such he doesn't expect that any new experimental evidence supporting it over any other interpretation will be forthcoming. He sees it as a way of understanding and developing intuition in regard to teaching quantum physics to students. It also helps explain all of the paradoxes that are quite difficult to explain if one insists that time runs only one way from past to future.

However, some new neurophysiological evidence that I mentioned earlier,[1] the work of Benjamin Libet and his colleagues at the School of Medicine, University of California, San Francisco, and an hypothesis I have put forward[4] may prove Cramer wrong. The evidence indicates that there is a delay in time of cerebral production, resulting in a conscious sensory experience after a peripheral sensation. In other words, if you step on a rock, your brain doesn't show enough appropriate activity to let you know this for a full half second. This is not surprising. However, this delay is combined with a subjective antedating of that experience. You will experience or believe that you experience the sensory

stimulation—the rock—well before your brain has registered any evidence of this experience.

In experiments carried out at the University of California School of Medicine by Libet et al., a subject's brain showed that *neuronal adequacy* (the achievement of enough neural firings to indicate that the brain has become aware of stimulation) wasn't achieved until a full 500 msecs (one-half of a second) elapsed following the sensation. Yet the subject stated that he was aware of the sensation within a few milliseconds (ten-thousandths of a second) of the stimulation. Thus the subject became aware before his brain did. Libet and his colleagues explained their data using what they called a "delay-and-antedating" hypothesis. They believed that the subjective awareness of the experience and the actual achievement of neuronal adequacy were not the same events, but they didn't offer any reason for the discrepancy.

In a recent paper[4] I suggested a quantum physical resolution of the "delay-and-antedating" hypothesis/paradox put forward by Libet et al. I proposed a first step toward the development of a quantum physical theory of subjective antedating based on the transactional interpretation of quantum mechanics. Accordingly, the future event—achieving neuronal adequacy—and the present event—stimulation of the subject's peripheral limb—constitute a transaction. A quantum wave of probability (the offer) issues from the present event (the stimulation). It travels to the future event—neuronal adequacy in the brain—that is then stimulated to send back through time the echo wave toward the present event.

I proposed that two events so correlated would be experienced as one and the same event. Any two offer-echo quantum physically correlated events separated in time or space will constitute a single experience—an event in consciousness. Whenever two events—a physical action and an observation of that action—are so correlated, they will be experienced as one and the same event. I suggest that this means, in general, that any two quantum physical events separated in time or space will constitute a single experience. In a sense, one must have two events in order to observe one: the action in the outside world and the awareness of that action in the inside world. Without one, the other cannot happen. If this is true, consciousness can only occur when two or more events are so quantum correlated. A single sensory event, without a neuronal correlate, will not be a conscious event.

This proposal also sheds light on what is known as *subjective referral in space* as well as the above-mentioned *subjective refer-*

ral in time. Subjective time referral is the time when an experience occurs according to a subject's belief. Subjective space referral is the place where a subject believes an experience occurs. After a peripheral sensation, neuronal adequacy is projected *back then* to the peripheral site, yet not felt to occur at the time the cortex was stimulated to fire. Libet suggests, in the same manner, that visual experience is projected *out there* onto the external world and not referred to the retinal net. Thus we feel a rock at our toes (subjective time referral) and see a star in outer space (subjective space referral).

If my hypothesis is correct, the quantum interpretation appears to offer a better explanation of the paradox of subjective antedating as well as suggest a necessary first step toward a quantum physical mind-brain theory. Only the future will tell us if this is right.

What Does This All Mean?

These ideas, the parallel worlds' photograph and the future-to-present transactional interpretation, are the latest and most original ideas to be added to quantum physics. They both attempt to resolve the mystery of quantum physics. Neither may be correct. Whatever the resolution might turn out to be, it will not return us to the classical determinism that was the forefather of the quantum theory. Each idea opens up a new possibility, and perhaps the two ideas are connected.[23] If parallel worlds really do exist, and the future can act backward through time to the present, there is a consistency.

Consider the Wigner friend example once again. In world 1, containing the living cat, the professor sends back through time an echo wave, which is received by the friend, who in turn sends back through time another echo wave to the stethoscope, which sends back in time an echo wave to the living cat. Now repeat all of this for world 2 and a dead cat. The cats in each world also send back in time echo waves to the cyanide device where the original offer wave all started. According to the transactional interpretation, only one of the echo waves actually reaches the cyanide device and thus triggers the device either to release or not release the poisonous gas. According to the parallel worlds model, both echo waves are received by the device.

The two interpretations are consistent if the echo waves are in parallel worlds, not just in one world. In this way we have a

reason for the appearance of parallel worlds—they are required to match the physical constraints necessary for any one world to appear. Unconstrained, all of physics including all possible superpositions, even the most bizarre, would appear to manifest in only one world. With constraints, multiple worlds manifest: within each world, the constraining laws manifest by forming that particular world. For example, an atom requires that an electron exist as a wave cloud. However, if a law of constraint says that there can be only one electron in an energetically stable atom, that electron must appear as a single particle in each one of an infinite number of parallel worlds rather than as an infinite number of particles in any one world.

These constraints bring sanity and rationality to our world. They are the laws of physics, such as the conservation of energy and momentum (the presence of a single photon rather than two when the energy requires that only one be present). Thus, the transactional interpretation may indeed be consistent with parallel worlds. Although the theory says there may be no need for them if there is always one echo wave confirmation to any offer wave, Albert's photograph example and Deutsch's quantum computer require that parallel worlds do exist. If they do, then a whole new range of phenomena can be anticipated. Together these ideas indicate that the future might just be more important than we ever could dream in our classical Newtonian beds.

Notes

Chapter 1

1. J. Jaynes, *The Origin of Consciousness in the Breakdown of the Bicameral Mind* (Boston: Houghton Mifflin Co., 1976), chaps. 3, 6.
2. F. Capra, *The Tao of Physics* (Berkeley: Shambhala Publications, 1975), p. 21.
3. T. Dantzig, *Number, The Language of Science* (New York: Doubleday & Co., 1956), pp. 125–129.

Chapter 2

1. R. March, *Physics for Poets* (New York: McGraw-Hill Book Co., 1970), p. 22.
2. K. Greider, *Invitation to Physics* (New York: Harcourt Brace Jovanovich, 1973), p. 24.
3. Ibid., p. 32.
4. Ibid., p. 65.
5. L. Cooper, *An Introduction to the Meaning and Structure of Physics* (New York: Harper & Row, 1968), p. 9 (quote).
6. G. Holton and S. G. Brush, *Introduction to Concepts and Theories in Physical Science,* 2nd ed. (Reading, Mass.: Addison-Wesley Publishing Co., 1973), pp. 64–66.
7. R. March, *Physics for Poets,* p. 6.
8. K. Greider, *Invitation to Physics,* p. 73.
9. G. Holton and S. G. Brush, *Concepts and Theories,* pp. 110–111.
10. F. Rutherford, G. Holton, and F. G. Watson, dirs., *The Project Physics Course* (New York: Holt, Rinehart & Winston, 1970), unit 2, chap. 8, p. 120.
11. R. March, *Physics for Poets,* p. 95.
12. Ibid.
13. C. G. Jung, ed., *Man and His Symbols* (New York: Dell Publishing Co., 1968), p. 9.
14. J. R. Burr and M. Goldinger, eds., *Philosophy and Contemporary Issues* (New York: The MacMillan Co., 1972), p. 254.
15. Ibid., p. 255.
16. Ibid., p. 259.
17. G. Holton and S. G. Brush, *Concepts and Theories,* p. 345.
18. Ibid., p. 392.
19. Ibid., p. 420.
20. Ibid., p. 422.
21. M. Jammer, *The Conceptual Development of Quantum Mechanics* (New York: McGraw-Hill Book Co., 1966), pp. 14–22.

Chapter 3

1. M. Jammer, *The Conceptual Development of Quantum Mechanics* (New York: McGraw-Hill Book Co., 1966), p. 21. See also R. March, *Physics for Poets* (New York: McGraw-Hill Book Co., 1970), p. 190.
2. O. Theimer, *A Gentleman's Guide to Modern Physics* (Belmont, Calif.: Wadsworth Publishing Co., 1973), p. 234.
3. M. Jammer, *Conceptual Development,* p. 19.
4. Ibid.
5. Ibid., p. 21.
6. A. Einstein, Podolsky, and Rosen, "Can Quantum-Mechanical Description of Physical Reality Be Considered Complete?" *The Physical Review* 47 (1935):37.
7. M. Jammer. *Conceptual Development,* p. 28.
8. A. B. Arons and M. B. Peppard, "Einstein's Proposal of the Photon Concept— A Translation of the Annalen der Physik Paper of 1905," *American Journal of Physics* 33 (1965): 368.
9. Ibid.

Chapter 4

1. R. March, *Physics for Poets* (New York: McGraw-Hill Book Co., 1970), p. 180.

Chapter 5

1. R. March, *Physics for Poets* (New York: McGraw-Hill Book Co., 1970), p. 207.
2. M. Jammer, *The Conceptual Development of Quantum Mechanics* (New York: McGraw-Hill Book Co., 1966), p. 243.
3. Ibid., p. 244.
4. Ibid., p. 251.

5. Ibid., p. 249.
6. Ibid., p. 257.

Chapter 6

1. M. Jammer, *The Conceptual Development of Quantum Mechanics* (New York: McGraw-Hill Book Co., 1966), p. 283.
2. Ibid.
3. W. Heisenberg, *Physics and Beyond* (New York: Harper & Row, 1971), p. 38.
4. M. Jammer, *Conceptual Development*, p. 272.
5. Ibid., p. 329.

Chapter 7

1. M. Jammer, *The Philosophy of Quantum Mechanics* (New York: John Wiley & Sons, 1974), p. 86.
2. Ibid., p. 115.
3. Ibid.
4. Ibid., p. 116.

Chapter 8

1. E. Wigner, "The Problem of Measurement," *American Journal of Physics* 31 (1963): 6. See also E. Witmer, "Interpretation of Quantum Mechanics and the future of Physics," *American Journal of Physics* 35 (1962): 40; W. Wootters and W. Zurek, "Complementarity in the double-slit experiment: Quantum nonseparability and a quantitative statement of Bohr's principle," *Physical Review D* 19 (1979): 473; H. Stapp, "Mind, Matter and Quantum Mechanics," talk given at a Joint Psychology, Philosophy, and Physics Colloquium, University of Nevada, Reno (October 20, 1967); H. Stapp, "The Copenhagen Interpretation and the Nature of Space-Time," *American Journal of Physics* 40 (1972), p. 1098.
2. M. Jammer, *The Philosophy of Quantum Mechanics* (New York: John Wiley & Sons, 1974), p. 44.
3. See, for example, M. Gardiner, "Mathematical Games," *Scientific American* (May, 1979): 22.
4. P. Watzlawick, *How Real is Real?* (New York: Vintage Books, 1977), p. 208. Here Watzlawick discusses Newcomb's paradox in the light of communication paradoxes and relates this to our notions of causality.

Chapter 9

1. A. Einstein, Podolsky, and Rosen, "Can Quantum-Mechanical Description of Physical Reality Be Considered Complete?" *The Physical Review* 47 (1935): 777.
2. Ibid.

Chapter 10

1. A. Einstein, H. A. Lorentz, H. Weyl, and H. Minkowski, *The Principle of Relativity* (New York: Dover Publications, 1923), p. 63.
2. G. Feinberg, "Possibility of Faster-Than-Light Particles," *Physical Review* 159 (1967): 1089. Gerald Feinberg was one of the first physicists to consider tachyons seriously.
3. G. Benford, D. Book, and W. Newcomb, "The Tachyonic Antitelephone," *Physical Review D* 2 (1970): 263. Benford, Book, and Newcomb discuss the amusing situation created by tachyons that allow people to communicate with themselves in their pasts. See also O. Bilaniuk, V. Deshpande, and E. Sudarshan, " 'Meta' Relativity," *American Journal of Physics* 30 (1962): 718.
4. Y. Terletskii, *Paradoxes in the Theory of Relativity* (New York: Plenum Press, 1968), p. 71.

Chapter 11

1. D. Bohm, *Quantum Theory* (Englewood Cliffs, N.J.: Prentice-Hall, 1951).
2. D. Bohm and B. Hiley, "On the Intuitive Understanding of Non-locality as Implied by Quantum Theory," *Foundations of Physics* 5 (1975): 94.
3. Ibid.
4. D. Bohm and Y. Aharanov, "Discussion of Experimental Proof for the Paradox of Einstein, Rosen, and Podolsky," *Physical Review D* 108 (1957): 1070.
5. M. Jammer, *The Conceptual Development of Quantum Mechanics* (New York: McGraw-Hill Book Co., 1966), p. 324.
6. Ibid.
7. J. Bernstein, "I Am This Whole World: Erwin Schroedinger," in *Project Physics Reader 5* (New York: Holt, Rinehart & Winston, 1968–69), p. 178 (quote).
8. Ibid.
9. Ibid., p. 179 (quote).
10. E. Schroedinger, "Discussions of Probability Relations Between Separated Sys-

tems," *Cambridge Philosophical Society Proceedings* 31 (1935): 555.

Chapter 12

1. B. DeWitt and N. Graham, "Resource Letter IQM-1 on the Interpretation of Quantum Mechanics," *American Journal of Physics* 39/7 (1971): 737. This article contains twelve references to the EPR paradox and several references to hidden variables research.
2. D. Bohm, "A Suggested Interpretation of the Quantum Theory in Terms of 'Hidden' Variables I," *Physical Review* 85 (1952): 166; D. Bohm and J. Bub, "A Refutation of the Proof by Jauch and Piron that Hidden Variables Can Be Excluded in Quantum Mechanics," *Review of Modern Physics* 38 (1966): 470; D. Bohm and J. Bub, "A Proposed Solution of the Measurement Problem in Quantum Mechanics by a Hidden Variable Theory," *Reviews of Modern Physics* 38 (1966): 453.
3. J. S. Bell, "On the Einstein Podolsky Rosen Paradox," *Physics* 1 (1964): 195–200.
4. R. Feynman, R. Leighton, and M. Sands, *The Feynman Lectures on Physics,* vol. 1 (Reading, Mass.: Addison-Wesley Publishing Co., 1965), chap. 26, p. 3.
5. Ibid.
6. F. Rutherford, G. Holton, and F. G. Watson, dirs., *The Project Physics Course* (New York: Holt, Rinehart & Winston, 1970), unit 2, chap. 9, p. 21.
7. R. Feynman, R. Leighton, and M. Sands, *Feynman Lectures,* vol. 2, chap. 19, p. 9.
8. Ibid.
9. Ibid.
10. D. Bohm, "Suggested Interpretation of the Quantum Theory," p. 166.
11. M. Jammer, *The Philosophy of Quantum Mechanics* (New York: John Wiley & Sons, 1974), p. 291.
12. Ibid., p. 294.
13. M. Born. *Natural Philosophy of Cause and Chance* (London: Oxford University Press, 1949), p. 93.
14. J. S. Bell, "On the Problem of Hidden Variables in Quantum Mechanics," *Reviews of Modern Physics* 38 (1966): 447.
15. J. S. Bell, "On the EPR Paradox," p. 195–200.
16. Ibid., p. 199.
17. H. Stapp, "Are Superluminal Connections Necessary?" *Il Nuovo Cimento* 40B (1977): 191; H. Stapp, "Bell's Theorem and World Process," *Il Nuovo Cimento* 29B/2 (1975): 270; H. Stapp, "Mind, Matter and Quantum Mechanics," talk given at a Joint Psychology, Philosophy, and Physics Colloquium, University of Nevada, Reno (October 20, 1967); H. Stapp, "The Copenhagen Interpretation and the Nature of Space-Time," *American Journal of Physics* 40 (1972): 1098; H. Stapp, "Theory of Reality," *Foundations of Physics* 7 (1977): 313; H. Stapp, "Whiteheadian Approach to Quantum Theory and the Generalized Bell's Theorem," *Foundations of Physics* 9 (1979): 1. The weirdness of these results still causes concern among physicists; Stapp addresses himself to Bell's results in these references. See also N. Herbert, "Cryptographic Approach to Hidden Variables," *American Journal of Physics* 43 (1975): 315; E. Wigner, "On Hidden Variables and Quantum Mechanical Probabilities," *American Journal of Physics* 38 (1970): 1005; Bernard d'Espagnat, "The Quantum Theory and Reality," *Scientific American* (November, 1979): 158.
18. J. Clauser and M. Horne, "Experimental Consequences of Objective Local Theories," *Physical Review D* 10 (1974): 532.
19. J. Clauser, Personal correspondence between Karl Popper and John Clauser (August 30, 1974).

Chapter 13

1. C. Bloch, *The Golem* (New York: Rudolf Steiner Publications, 1972), p. 1.
2. T. Johnston, "Will Your Next Home Appliance Be a Mini-Computer?" *New West* (March 4, 1977), pp. 50–59.
3. K. O'Quinn, "The Whole World in Your Hands!" *Future Life* 13 (1979): 52.
4. L. Bass, "A Quantum Mechanical Mind-Body Interaction," *Foundations of Physics* 5 (1975): 160 (quote).
5. M. Jammer, *The Philosophy of Quantum Mechanics* (New York: John Wiley & Sons, 1974), p. 499.
6. Ibid.
7. J. Mehra, "Quantum Mechanics and the Explanation of Life," *American Scientist* 61 (1973): 722–728. Wigner's ideas for extending quantum mechanics to include consciousness are given in this reference. For Wigner's views on consciousness and quantum physics, see also E. Wigner, "The Problem of Measurement," *American Journal of Physics* 31 (1963): 6.

8. B. DeWitt and N. Graham, eds., *The Many-Worlds Interpretation of Quantum Mechanics* (Princeton: Princeton University Press, 1973), p. 3. This reference contains Everett's thesis.

9. M. Jammer, *Philosophy,* p. 500.

10. B. DeWitt and N. Graham, eds., *Many-Worlds Interpretation,* quote in frontispiece.

11. B. DeWitt, "Quantum Mechanics and Reality," *Physics Today* (September, 1970): 30; L. E. Ballentine et al., "Quantum Mechanics Debate," *Physics Today* (April, 1971): 36. These two articles contain DeWitt's explanation of the many-worlds interpretation of quantum mechanics and the resultant rebuttal of reluctant physicists.

12. B. DeWitt and N. Graham, "Resource Letter IQM-1 on the Interpretation of Quantum Mechanics," *American Journal of Physics* 39/7 (1971): 116.

13. L. Oteri, ed., "Quantum Physics and Parapsychology," parts I and II, proceedings of an international conference, Geneva, Switzerland, 1974 (New York: Parapsychology Foundation, 1975), pp. 1–53. E. H. Walker, the author of this article and one of the pioneers in the physics of consciousness, follows Wigner's approach and Bohm's hidden variable approach.

14. B. DeWitt and N. Graham, "Resource Letter IQM-1," pp. 110–119.

15. Ibid., p. 114. Also see L. E. Ballentine, "The Statistical Interpretation of Quantum Mechanics," *Reviews of Modern Physics* 42 (1970): 358.

16. B. DeWitt and N. Graham, "Resource Letter IQM-1," p. 151.

17. Ibid.

Chapter 14

1. R. Feynman, "The Value of Science," *Project Physics Reader 1,* Authorized Interim Version (1968–69), p. 3.

2. Ibid., p. 4.

3. L. Bass, "A Quantum Mechanical Mind-Body Interaction," *Foundations of Physics* 5 (1975): 159.

4. R. Keynes, "Ion Channels in the Nerve-Cell Membrane," *Scientific American* (March, 1979): 126.

5. C. Stevens, "The Neuron," *Scientific American* (September, 1979): 55.

6. L. Bass, "Mind-Body Interaction," p. 161.

7. Ibid., p. 167.

8. Ibid., p. 168.

9. W. Penfield, *The Mystery of the Mind* (Princeton: Princeton University Press, 1975), p. 109.

10. L. Bass, "Mind-Body Interaction," p. 171.

11. J. Jaynes, *The Origin of Consciousness in the Breakdown of the Bicameral Mind* (Boston: Houghton Mifflin Co., 1976).

12. C. Suares, Personal Communication (Fall, 1974).

13. R. Ornstein, ed., *The Nature of Human Consciousness* (New York: The Viking Press, 1974), part 2.

14. M. Jammer, *The Conceptual Development of Quantum Mechanics* (New York: McGraw-Hill Book Co., 1966), p. 350.

15. R. M. Bucke, *Cosmic Consciousness* (New York: E. P. Dutton & Co., 1969); M. H. Chase, "The Matriculating Brain," *Psychology Today* (June, 1973): 82. Chase discusses the possibility of the willful control of a single neuron in the human body. See also J. V. Basmajian, "Control and Training of Individual Motor Units," *Science* 141 (1963): 440–441. Basmajian discusses how the mind singles out and controls the firing of a neuron through the technique of biofeedback.

Chapter 15

Opening quotation from A. S. Wightman. "E.P. Wigner: An Introduction." In *New Techniques and Ideas in Quantum Measurement Theory,* D.M. Greenberger, ed. Annals of the New York Academy of Sciences, Vol. 480, December 30, 1986.

1. See chapter 13 for a first discussion of Everett's idea.

2. See chapter 6 for the definition of the quantum wave of probability.

3. B. Libet. "Subjective Antedating of a Sensory Experience and Mind-Brain Theories: Reply to Honderich (1984)." *Journal of Theoretical Biology* Vol. 114, pp. 563–570, 1985.

4. I have suggested such a proposal in a paper very recently submitted to the *Journal of Theoretical Biology.* See F. A. Wolf. "On the Quantum Physical Theory of Subjective Antedating." Submitted in 1987.

5. See chapter 13 to review the paradox. Instead of a quantum wave function, the friend has trapped a cat in the box à la the Schrödinger Cat paradox.

6. See chapter 8 for a discussion of this principle.

7. Or perhaps a stringlike particle according to so-called *superstring* theories. In this new development, physicists imagine that fundamental particles are not points at all, but are folded up strings with the folds occurring in as many as eight other dimensions. Even if this turns out to be so, it won't resolve the Wigner's friend paradox.

8. See chapter 13, the final section.

9. Wigner's friend is discussed in chapter 13.

10. Schrödinger's cat is discussed in chapter 11.

11. See the new preface. The meeting was *New Techniques and Ideas in Quantum Measurement Theory,* held by the New York Academy of Sciences on January 21–24, 1986, in New York City.

12. See the new preface for a rundown of what happened at the New York meeting of the first gathering of quantum physicists since 1927.

13. D. Z. Albert. "How to Take a Photograph of Another Everett World." In *New Techniques and Ideas in Quantum Measurement Theory,* D.M. Greenberger, ed. Annals of the New York Academy of Sciences, Vol. 480, December 30, 1986.

14. I ask the reader who is having a hard time visualizing all of this to look back at the drawing on page 191 in chapter 11. Imagine that you are the professor and that the little guy in the drawing is the friend. No more needs to be said about the cat.

15. D. Deutsch. "Quantum Theory, the Church-Turing Principle and the Universal Quantum Computer." *Proceedings of the Royal Society of London,* Vol. A 400, pp. 97–117, 1985.

16. F. A. Wolf. *Star Wave: Mind, Consciousness, and Quantum Physics.* New York: Macmillan, 1984.

17. D. Deutsch. "Quantum Theory," pp. 97–117.

18. J. G. Cramer, "Generalized Absorber Theory and the Einstein-Podolsky-Rosen Paradox." *Physical Review* Vol. 22, p. 362, 1980. See also J. G. Cramer, "The Transactional Interpretation of Quantum Mechanics." *Reviews of Modern Physics* 58/3 (1986).

19. The reader should return to chapter 7 for a discussion of the Bohr or Copenhagen interpretation of quantum mechanics. Also review chapter 8 to see how Bohr uses it to explain complementarity.

20. Now a complex number is really two separate numbers. One of the numbers is called the "real part" and the other is called the "imaginary part." The imaginary part is written with the letter i in front of it to signify that it is an imaginary number. It is a fact that all quantum waves are composed of both real and imaginary parts, which in itself is very strange. Since the quantum wave represents the state of "our knowledge" about a system, as in the Copenhagen interpretation, how do the two parts of the wave give us only one answer?

We know how. We multiply the original wave by another wave that has the same two numbers but arranged slightly differently. This other wave is the complex-conjugate of the original wave. For example, if the original wave—evaluated at a certain point in space-time—had the value $5 + i3$, the complex-conjugated wave would have similar values but would be written $5 - i3$. That minus sign is significant. When these two numbers are multiplied together the result is a real positive number containing no *is:* $25 + 9$, or 34.

21. J. A. Wheeler. In *The Mathematical Foundations of Quantum Mechanics,* A. R. Marlow, ed. New York: Academic Press, 1978. See also J. A. Wheeler, "Delayed-Choice Experiments and the Bohr-Einstein Dialogue." *The American Philosophical Society and the Royal Society.* Papers read at a joint meeting June 5, 1980. Library of Congress catalog card number: 80-70995.

22. For a description of the double slit experiment see the introduction and the accompanying figure; see also chapter 9 and the index entries on wave-particle duality.

23. See my latest book entitled *Parallel Universes: Worlds Within Our Present Senses,* published by Simon & Schuster (1989). In this book, I look further into the meaning of parallel worlds and why physicists are taking them more seriously today.

Bibliography

Arons, A. B., and Peppard, M. B. "Einstein's Proposal of the Photon Concept—A Translation of the Annalen der Physik Paper of 1905." *American Journal of Physics* 33 (1965), pp. 367–374.

Ballentine, L. E. "The Statistical Interpretation of Quantum Mechanics." *Reviews of Modern Physics* 42 (1970), p. 358.

Ballentine, L. E.; Pearle, P.; Walker, E. H.; Sachs, M.; Koga, T.; Gerver, J.; and DeWitt, B. "Quantum Mechanics Debate." *Physics Today* (April, 1971), p. 36.

Basmajian, J. V. "Control and Training of Individual Motor Units." *Science* 141 (1963), pp. 440–441.

Bass, L. "A Quantum Mechanical Mind-Body Interaction." *Foundations of Physics* 5 (1975), p. 159.

Bell, J. S. "On the Einstein Podolsky Rosen Paradox." *Physics* 1 (1964), pp. 195–200.

Bell, J. S. "On the Problem of Hidden Variables in Quantum Mechanics." *Reviews of Modern Physics* 38 (1966), p. 447.

Bello, F. "Great American Scientists: The Physicists." *Fortune Magazine* 61, (March, 1960), p. 113.

Benford, G.; Book, D.; and Newcomb, W. "The Tachyonic Antitelephone." *Physical Review D* 2 (1970), p. 263.

Bernstein, J. "I Am This Whole World: Erwin Schroedinger." In *Project Physics Reader 5*, pp. 171–180. New York: Holt, Rinehart & Winston, 1968–69.

Bilaniuk, O.; Deshpande, V.; and Sudarshan, E. "'Meta' Relativity." *American Journal of Physics* 30 (1962), p. 718.

Bloch, C. *The Golem.* New York: Rudolf Steiner Publications, 1972.

Bohm, D. *Quantum Theory.* Englewood Cliffs, N.J.: Prentice-Hall, 1951.

Bohm, D. "A Suggested Interpretation of the Quantum Theory in Terms of 'Hidden' Variables I." *Physical Review* 85 (1952), p. 166.

Bohm, D., and Aharonov, Y. "Discussion of Experimental Proof for the Paradox of Einstein, Rosen, and Podolsky." *Physical Review D* 108 (1957), p. 1070.

Bohm, D., and Bub, J. "A Proposed Solution of the Measurement Problem in Quantum Mechanics by a Hidden Variable theory." *Reviews of Modern Physics* 38 (1966), p. 453.

Bohm, D., and Bub, J. "A Refutation of the Proof by Jauch and Piron that Hidden Variables Can Be Excluded in Quantum Mechanics." *Review of Modern Physics* 38 (1966), p. 470.

Bohm, D., and Hiley, B. "On the Intuitive Understanding of Non-locality as Implied by Quantum Theory." *Foundations of Physics* 5 (1975), pp. 93–109.

Bohr, N. "Can Quantum-Mechanical Description of Physical Reality Be Considered Complete?" *Physical Review* 48 (1935), pp. 696.

Born, M. *Natural Philosophy of Cause and Chance.* London: Oxford University Press, 1949.

Brown, G. Spencer. *Laws of Form.* Toronto: Bantam Books, 1973.

Bucke, R. M. *Cosmic Consciousness.* New York: E. P. Dutton & Co., 1969.

Burr, J. R., and Goldinger, M., eds. *Philosophy and Contemporary Issues.* New York: The Macmillan Co., 1972.

Capra, F. *The Tao of Physics.* Berkeley: Shambhala Publications, 1975.

Chase, M. H. "The Matriculating Brain." *Psychology Today* (June, 1973), p. 82.

Clauser, J. Personal correspondence between Karl Popper and John Clauser, August 30, 1974.

Clauser, J., and Horne, M. "Experimental Consequences of Objective Local Theories." *Physical Review D* 10 (1974), p. 526.

Cooper, L. *An Introduction to the Meaning and Structure of Physics.* New York: Harper & Row, 1968.

Dantzig, T. *Number. The Language of Science.* New York: Doubleday & Co., 1956.

d'Espagnat, B. "The Quantum Theory and Reality." *Scientific American* (November, 1979), p. 158.

DeWitt, B. "Quantum Mechanics and Reality." *Physics Today* (September, 1970), p. 30.

DeWitt, B., and Graham, N. "Resource Letter IQM-1 on the Interpretation of Quantum Mechanics." *American Journal of Physics* 39/7 (1971), p. 724.

DeWitt, B., and Graham, N., eds. *The Many-Worlds Interpretation of Quantum Mechanics.* Princeton: Princeton University Press, 1973.

Einstein, A.; Lorentz, H. A.; Weyl, H.; and Minkowski, H. *The Principle of Relativity.* New York: Dover Publications, 1923.
Einstein, A., Podolsky, and Rosen. "Can Quantum-Mechanical Description of Physical Reality Be Considered Complete?" *Physical Review* 47 (1935), p. 777.
Einstein, A.; Tolman, R. C.; and Podolsky, B. "Knowledge of Past and Future in Quantum Mechanics." *Physical Review* 37 (1931), pp. 780–781.

Feinberg, G. "Possibility of Faster-Than-Light Particles." *Physical Review* 159 (1967), p. 1089.
Feynman, R. "Scientific Imagination." *Project Physics Reader 4,* Authorized Interim Version (1968–69), p. 239.
Feynman, R. "The Value of Science." *Project Physics Reader 1,* Authorized Interim Version (1968–69), p. 1.
Feynman, R.; Leighton, R.; and Sands, M. *The Feynman Lectures on Physics.* Reading, Mass.: Addison-Wesley Publishing Co., 1965.

Gardiner, M. "Mathematical Games." *Scientific American* (May, 1979), pp. 18–25.
Greider, K. *Invitation to Physics.* New York: Harcourt Brace Jovanovich, 1973.
Gwynne, P., with Begley, S., and Hager, M. "The Secrets of the Human Cell." *Newsweek* (August 20, 1979), p. 48.

Heisenberg, W. *Physics and Beyond.* New York: Harper & Row, 1971.
Herbert, N. "Cryptographic Approach to Hidden Variables." *American Journal of Physics* 43 (1975), p. 315.
Hofstadter, D. *Gödel, Escher, Bach: An Eternal Golden Braid.* New York: Basic Books, 1979.
Holton, G., and Brush, S. G. *Introduction to Concepts and Theories in Physical Science.* Second Edition. Reading, Mass.: Addison-Wesley Publishing Co., 1973.
The Holy Bible, New International Version of The New Testament. Grand Rapids, Mich.: Zondervan Bible Publishers, 1973.
Howe, R., and VonFoerster, H. "Introductory Comments to Francisco Varela's Calculus for Self-Reference." *International Journal of General Systems* 2 (1975), pp. 1–3.

Jammer, M. *The Conceptual Development of Quantum Mechanics.* New York: McGraw-Hill Book Co., 1966.
Jammer, M. *The Philosophy of Quantum Mechanics.* New York: John Wiley & Sons, 1974.
Jaynes, J. *The Origin of Consciousness in the Breakdown of the Bicameral Mind.* Boston: Houghton Mifflin Co., 1976.
Johnston, T. "Will Your Next Home Appliance Be a Mini-Computer?" *New West* (March 4, 1977), pp. 50–59.
Jung, C. G., ed. *Man and His Symbols.* New York: Dell Publishing Co., 1968.

Keynes, R. "Ion Channels in the Nerve-Cell Membrane." *Scientific American* (March, 1979), p. 126.

March, R. *Physics for Poets.* New York: McGraw-Hill Book Co., 1970.
Mehra, J. "Quantum Mechanics and the Explanation of Life." *American Scientist* 61 (1973), pp. 722–728.
Morris, W., ed. *The American Heritage Dictionary of the English Language.* Boston: American Heritage Publishing Co. and Houghton Mifflin Co., 1969.

Nagel, E., and Newman, J. *Gödel's Proof.* New York: New York University Press, 1958.

O'Quinn, K. "The Whole World in Your Hands!" *Future Life* 13 (1979), p. 52.
Ornstein, R., ed. *The Nature of Human Consciousness.* New York: The Viking Press, 1974.
Oteri, L., ed. "Quantum Physics and Parapsychology." Parts I and II, Proceedings of an International Conference, Geneva, Switzerland, 1974. New York: Parapsychology Foundation, 1975.

Penfield, W. *The Mystery of the Mind.* Princeton: Princeton University Press, 1975.
Pirani, F. "Noncausal Behavior of Classical Tachyons." *Physical Review D* 1 (1970), p. 3224.

Rutherford, F.; Holton, G.; and Watson, F. G., directors. *The Project Physics Course.* New York: Holt, Rinehart & Winston, 1970.

Schroedinger, E. "Discussion of Probability Relations Between Separated Systems." *Cambridge Philosophical Society Proceedings* 31 (1935), p. 555.
Schulman, L. "Tachyon Paradoxes." *American Journal of Physics* 39 (1971), p. 481.

Stapp, H. "Are Superluminal Connections Necessary?" *Il Nuovo Cimento* 40B (1977), p. 191.

Stapp, H. "Bell's Theorem and World Process." *Il Nuovo Cimento* 29B/2 (1975), p. 270.

Stapp, H. "The Copenhagen Interpretation and the Nature of Space-Time." *American Journal of Physics* 40 (1972), p. 1098.

Stapp, H. "Mind, Matter and Quantum Mechanics." Talk given at a Joint Psychology, Philosophy, and Physics Colloquium, University of Nevada, Reno, October 20, 1967.

Stapp, H. "Theory of Reality." *Foundations of Physics* 7 (1977), p. 313.

Stapp, H. "Whiteheadian Approach to Quantum Theory and the Generalized Bell's Theorem." *Foundations of Physics* 9 (1979), p. 1.

Stevens, C. "The Neuron." *Scientific American* (September, 1979), p. 55.

Suares, C. *The Cipher of Genesis.* Berkeley: Shambhala Publications, 1970.

Suares, C. Personal Communication, Fall, 1974.

Terletskii, Y. *Paradoxes in the Theory of Relativity.* New York: Plenum Press, 1968.

Theimer, O. *A Gentleman's Guide to Modern Physics.* Belmont, Calif.: Wadsworth Publishing Co., 1973.

Thomsen, D. "The Blob That Ate Physics." *Science News* 108, p. 28.

Thomsen, D. "Is Modern Physics for Real?" *Science News* 109 (1976), p. 332.

Toben, B. *Space-Time and Beyond.* New York: E. P. Dutton, 1975.

Varela, G., and Francisco, J. "A Calculus for Self-Reference." *International Journal of General Systems* 2 (1975), pp. 5–24.

Watzlawick, P. *How Real Is Real?* New York: Vintage Books, 1977.

Wheeler, J. "From Relativity to Mutability." In *The Physicist's Conception of Nature,* edited by J. Mehra, pp. 242–244. Holland: D. Reidel Publishing Co., 1973.

Wigner, E. "On Hidden Variables and Quantum Mechanical Probabilities." *American Journal of Physics* 38 (1970), p. 1005.

Wigner, E. "The Problem of Measurement." *American Journal of Physics* 31 (1963), p. 6.

Witmer, E. "Interpretation of Quantum Mechanics and the Future of Physics." *American Journal of Physics* 35 (1962), p. 40.

Wootters, W., and Zurek, W. "Complementarity in the double-slit experiment: Quantum nonseparability and a quantitative statement of Bohr's principle." *Physical Review D* 19 (1979), p. 473.

Zukav, G. *The Dancing Wu Li Masters.* New York: William Morrow and Co., 1979.

Zwick, M. "Quantum Measurement and Gödel's Proof." Paper at Department of Biophysics and Theoretical Biology, University of Chicago, Chicago, Ill., June, 1975.

Index